Bluegrass Odyssey

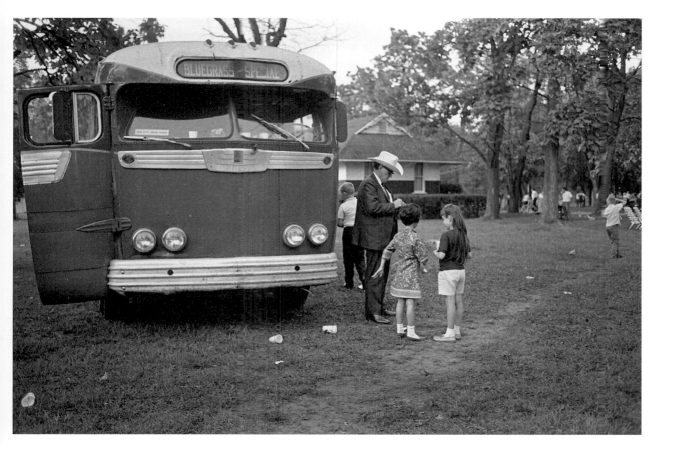

Page i: Franklin, Ohio, September 8, 1968. Bill Monroe and his tour bus at the Chautauqua Park Bluegrass Festival.

MUSIC IN AMERICAN LIFE

A list of books in the series appears at the end of this book.

Carl Fleischhauer and
Neil V. Rosenberg

University of Illinois Press
URBANA AND CHICAGO

Bluegrass Odyssey

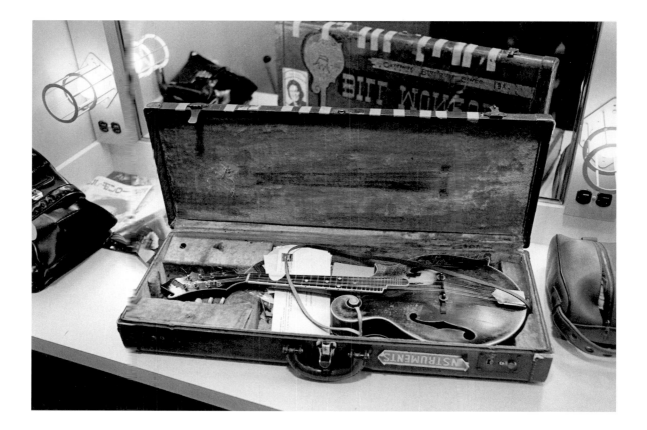

A Documentary in Pictures and Words, 1966–86

Publication of this book was supported by grants from the Lyndhurst Foundation, *Bluegrass Unlimited,* and Ralph and Ruth Fisher.

Title page photograph: Nashville, Tennessee, October 15, 1975. Bill Monroe's "master model" F-5 Gibson mandolin backstage at the Grand Ole Opry house during the Early Bird Blue Grass Concert.

Library of Congress Cataloging-in-Publication Data
Fleischhauer, Carl.
Bluegrass odyssey : a documentary in pictures and words, 1966–86 /
Carl Fleischhauer and Neil V. Rosenberg.
p. cm. — (Music in American life)
Includes index.
ISBN 0-252-02615-2
1. Bluegrass music—History and criticism. 2. Bluegrass musicians—Portraits.
I. Rosenberg, Neil V. II. Title. III. Series.
ML3520.F6 2001
781.642'09—dc21 00-008713

C 5 4 3 2 1

To Teya and Lisa Rosenberg and Paula Johnson,

with many thanks for years of happiness

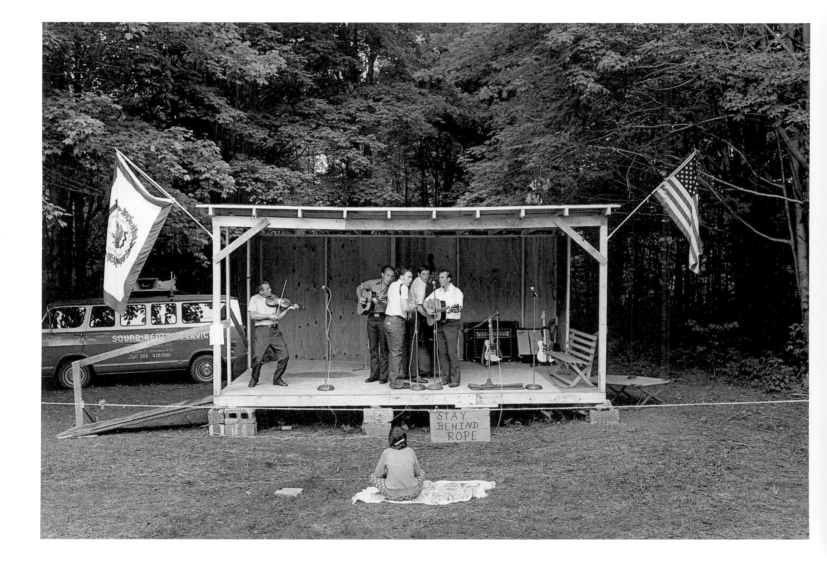

Webster Springs, West Virginia, July 5, 1974.
The Mountain State Bluegrass Boys at the
Mountain State Bluegrass Festival.

Contents

Preface and Acknowledgments

This book is a narrative in pictures and words. Its subject is bluegrass music—or, more accurately, a community bounded not by geography but by its connection to bluegrass music. The chapters represent aspects of this community's culture: the music itself, the places where the community may be found, and the relationships among community members, including relationships of blood and kin.

Reading the narrative requires that you interpret both pictures and words. The photographs don't illustrate the text; nor does the text explicate the photographs. Rather, as it says in the afterword, this book "modulates between a photo essay and a picture poem." The narrative reports some of the fieldwork findings of the photographer (Carl Fleischhauer) and the writer (Neil Rosenberg) but—especially through the photographs—also transfers part of the fieldwork experience to you, the reader, offering an opportunity to make your own observations and interpretations. To be sure, your ability to observe is limited to the momentary windows that the photographer has provided, but we believe that the pictures contain much for you to see and consider.

We are grateful to the people in the photographs (and just off-camera) who helped us during our many visits to the places described. We send a special thank you to our colleagues who read the text and reviewed the captions for accuracy, including Wendell Allen, who passed away as we were completing the manuscript, Tom Ewing, Scott Hambly, Pete Kuykendall, and Sandy Rothman. Additional assistance was gen-

erously provided by Dinah Adkins, Grethel Bennett, Ron Chacey, Dwight Diller, Mimi Hart, Richard Hefner, John Hutchison, Estyl G. Shreve, Richard D. Smith, Creston E. Stewart, and Charles K. Wolfe. The photographs on page 70 are from the collections of the American Folklife Center at the Library of Congress. We would also like to thank our friends at the University of Illinois Press, especially our acquiring editor, Judith McCulloh, and the ever-patient art director, Copenhaver Cumpston.

We cannot page through this book ourselves without reflecting on the loss of so many of the community members who are pictured here. As we considered how to pay tribute to them, we recalled lyrics from one of Bill Monroe's most moving songs:

> I hear a voice out in the darkness
> It mourns and whispers through the pines
> I know it's my sweetheart a-calling
> I hear her through the walls of time.

Bluegrass Odyssey

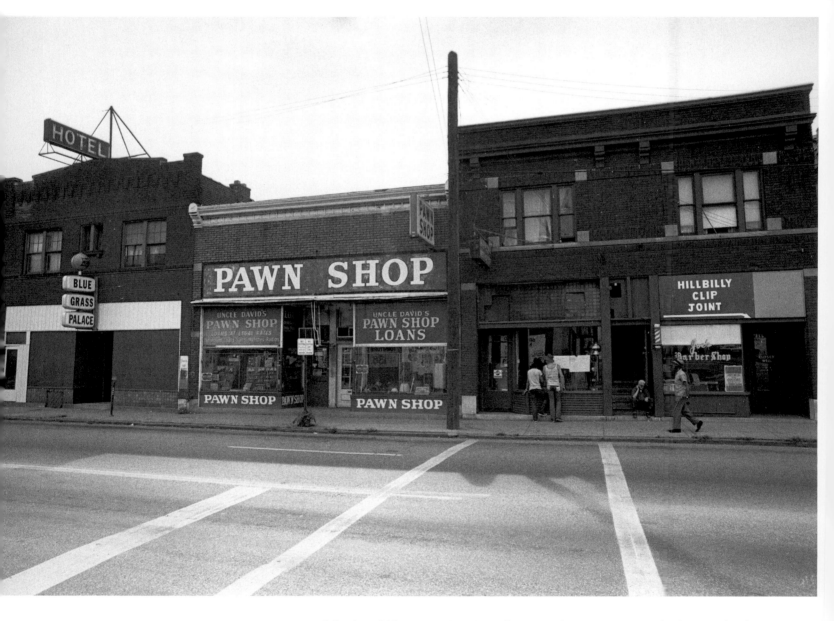

Columbus, Ohio, August 16, 1972. The Blue Grass Palace on Parsons Avenue near Marion Road in Columbus's South End, just a pawn shop away from the Hillbilly Clip Joint. Like bars in Detroit, Cincinnati, Chicago, Dayton, and Baltimore, the Blue Grass Palace, earlier called the Par-Mar, catered to people who had moved north from the Upper South.

Introduction

In 1960, when Carl Fleischhauer and I first met, we had both recently discovered bluegrass music. Undergraduates at small liberal arts colleges in Ohio, we'd grown up in middle-class families in university towns. Music was first introduced to us as a facet of the arts—part of the intellectual world of our parents. Naturally, we grew up also immersed in the popular music of the era. Like most teenagers in the 1950s we embraced new popular forms that helped us articulate personal identity: rhythm and blues, rock and roll, and, by the time we reached college, folk music, which is where we encountered bluegrass. We experienced bluegrass first as popular music on records, and then we began to think of it as art. Flatt and Scruggs were the stars of bluegrass at this point; Bill Monroe, the man who'd invented bluegrass, was a distant figure. As we moved from passive appreciation to active participation, we bought the appropriate instruments and learned our favorite songs.

Within a few years we had tracked these sounds into a music culture, connecting the sounds with the community from which they sprang. In Ohio, as in other northern and eastern states at the time, bluegrass was chiefly the music of Appalachian emigrants and other working-class people. It could be heard on weekend nights in hillbilly bars, on Sunday morning gospel broadcasts from tiny radio stations, and at country music parks on Sunday afternoons. By the mid-1960s we'd moved on to graduate school in southern Ohio and Indiana and become immersed in the local bluegrass scenes.[1] By this time Bill Mon-

roe, with Ralph Rinzler's help, was moving back to center stage in the growing world of bluegrass.

Meanwhile, at the bars and parks we discovered that bluegrass was perpetuated by people who not only knew how to sing and play it but who also bought, sold, repaired, and built the instruments it was played on. The instrument scene was just one strand in a cultural web that reached out in time and space to include disc jockeys, evangelists, promoters, relatives, and lovers from down home. The more deeply we delved into this scene, the more we wanted to know about it. Eventually our curiosity and personal involvement prompted us to apply the skills we were learning in our studies to the documentation of bluegrass. In the late 1960s I published an article on the historical origins of the music, while Carl produced a twenty-minute film portrait of a young bluegrass musician.[2]

By the early 1970s the bluegrass music scene had changed considerably. Within a few years hundreds of festivals had sprung up. The southern working-class people born in the 1920s and 1930s who'd been there first were now joined by a younger generation. There were more middle-class bluegrass fans, and many new followers of the music were from outside the South. Although Monroe was now the dominant figure, second-generation bands like the Osborne Brothers and the Country Gentlemen were in their prime, and counterculture-influenced youth were challenging the tried and true with innovations some were calling "newgrass." The cultural web we'd first encountered had spread with the help of magazines, clubs, specialized record companies, and other movement paraphernalia. We had completed our graduate studies and were working at large regional universities; in correspondence between West Virginia and Newfoundland we traded ideas, recordings, and information about this mushrooming bluegrass scene.

In 1971 an editor at the University of Illinois Press asked me to write a book on bluegrass for its new series Music in American Life. I thought immediately of the visual aspects of the music and its culture. Carl and I began discussing this in our correspondence. It was an exciting time for the music, and we'd been involved in it long enough to recognize the many dimensions of contemporary bluegrass that could be captured and represented visually.

In August 1972 we set out to explore this subject in a joint field trip that took us from West Virginia through Kentucky, Ohio, Indiana, and on to Illinois. Along the way we visited one of Bill Monroe's festivals, dropped in on a recording session at Rusty York's studio in Cincinnati, interviewed J. D. Crowe, Birch Monroe, and others, shopped at the

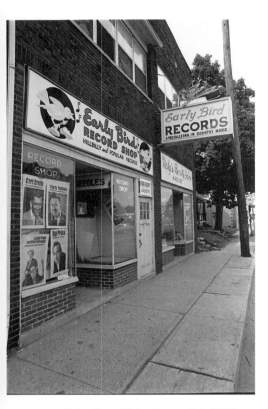

Columbus, Ohio, August 16, 1972. The Early Bird Record Shop in Columbus's South End.

Early Bird Record Shop in Columbus. Some of the photographs from that 1972 trip appear in this book, including a series of them in the second chapter, "Destination." During the trip we talked a lot about capturing bluegrass culture past and present in pictures, a dialogue that continued in the years that followed. Carl's photographs helped to illustrate my books *Bill Monroe and His Blue Grass Boys: An Illustrated Discography* and *Bluegrass: A History,* and over the years they've also appeared in other books, magazines, and on album covers.[3]

During the 1980s Carl's work as a media specialist at the Library of Congress's American Folklife Center took him away from the bluegrass scene. By the end of the decade my own research also followed other paths. Bluegrass continued to develop, as one might expect, and it was through one such development that the idea for this book emerged. By the early 1990s the annual conventions of the burgeoning International Bluegrass Music Association (IBMA), a trade organization, in Owensboro, Kentucky, had become a site of revitalization in the bluegrass music world. In September 1992 the newly established International Bluegrass Music Museum opened its doors in Owensboro for a preview during the IBMA convention. The featured exhibition was "The Bluegrass Landscape," a much-elaborated version of a 1987 lecture Carl had delivered at Brown University at the invitation of ethnomusicologist and folklorist Jeff Todd Titon. The exhibition covered the period 1968–83, evoking the world of bluegrass Carl had recorded. After viewing the exhibition and hearing the responses of others who saw it, I suggested to Carl that the time had come for a book of his bluegrass photographs. I knew there were many more good ones that had never been printed. Shots I'd seen on his proof sheets reminded me of rare vintage recordings lying unissued. Documents evocative of a cultural scene, of times and places now passed, they offered new dimensions for the present. I knew too that these pictures worked in more than one way: while bluegrass fans could recognize familiar faces and settings, outsiders found the unfamiliar images attractive and intriguing.

Bluegrass Odyssey is organized to reflect that basic duality. In a sense it doesn't matter who the people are or where the photographs were taken because the actions and places speak for themselves. But in another sense these things matter very much to us, for these images also document our personal journeys of discovery. We've grouped them together so as to share with you those aspects of the bluegrass music culture that first struck us and drew us into the scene.

In the first chapter, "Intensity," we offer a group of photos chosen to convey first impressions of the music itself. The intensity of bluegrass

performance was one of the things that attracted us to the music. In presenting the music onstage, bluegrass musicians use voices and acoustic instruments to project the music through microphones. It's hard work, yet they seem to be relaxed and happy. The lyrics often tell sad stories at toe-tapping or breakneck speed. The photographic narrative begins with images of musicians onstage in a variety of venues, followed by scenes of the backstage activities that take place before and after performances. The chapter defines the music in terms of the range of artists who play it and the diversity of places in which the music can be found.

The pictures in the second chapter, "Destination," follow our own experience as our interest expanded from the music to its cultural context, from the sound to ethnography. In presenting images from our journeys to bluegrass destinations, we document a number of associated elements: musical instrument merchants, an Opry star grabbing a meal before the show, and a cross section of performance venues, including a blue-collar bar in Ohio, nightclubs in Washington, D.C., a country music hall in North Hollywood, California, the Library of Congress, and a small-town barbershop in Maryland.

As we were drawn into this intense music we became fascinated with the behind-the-scenes details—from performing to instrument repair to recording. The third chapter, "Transaction," explores several levels of reciprocation and negotiation. It documents transactions where money changes hands: the production of sound recordings, paid performances, the sale of merchandise, and so on. But the chapter also highlights the nonmonetary exchanges that occur within these activities—for example, determining the sequence of songs in a set or the order of bands during a festival afternoon. The narrative, which reflects our own first steps into the backstage areas of bluegrass, concludes with a series of portraits of the people whose work depends on the music: disc jockeys and those who photograph and write about the music.

In the fourth chapter, "Community," the pictures interpret the human connections that we discovered as we became familiar with the music, its transactions, and its sites. Involvement in bluegrass music creates a web, a sense of neighborliness among friends and strangers when they're linked in celebration for the first time at festivals, concerts, jam sessions, and other events. In sketching the human groupings that mark bluegrass, and in documenting the shifting friendships and alliances within the community, physical arrangements are also noted. On- and offstage, during musical performances and other interactions, band members, listeners, and bystanders position themselves to form duos, trios, and circles.

Everywhere you look in bluegrass music you can find examples of the basic connections that tie individuals together, and as we looked through Carl's photographs we were struck by the number of examples to be found of one such connection—the family. The fifth chapter, "Family," surveys this topic, principally among performers but also in such activities as the publication of the leading bluegrass enthusiast's magazine. It closes with an image of Everett Lilly, a musician who retired and moved from Boston back to his native West Virginia after the accidental death of his teenage son.

The last chapter, "The Monroe Myth," is a meditation on an individual—arguably the leading figure in bluegrass music—and his family. No single family is more important to the bluegrass story than that of Bill Monroe. Like most people who discover bluegrass, we sought to learn more about Monroe, his family, and his home community of Rosine, Kentucky, which Carl visited and photographed on two occasions. Words and pictures take you on the road with Monroe, visiting his birthplace and the graveyard in which his parents are buried. The chapter closes with an image of Monroe—his brother, sister, sister-in-law, and son behind him—dedicating the headstone of his uncle Pendleton Vandiver, who died in 1932. Vandiver's fiddle playing had influenced Monroe as a youth, and Monroe memorialized him in the song "Uncle Pen."

Bluegrass Odyssey closes with an afterword in which Carl discusses his photographic approach and technique. He presents his views on pictorial documentation, provides an overview of his working methods, and tells how this book was assembled and edited.

Notes

1. My account of this process is related in "Picking Myself Apart: A Hoosier Memory," *Journal of American Folklore* 108 (1995): 277–86.
2. Neil V. Rosenberg, "From Sound to Style: The Emergence of Bluegrass Music," *Journal of American Folklore* 80 (1967): 143–50; Carl Fleischhauer, *John Mitchel Hickman* (16mm motion picture, B&W, 1968). The film took second prize in the 1969 National Student Film Festival.
3. Neil V. Rosenberg, *Bill Monroe and His Blue Grass Boys: An Illustrated Discography* (Nashville: Country Music Foundation Press, 1974); Rosenberg, *Bluegrass: A History* (Urbana: University of Illinois Press, 1985).

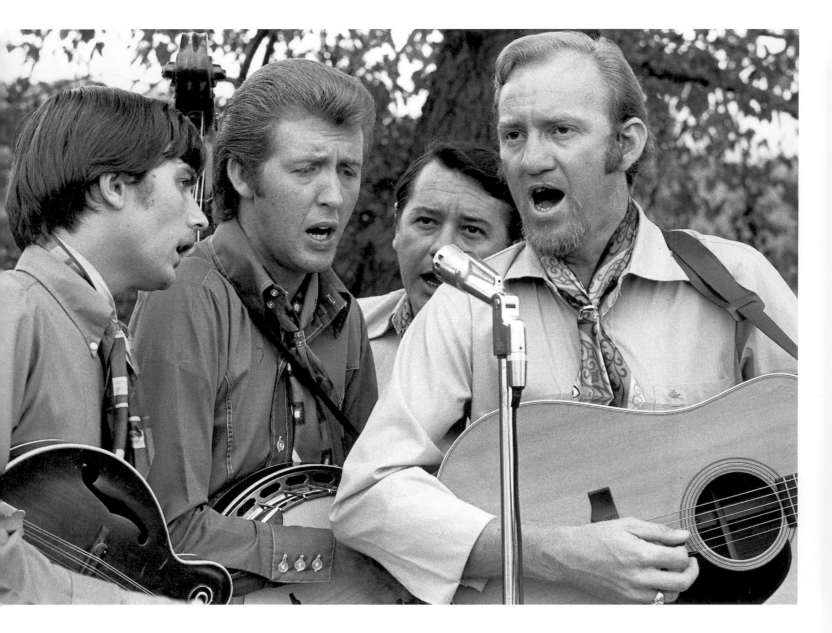

West Finley, Pennsylvania, August 7,
1970. J. D. Crowe and the Kentucky
Mountain Boys—Larry Rice, Crowe,
Bobby Slone, and Doyle Lawson—at
the Fifth Annual Pennsylvania Bluegrass
Festival.

Intensity

arl and I grew up in the 1940s when the dominant home entertainment media were aural—radio and records—so that it was our ears rather than our eyes that first drew us to the intensity of bluegrass. Monaural records and the radio carried layers of sound: a lead fiddle with an underlay of banjo rippling along on top of rhythmic riffs and patterns from mandolin, guitar, and bass. Another layer was created by voices; if there was more than one, they were singing harmony. The layers weren't discrete; indeed, part of the aural excitement lay in the interplay among them. As a vocalist ended a verse, a guitar's bass strings responded with a burst of melodic punctuation, what we later learned to call a "run." Visually accustomed to classical music or pop and jazz bands in concert, and to folk music in a variety of formal and informal settings, we didn't really know how to imagine bluegrass in performance. When we finally began to see live bluegrass performances, a visual world unfolded. One of the first things we noticed was how the musicians moved onstage. We realized that we'd been hearing aural textures created by people who moved around a fixed focal point—the microphone.

Until the 1970s bluegrass musicians sang and played into one or two microphones. With four, five, or six musicians onstage using acoustic

instruments without electric pickups, distance from and direction toward the microphone determined much of what the audience heard. Then as now bluegrass musicians not only played instruments but sang as well. The legendary "choreography" of Lester Flatt, Earl Scruggs, and the Foggy Mountain Boys enabled them to "gang around the mike," as Flatt described it, to deliver five-part harmony, along with his rhythm guitar, with his legendary "G runs," and the backup work of Scruggs on the banjo and Josh Graves on the Dobro—all audible in a way that duplicated the sound of their records and broadcasts.

The dynamics of the music dictated dramatic shifts—movements toward and away from the microphone as instrumental breaks followed vocals. The first-generation bluegrass leaders spoke of their music in sports terms—the man at the mike was the batter or ball carrier (Monroe's metaphor was the baseball team; members of Flatt and Scruggs's Foggy Mountain Boys preferred football). The need for teamwork drove them to develop ways of listening to each other onstage, of hearing their own instruments. All bluegrass mandolinists knew how to haul their Gibsons up to the mike like Bill Monroe did, enabling them to "cut" (be heard) across noisy barrooms, to the outer perimeters of open-air parks, or over the airwaves. Similarly, guitarists thrust their instruments toward the microphone at the end of phrases to dunk runs into it like a basketball into a hoop. All of this was with only one or two mikes, without the monitor speakers prevalent today that let players hear themselves.

During the 1970s, when most of the pictures in this book were taken, the number of microphones used onstage began to increase. But even as the technologies and practices of performance changed, the intensity of individual performances within the band setting remained: the solo vocal by a supporting band member or the rush of the fiddler to the mike remained constants in bluegrass performances. In the mid-1990s, one of the leading bands in bluegrass, Doyle Lawson and Quicksilver, spearheaded a return to the old single-mike technology, bringing back the choreography and blending that charmed early bluegrass audiences, now seen as part of its heritage.

The intense kaleidoscope of movement onstage was the first thing we saw. Then, as our eyes became accustomed to the shifting patterns, we began to notice that at the musical focal points of verse, chorus, and instrument break the musicians formed brief but intense tableaux. Band members concentrated on hearing each other as they created tight gospel quartets, each singer listening intently and adjusting his or her part to the sound, barely seeing the other performers. Singing harmony is a demanding but pleasurable experience for the singers themselves and

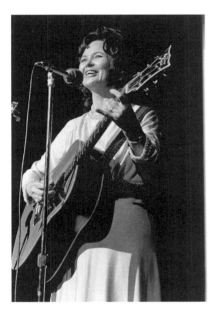

Nashville, Tennessee, October 15, 1975. Betty Fisher at the Early Bird Bluegrass Concert at the Grand Ole Opry house.

doesn't always require an audience. Indeed, while watching a band in action, Carl and I sometimes had the sense of being voyeurs, witnesses to private moments.

The intensity of bluegrass performance also comes in part from knowing that the musicians themselves aren't always certain what to expect from each other, particularly when the focus shifts from ensemble to solo. No two of Bill Monroe's mandolin breaks were quite the same; over the years scores of his Blue Grass Boys learned to listen carefully to what he was doing, to anticipate what was in effect a surprise music lesson. Yet in the midst of such involvement musicians still found moments to connect outward, flashing a smile or a grimace at someone in the audience. These ways of recognizing connections with individual audience members drew us further into the music, winning us over by conveying a sense of personal friendship and shared playfulness.

The creation of spinoff bands, and the permutations and transformations of personnel within a single band, can leave a fan wishing for a printed scorecard. Seen at any one performance, a bluegrass band appears as a tightly meshed group, a team. Yet most bluegrass bands change, if not from month to month, then at least from year to year. The very tightness of the music creates friction; the marginality of the music business prompts individual decisions to move on to greener pastures. The reputations of virtuoso singers and players may rival those of bands. Part of the intensity in following bluegrass comes from the excitement—or at least the curiosity—about new faces in old bands and old faces in new bands.

In the 1960s and 1970s the music mirrored the generational struggles of the times. Young turks sojourned in established bands—Peter Rowan with Bill Monroe, Ricky Skaggs with Ralph Stanley, Marty Stuart with Lester Flatt—leaving their marks on the music before moving into other, more mainstream popular forms. When some of the hot young pickers in Lonnie Peerce's Bluegrass Alliance left to form their own group, the New Grass Revival, they imported repertoire, musical sensibilities, garb, hair length, and other trappings of countercultural style from rock. Such novelties, whether transfusion or fusion (the musical buzzword of those times), were telegraphed to fans by new recordings, the emergent monthlies like *Bluegrass Unlimited* and *Muleskinner News,* and word of mouth. All nurtured a sense of bluegrass as a dynamic, happening scene.

This sense was heightened by the emphasis on history in many bluegrass festivals. In the late 1960s and 1970s most of the founders were alive and actively performing. It was not uncommon for them to participate in ritual performances that reenacted the genre's history. The pat-

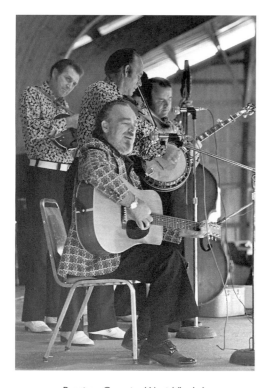

Preston County, West Virginia, September 1974. Mac Wiseman, seated, at the Appalachia Lake Festival, accompanied by the Shenandoah Cut-Ups: Gene Burrows, Tater Tate, and Billy Edwards.

tern was set in 1965 when, for the finale of his Roanoke Blue Grass Festival at Cantrell's Horse Farm in Fincastle, Virginia, promoter Carlton Haney staged "The Story of Blue Grass," a reunion of former Blue Grass Boys with Bill Monroe. Recreating performances they'd recorded with Monroe in the previous twenty-five years, they gave the audience a living history exhibition, one of the many hits of that first bluegrass festival. Such events became a staple in subsequent festivals. The inclusion of venerable bands in reunions that reassembled lineups from years past, or of retired stars in cameo guest appearances, catered to bluegrass audiences' abiding interest in times past. Events like this are still part of today's bluegrass festivals.

In addition to these explicit reenactments, history was staged in other less obvious ways that connected the present with the past as the festival movement brought old-timers back into action. Mac Wiseman, who'd played with both Bill Monroe and Flatt and Scruggs in the late 1940s, had not had his own band since 1956. But as the festivals began to spread, he began to make personal appearances as a "single" working with such bands as the Shenandoah Cut-Ups. Formerly the Blue Grass Cut-Ups, this band was founded and led by Red Smiley in the mid-1960s. It too represented history, since the name recalled Smiley's work with Don Reno between 1952 and 1964, when Reno and Smiley and the Tennessee Cut-Ups were part of the first generation of bluegrass bands. When Wiseman joined Lester Flatt onstage for duets in 1974, it was a historical reenactment that was out of the ordinary. Flatt was appearing with the Nashville Grass, a band he formed after splitting up with Earl Scruggs in 1969 and worked with until a few months before his death in 1979. He and Wiseman made three major-label albums together in the seventies, capitalizing on their historical status and renewed activities together.

But historical status doesn't necessarily translate into income, and reunions aren't always advertised. When Pete Kuykendall and Mike Seeger joined Bill Clifton and Red Rector at Indian Springs, Maryland, in 1974, it was a personal reunion for three early, influential bluegrass promoters from the Washington, D.C.–Virginia area. In the late 1950s and early 1960s Kuykendall and Seeger had recorded and performed with Clifton, but their musical association was not "legendary." Assembled on the fly at a festival, a band like this recalled earlier times in the music but also asserted the core values of its participants. Although they had "day jobs"—magazine editor, festival organizer, private scholar, and educator—music came first. The associations created by playing in a band are in themselves intense and easily embedded in memory, to be retrieved for sentimental reasons.

The intensity of memories like this fueled the success of Ralph Stanley in the 1970s. When Stanley's older brother Carter died in 1966 it signaled the end of one of bluegrass's most influential first-generation bands; the two had been recording and touring together since 1947. Their piercing high harmonies, along with Ralph's minimalist metallic banjo and, in their final years together, a lead acoustic guitar, were bluegrass's hardcore sound. In 1967 Ralph, a tenor singer and banjoist, began the task of reinventing the Stanley sound. While memorializing Carter, the new band slowly diverged from the old sound. Ralph's first band included Melvin Goins and Larry Sparks, both of whom went on to their own outfits. Sparks was the first of what now seems an endless supply of young singers who could match the textures of Carter Stanley's voice. By contrast, Ralph recruited backup musicians of his own age, such as fiddler Curly Ray Cline and bassist Jack Cooke. In 1974 Keith Whitley took over as lead singer; earlier, as teenagers, Whitley and Ricky Skaggs had worked together, recreating the old Stanley Brothers duets within Ralph Stanley's band.

Maintaining a "sound" in the face of change is a challenge fans contribute to and appreciate. When John Duffey, an influential founding member, left the Country Gentlemen in 1969, many wondered if the intensity of the "classic" aggregation of the band could be maintained without Duffey's powerful vocals. It turned out that the other founding leader, Charlie Waller, was able to put together new versions of the band that kept winning popularity polls throughout the 1970s. Duffey became a distinguished alumnus, one among many. The band is still playing, though only Waller remains from the original group.

When the Country Gentlemen's music was newly popular it was described as "progressive bluegrass," a borrowing from "progressive jazz." The band eschewed country music venues in favor of coffeehouses, folk festivals, and suburban or urban nightclubs and many elements of their sound distinguished them from first-generation bands such as Jim and Jesse and Flatt and Scruggs. Members of the Country Gentlemen dressed in casual but matching contemporary outfits, thereby further distinguishing them from the country music–focused first-generation groups who typically wore western-style suits and shirts, scarves or neckties, and hats. Such bands as the Johnson Mountain Boys, which emerged in the early 1980s in the Washington, D.C., area as a pioneer post-progressive group, paid tribute to these first-generation bands in a repertoire, sound, and look that has come to be associated with what's now called "traditional bluegrass."

The earliest bluegrass audiences were mainly southern whites of hum-

ble origin. But by the late 1960s the music's demographic base had broadened to include people from other regions and classes, though it was then, and is to this day, an almost entirely white audience. This is a family music not just in terms of who makes it and what many of its lyrics convey but also in terms of those who choose to listen and watch. Sitting in a typical audience you notice not only a wide range of ages and obvious family connections but also the casual conversations that go on as people relate to the music and to one another.

Although it has been described as a music listened rather than danced to, dance is never far from bluegrass. In fact, the instrumental repertoire is built around old dance tunes. During the 1970s when the New Grass Revival and other country rock–influenced performers began drawing young people to festivals, organizers created special areas in which youths could dance in response to the music, mixing boogie with square dance. But dancing to the music has seemed more appropriate to most bluegrass fans in informal contexts. At parking lot jam sessions the intensity of the music is transmuted into dance as friends or passersby break into clogs or step dances, solo display traditions that were sometimes performed onstage by Monroe, Flatt, and others.

As the number of bluegrass festivals grew from one in 1965 to over seven hundred a decade later, they drew increasingly heterogeneous crowds. Just as boogie and clog showed up in dance, other style preferences could be seen in food and drink, dress, camping accommodations, and, of course, musical favorites. These differences aside, the temporary and public constraints of the event and site threw people together, for better or worse. Occasionally this led to conflict, but most festivalgoers tolerated these frictions and differences as they focused on the music that brought them together.

At festivals many things that would otherwise be private are open to public view. For example, there are usually no dressing rooms and often only the tiniest of enclosed backstage areas, so it's possible to glimpse performers making their way to and from the stage. Even though the cases they carry and their stage dress mark them as performers—musicians have a certain feeling of vulnerability when carrying an instrument case in a crowd—the audience members pay little attention to them. They are granted anonymity, as if surrounded by their own aura of invisibility, until their performance begins. Not all music festivals are like this; today, newcomers to bluegrass still comment on the relative lack of distance between stars and fans.

Backstage at a bluegrass festival is rarely anything like the green room of a concert hall, where performers are out of the public view. In blue-

Sutton, West Virginia, May 25, 1975. At the Braxton County Bluegrass Festival.

grass closed doors are rare; in fact, the backstage may consist only of a fenced-off area. In these public circumstances bluegrass musicians create their own private backstage spaces, sharing musical ideas or humorous anecdotes, oblivious to the audience members just on the other side of the fence.

The ritualistic nature of performances at festivals in the early years was dramatized by special events that brought all of the performers onstage at the same time. Bill Monroe, who borrowed the idea from Carlton Haney, explored variations of this ritual at his annual festival in Bean Blossom, Indiana—from a giant finale with all the bands, to a collegial gospel singsong on Sunday morning, to massed fiddlers. These events were like big parking lot jam sessions held onstage, so it was logical that Monroe would take to holding an offstage Sunset Jam Session, which was open to all festival-goers at Bean Blossom.

Such communal events ease the tensions faced in those last lonely moments as the band makes its way to the stage. Instruments are carried caseless, which can be dangerous: I've seen broken fiddle bows, dropped guitars, new dents on the peghead of valued fancy banjos. Fear mixes with the adrenaline that begins flowing prior to the introduction and the first piece, building to the release that is performance.

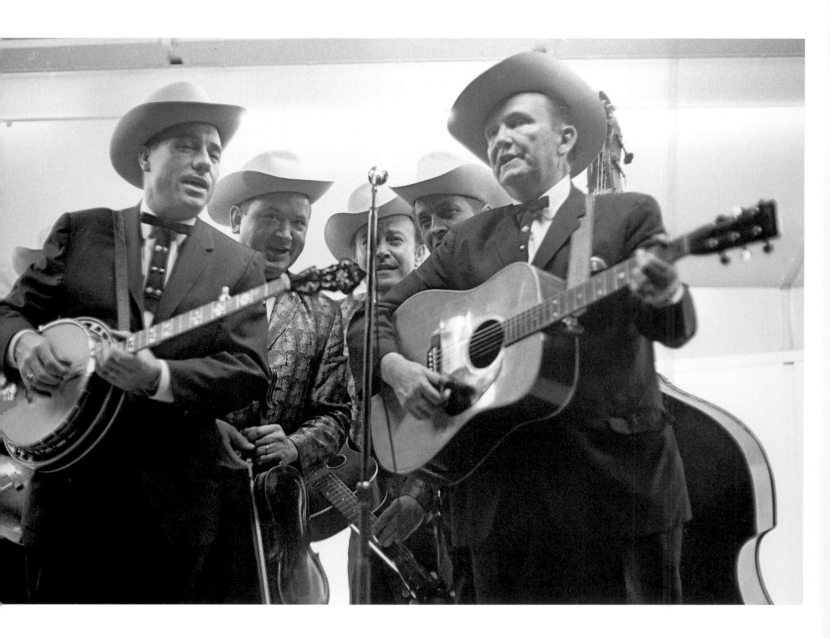

Above: Columbus, Ohio, November 1967. Lester Flatt, Earl Scruggs, and the Foggy Mountain Boys—Howard G. "Johnny" Johnson (partly hidden on the left), Scruggs, Paul Warren, Josh Graves, Jake Tullock, and Flatt—gang around the mike at a festival at the Ohio State Fairgrounds. Carl recalls that one of the promoters was a local blue-grass bandleader, Sid Campbell, who ruefully told him that the event had lost money.

Opposite, top: Bean Blossom, Indiana, June 1970. Earl Scruggs takes a guitar break at Bill Monroe's annual Bean Blossom festival. Scruggs not only raised the guitar to the mike when he took his break but also laid his left ear on the sound box to monitor his playing. At this event Scruggs appeared with his sons in a group called the Earl Scruggs Revue.

Opposite, bottom: Cincinnati, Ohio, March 1970. Earl Taylor raises his mandolin to the microphone during an in-strumental break while performing with his Stoney Mountain Boys at the Terrace Bar in Cincinnati's "Over-the-Rhine" neighborhood. The band includes banjoist Sandy Rothman, snare drummer David McCall (partly hidden behind Rothman), Taylor, bass-ist Vernon "Boatwhistle" McIntyre, and guitarist-singer Jim McCall. This photo-graph was taken just before the Terrace Bar changed its name to Aunt Maudie's Country Garden.

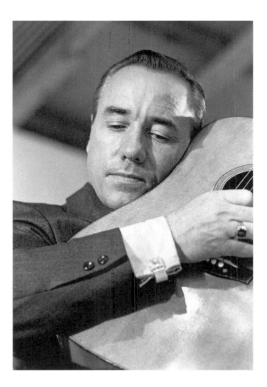

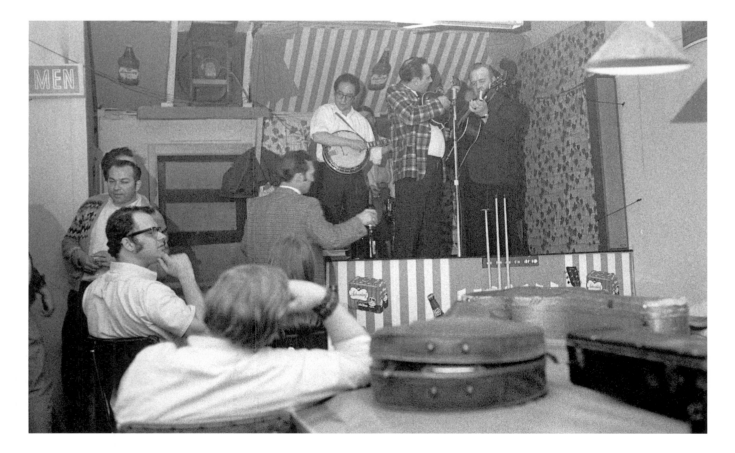

Right: Reynoldsburg, Ohio, June 30, 1974. Band member Gloria Belle Flickinger with Jimmy Martin and his Sunny Mountain Boys at the Frontier Ranch festival.

Below: West Finley, Pennsylvania, August 8, 1970. Carl Story, often called the father of bluegrass gospel music, and his Rambling Mountaineers—Frankie Belcher, Bruce Jones, Lee Jones, and Story—sing a quartet at the Fifth Annual Pennsylvania Bluegrass Festival.

Opposite, top: Alexandria, Virginia, July 7, 1981. Ricky Skaggs at the Birchmere. Skaggs, a bluegrass prodigy in the 1970s, had just released his first Epic album, *Waiting for the Sun to Shine.* His electric country band at this appearance included fiddler Bobby Hicks and fianceé Sharon White.

Opposite, bottom: Columbus, Ohio, November 1967. Don Reno and Bill Harrell with George Shuffler at a festival held at the Ohio State Fairgrounds.

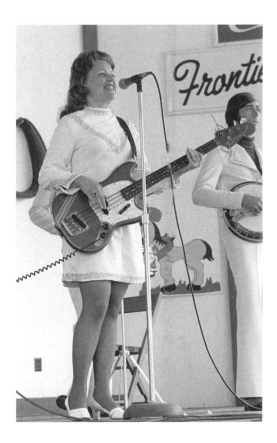

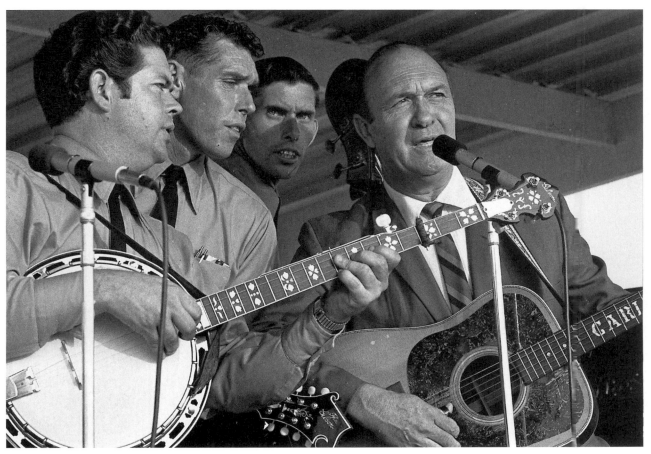

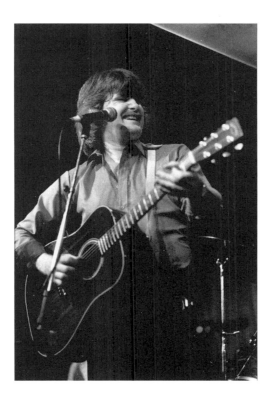

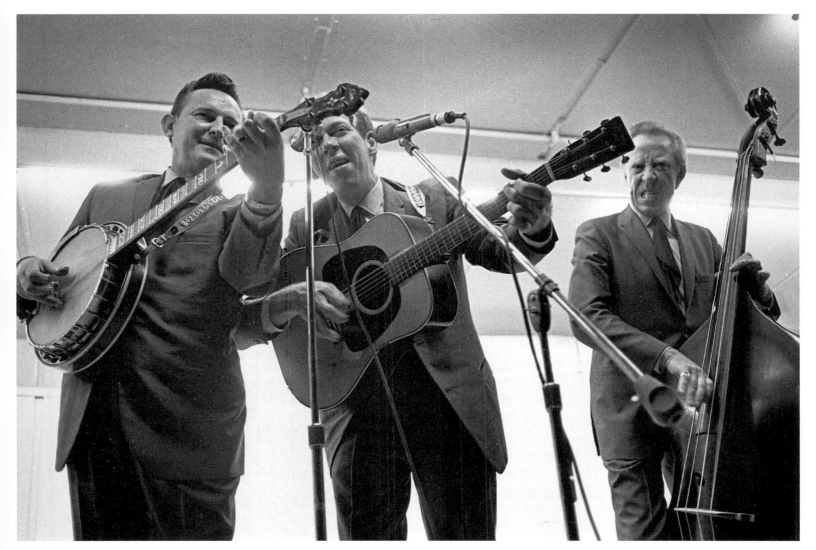

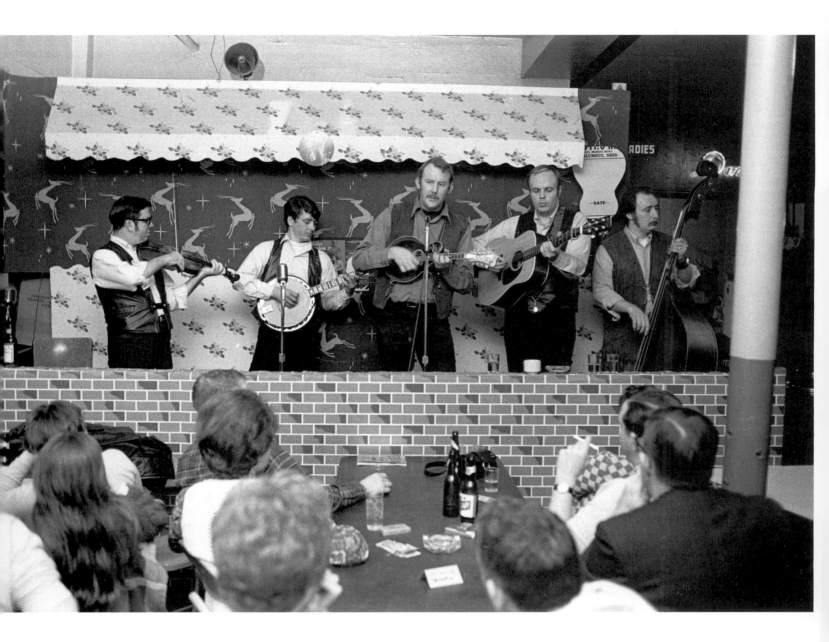

Above: Columbus, Ohio, February 21, 1970. The Bluegrass Alliance at the Astro Inn: Lonnie Peerce, Buddy Spurlock, Danny Jones, Dan Crary, and Ebo Walker. The decorative corrugated paper on the back of the stage celebrates Christmas, though this photograph was taken well past the traditional end of the holiday season.

Opposite, top: Smithfield, Virginia, August 27, 1977. The New Grass Revival, a spinoff of the Bluegrass Alliance, at the Bluegrass Camporee:

Courtney Johnson, Sam Bush, John Cowan, and Curtis Burch.

Opposite, bottom: Columbus, Ohio, November 1967. Red Smiley and the Blue Grass Cut-Ups at a festival held at the Ohio State Fairgrounds: Tater Tate, Billy Edwards, Smiley, Gene Burrows, and John Palmer.

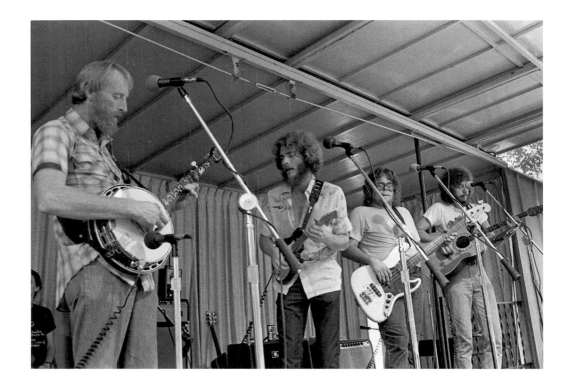

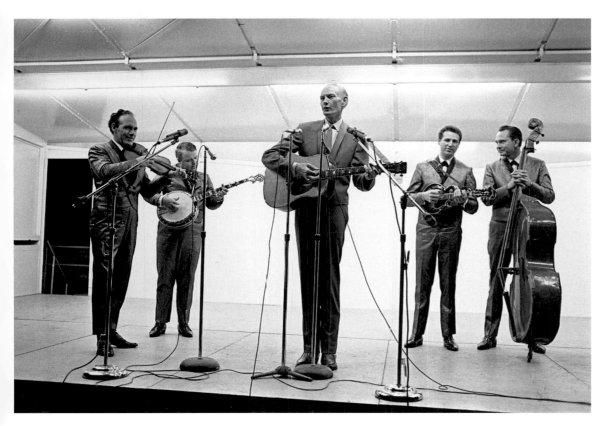

Reynoldsburg, Ohio, June 30, 1974. Mac Wiseman and Lester Flatt sing a duet at the Frontier Ranch festival to promote their new album on RCA Victor. In 1948 Wiseman briefly worked with Flatt and Scruggs when the pair formed a new band after leaving Bill Monroe. Wiseman then moved on to take Flatt's place as vocalist in Monroe's Blue Grass Boys before launching his own career as a soloist in 1951. Although he laid his guitar aside to perform with Wiseman, Flatt kept his thumb and finger picks on.

Vienna, Virginia, July 2, 1978. Lester Flatt and the Nashville Grass at Wolf Trap Farm Park, near Washington, D.C. This photograph was taken at a one-day bluegrass festival held in the park's Filene Center about a year before Flatt's death. According to Carl it was both sad and inspiring to see Flatt perform in his weakened state. He stayed onstage for about half of the set, sitting on a stool, and let his band—Curly Seckler, Marty Stuart, Blake Williams, Tater Tate, Charlie Nixon, and Pete Corum— handle the rest of the show.

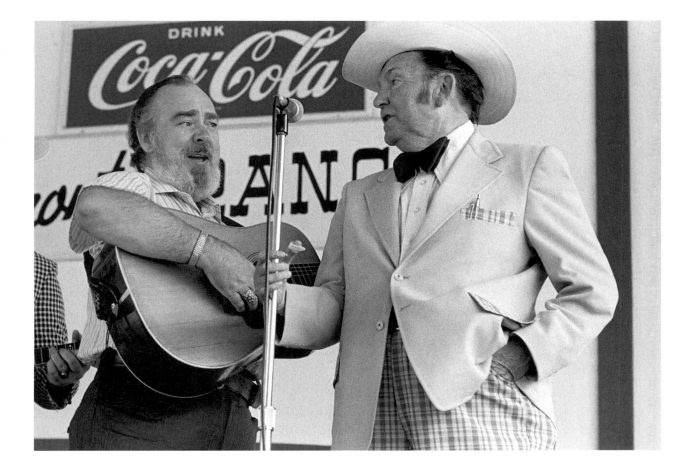

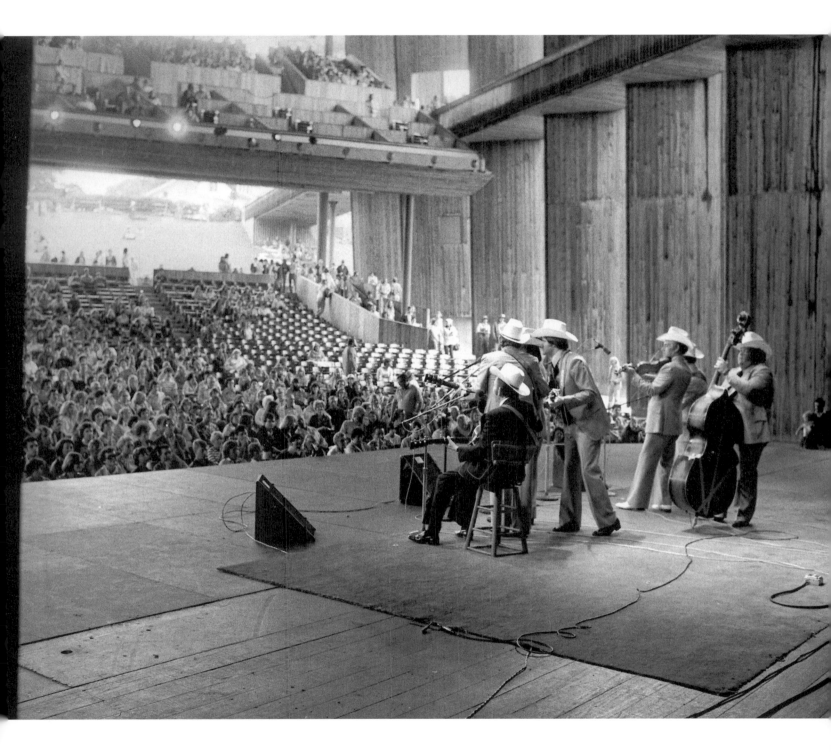

Below: Culpeper, Virginia, June 10, 1972. The Dillards at the Blue Grass Folk Music Festival: Mitch Jayne, Rodney Dillard, Billy Ray Lathum, and Dean Webb; drummer Paul York is out of the frame at left. This West Coast group did not often perform in the East. With drums and pickups on some of the instruments they weren't "pure" bluegrass, but the Culpeper audience responded to their energetic performance. Many were eager to see the "legendary" Billy Ray—Lathum's usual stage name—known from his 1960s L.A. stint with Clarence and Roland White in the seminal Kentucky Colonels.

Opposite, top: Nashville, Tennessee, October 15, 1975. Bill Monroe and Jimmy Martin sing together at the Grand Ole Opry's Early Bird Bluegrass Concert. Between 1950 and 1954 Martin played guitar with Monroe and sang lead on many of his most popular recordings, including "I'm on My Way to the Old Home," "Memories of Mother and Dad," and "Uncle Pen."

Opposite, bottom: Indian Springs, Maryland, June 1, 1974. Bill Clifton and his band—Charlie Smith, Pete Kuykendall, Red Rector, Clifton, and Mike Seeger— at the *Bluegrass Unlimited* Festival.

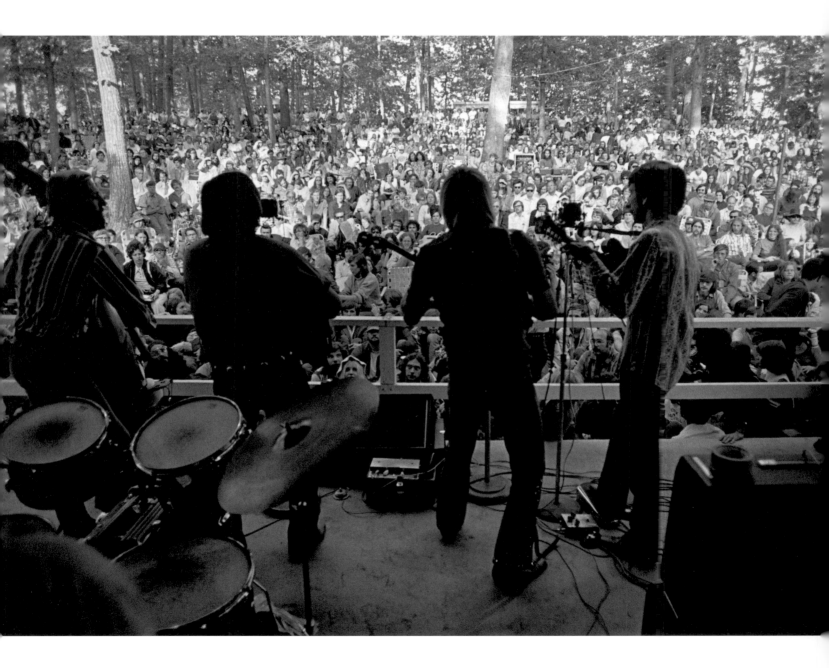

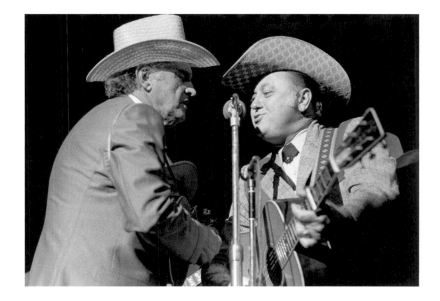

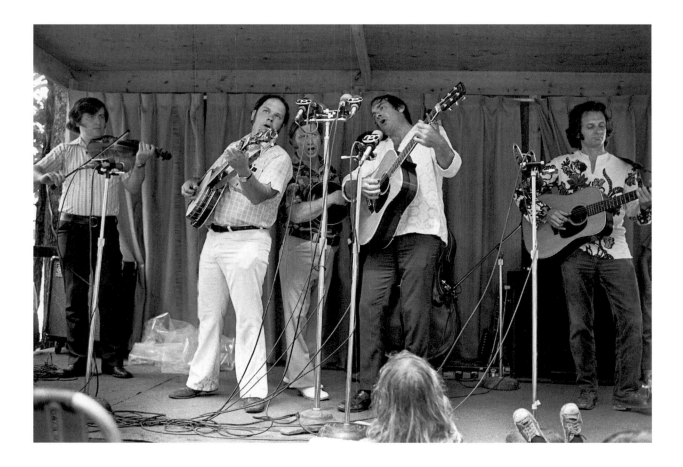

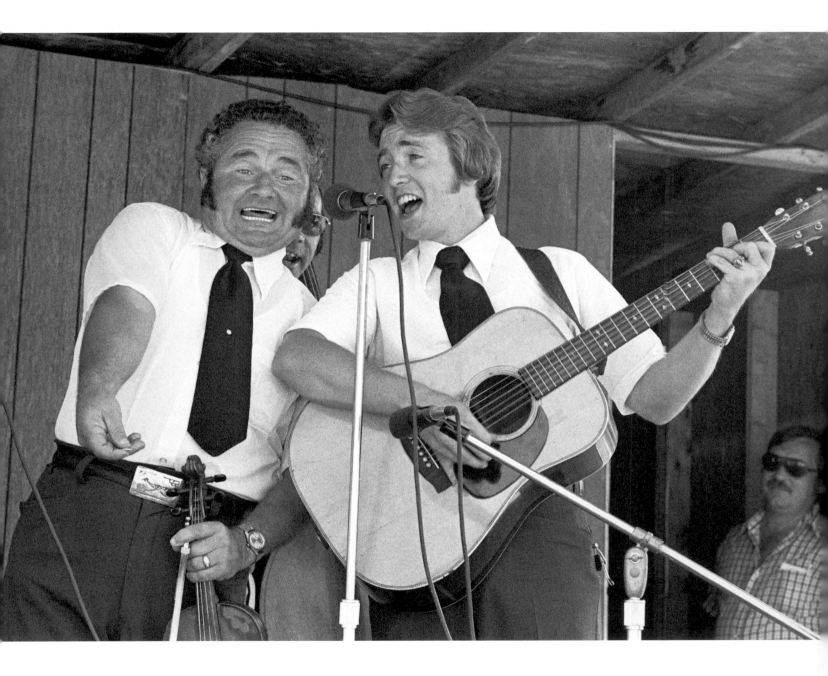

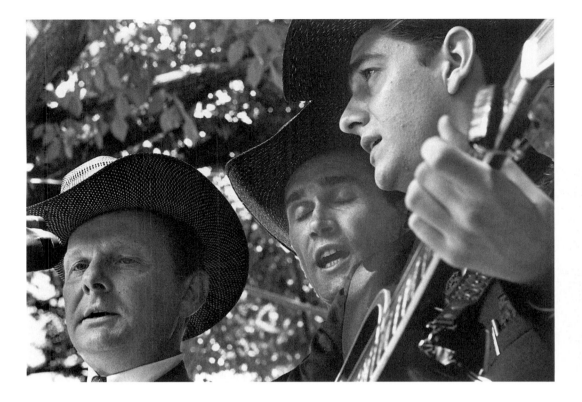

Stumptown, West Virginia, 1976. Curly Ray Cline and Keith Whitley, members of the Ralph Stanley's Clinch Mountain Boys, singing the line "all the money I've made" in the comic song "Why Me Ralph?" at Bill Monroe and Ralph Stanley's First Annual Old-Time West Virginia Bluegrass Festival at Aunt Minnie's Farm.

Washington, D.C., July 1968. Ralph Stanley and the Clinch Mountain Boys—Stanley, Melvin Goins, and Larry Sparks—singing a trio at the Smithsonian Institution's Festival of American Folklife.

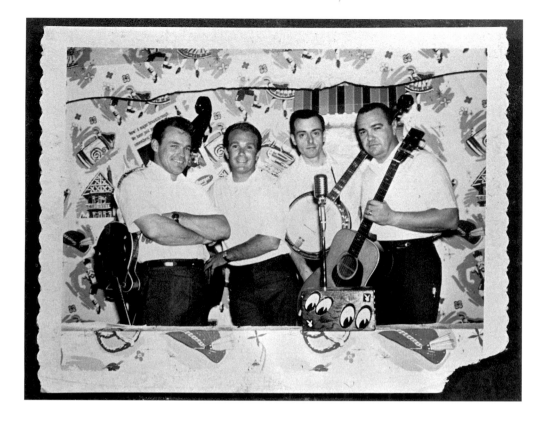

Above: Columbus, Ohio, early 1960s. Sid Campbell and his Dixie Gentlemen at the Astro Inn: Ralph "Robbie" Robinson, Chuck Cordell, John Hickman, and Campbell. From the 1950s into the 1980s, Campbell was at the center of the Columbus bluegrass scene as bandleader, disc jockey, and father figure to a host of younger musicians. By 1974, when Carl copied Campbell's scrapbook snapshot of his favorite band of the 1960s, Cordell and Robinson— pioneer bluegrass luthier, banjoist, and mandolinist—had been dead for seven years, killed together in the crash of a private plane, while influential banjoist Hickman had moved to southern California. Campbell died in 1987. In this photograph the Astro Inn's decorative wallpaper celebrates Oktoberfest.

Opposite: Rosine, Kentucky, September 14, 1973. Ralph Stanley and the Clinch Mountain Boys—Curly Ray Cline, Roy Lee Centers, Stanley, Rickie Lee, and Jack Cooke—pose backstage at the Monroe Homecoming and Bluegrass Festival.

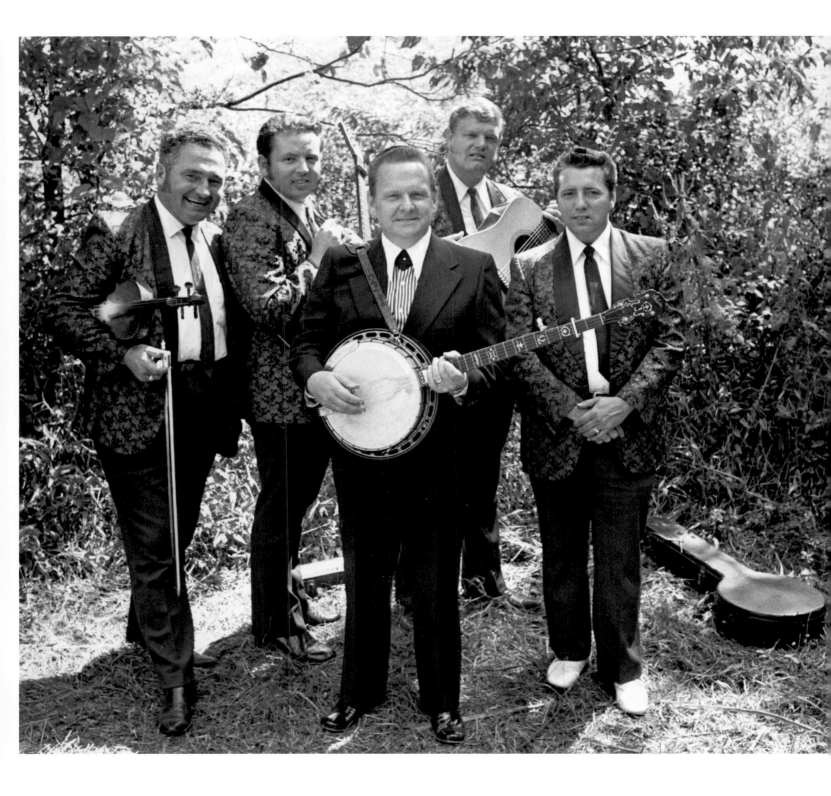

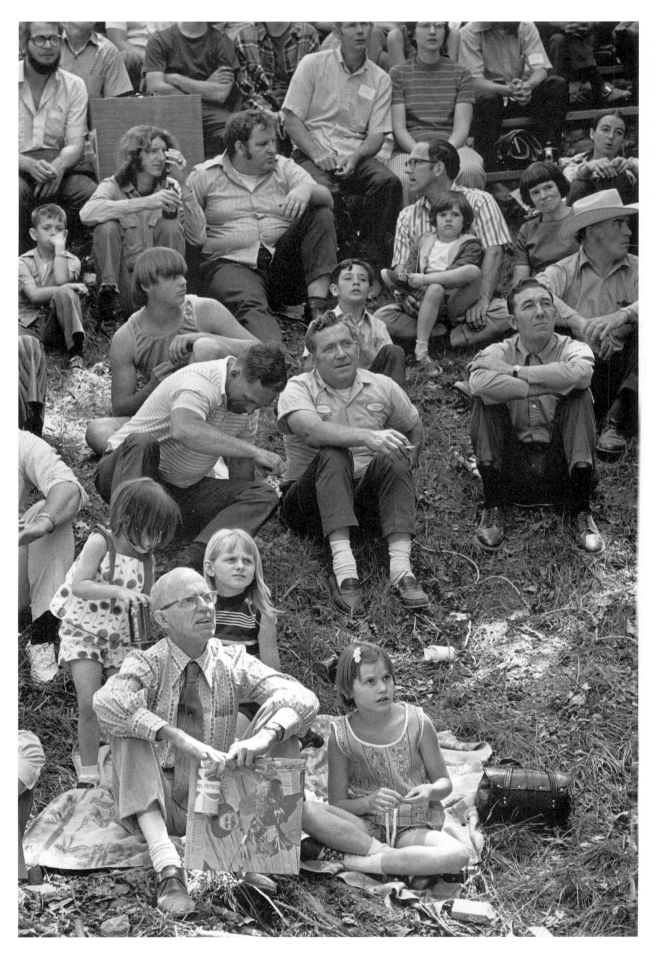

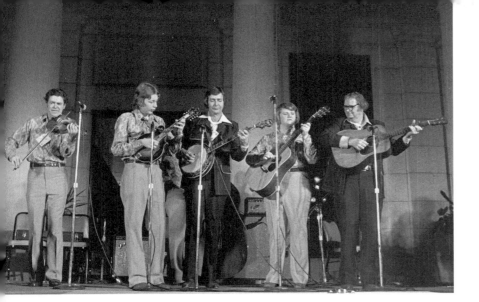

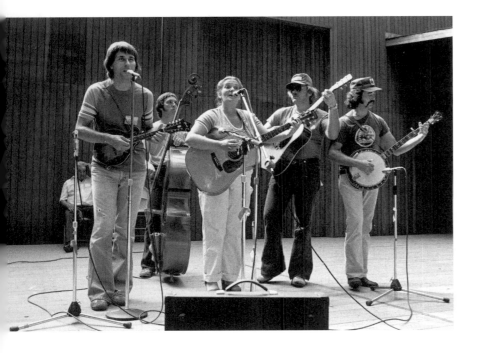

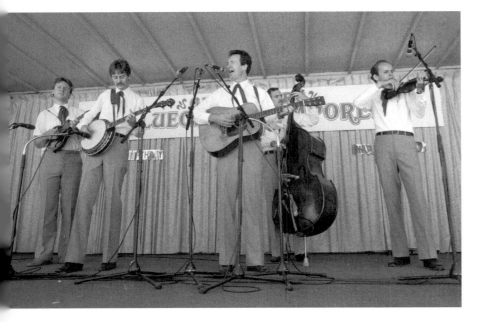

Opposite: McClure, Virginia, May 24, 1972. The audience at the Carter Stanley Memorial Festival. In the upper right corner are Betty and Raymond K. McLain (striped shirt) with their daughter Nancy Anne (sitting on her father's lap). The McLain Family—Raymond and three other children—performed at the festival.

Top: Washington, D.C., January 21, 1977. Ted Lundy, Bob Paisley, and the Southern Mountain Boys—Jerry Lundy, John Haftl, Wes Rineer (mostly hidden behind John), Ted, Dan Paisley, and Bob—onstage in matching contemporary outfits at the Carter-Mondale Inaugural Concert at the Union Station Visitors' Center.

Middle: Vienna, Virginia, July 12, 1980. The Dry Branch Fire Squad—Ron Thomason, Dick Irwin, Mary Jo Leet, Johnny Lee Baker, and John Hisey—in casual dress for an afternoon show at the National Folk Festival in Wolf Trap Farm Park.

Bottom: Gettysburg, Pennsylvania, September 13, 1986. The Johnson Mountain Boys—David McLaughlin, Richard Underwood, Dudley Connell, Marshall Wilborn, and Eddie Stubbs—at the Gettysburg Bluegrass Camporee dressed in a style reminiscent of first-generation bluegrass bands.

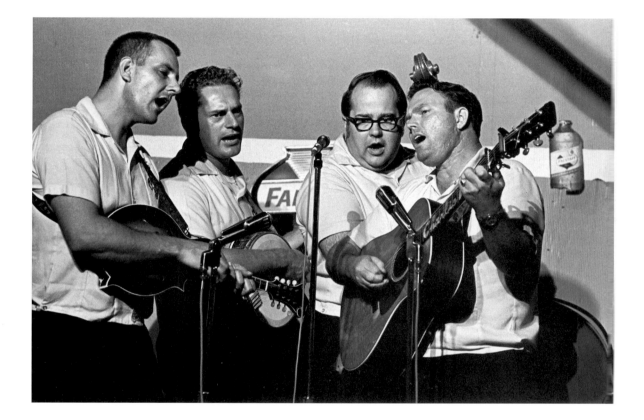

Above: Columbus, Ohio, summer 1968. The Country Gentlemen—John Duffey, Eddie Adcock, Ed Ferris, and Charlie Waller—sing a quartet at Spring Lakes Park.

Opposite: Logan, Ohio, summer 1969. The Country Gentlemen—Eddie Adcock, Jimmy Gaudreau, Charlie Waller, and Ed McGlothlin—at a small music park. This shot of a rare version of the band also captures the transitory nature of the venue, where a bare-bones stage was erected in a large barnlike building. The proscenium is defined by the edge of the raised stage, the row of reflector bulbs, and the microphones. One mike is a focal point for Waller who positions his guitar to project its sound into the public address system. Although the audience is out of frame to the left, listeners are represented in this photograph by a portable tape recorder, plugged into a stage outlet, with its microphone resting on the front of the stage.

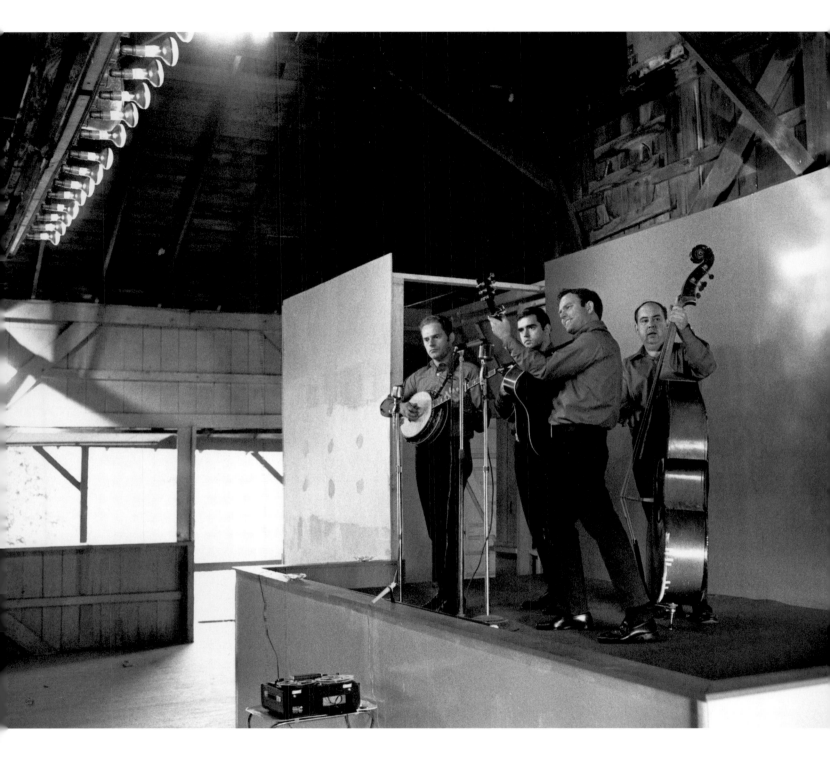

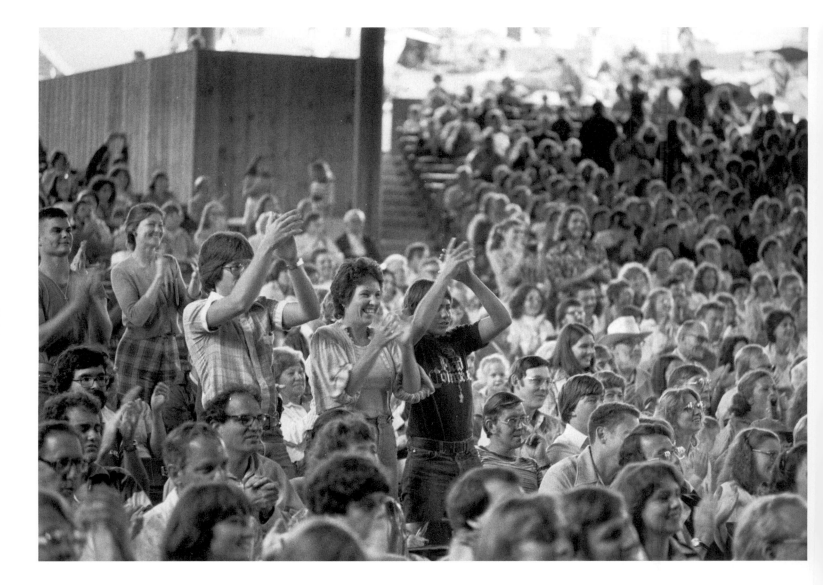

Vienna, Virginia, July 2, 1978. Buck White buck dances and the audience responds at the Wolf Trap Bluegrass Festival.

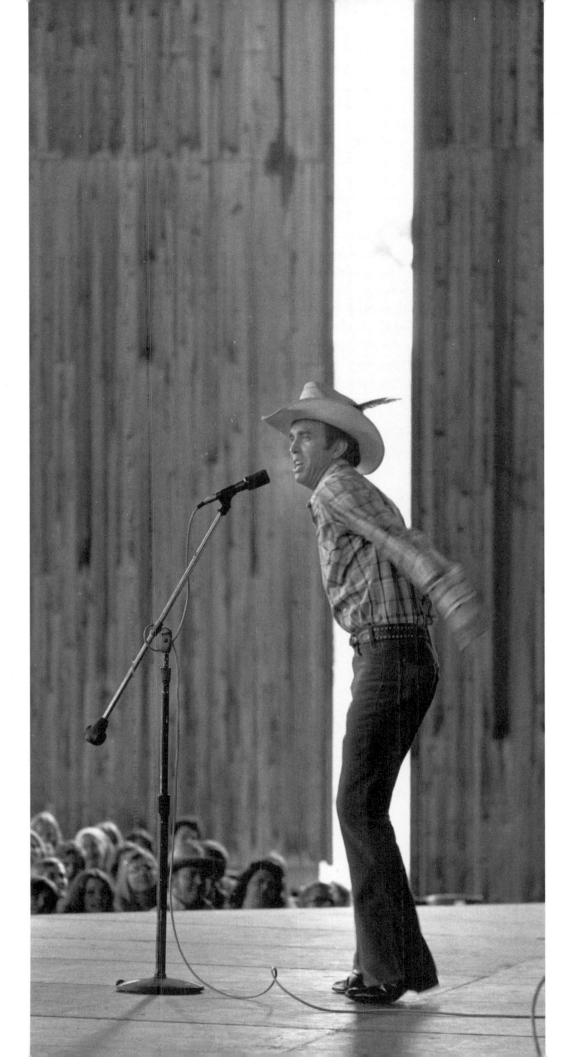

Smithfield, Virginia, August 27, 1977.
Dancers at the Bluegrass Camporee.

Rosine, Kentucky, September 14, 1973.
Picking and dancing at a jam session in
the parking lot at the Monroe Home-
coming and Bluegrass Festival.

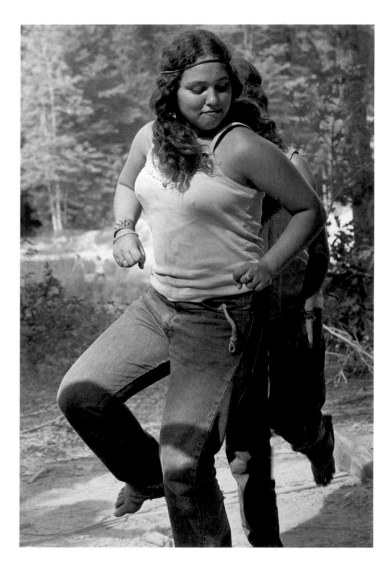

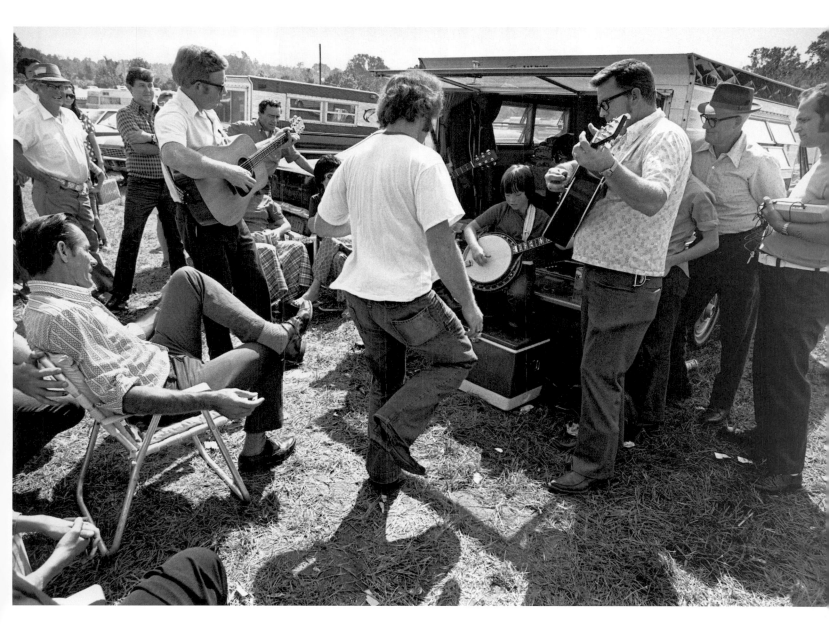

Reynoldsburg, Ohio, June 30, 1974.
Marty Stuart and Sonny Osborne share
a joke backstage at the Frontier Ranch
festival.

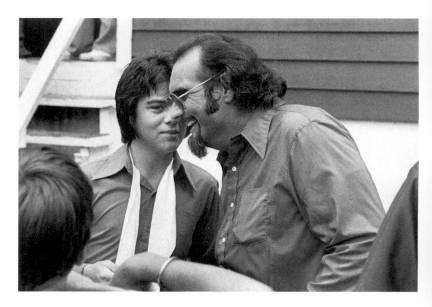

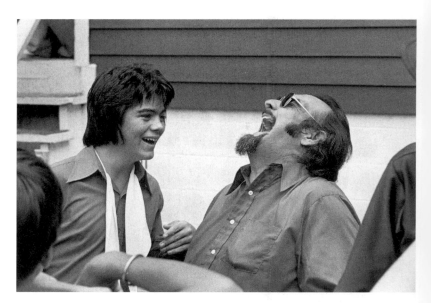

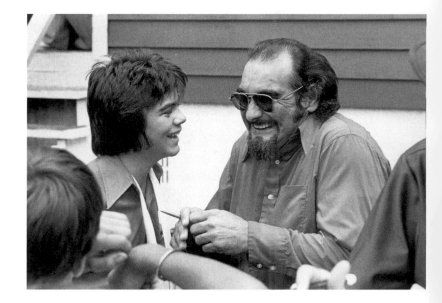

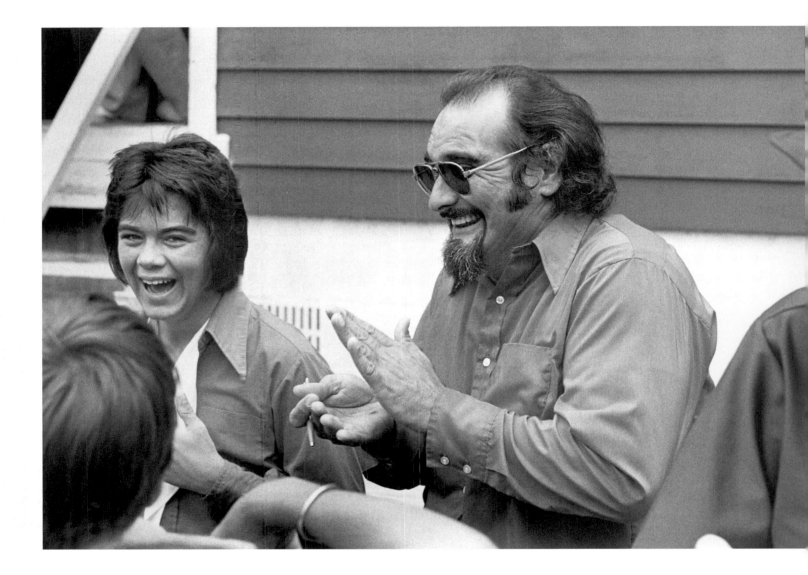

Washington, D.C., February 17, 1980. Mike Auldridge and Jerry Douglas jam in a dressing room at a concert put together by Birchmere Music Hall owner Gary Oelze and staged at George Washington University's Lisner Auditorium.

Monterey, Virginia, March 24, 1973. Black Mountain Bluegrass Boys Harley Carpenter and Richard Hefner, with Ralph (Joe) Meadows, rehearse in the shower room of the Highland High School gym for their set at the Maple Festival. Smooth, hard tiles create an echo chamber, just right for a last-minute rehearsal during which a band wants to be certain the music is together and the instruments are in tune.

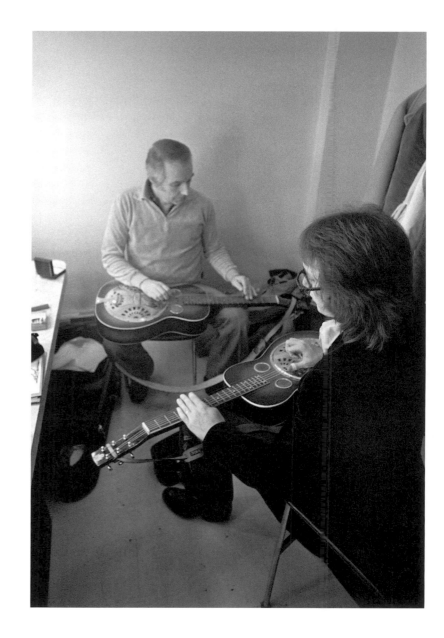

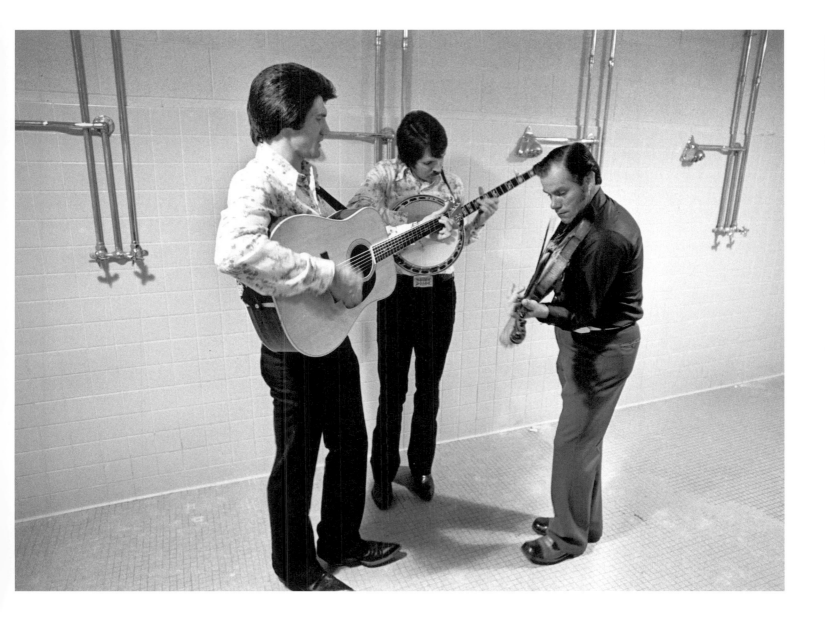

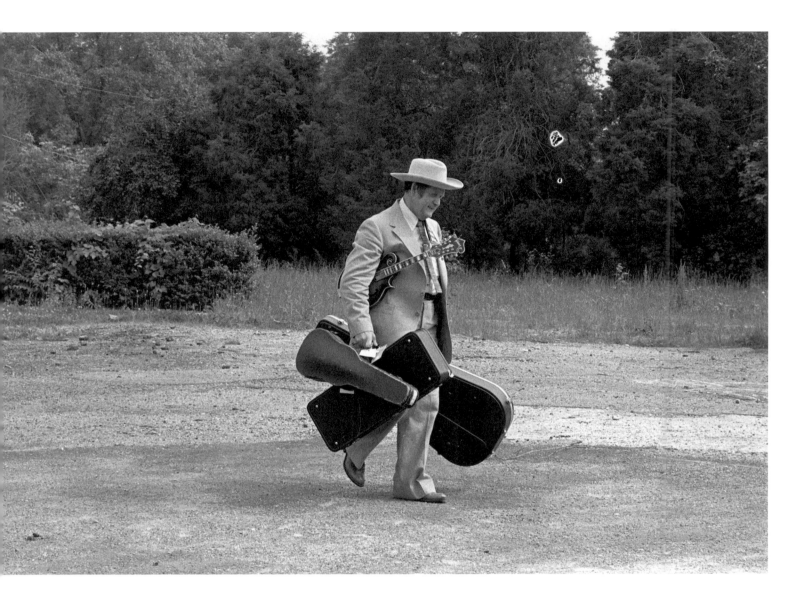

Glen Echo, Maryland, June 10, 1979. Everett Lilly heading for the stage at Glen Echo Park.

Washington, D.C., March 10, 1974. Ralph Stanley and the Clinch Mountain Boys en route from the dressing room and onstage at the Baird Auditorium, National Museum of Natural History, Smithsonian Institution. Band members are Roy Lee Centers, Stanley, Jack Cooke, Rickie Lee, and Curly Ray Cline; master of ceremonies Ralph Rinzler is seated stage right. A recording of this concert was issued on Atteiram CD 1662, *Live at the Smithsonian Institution.*

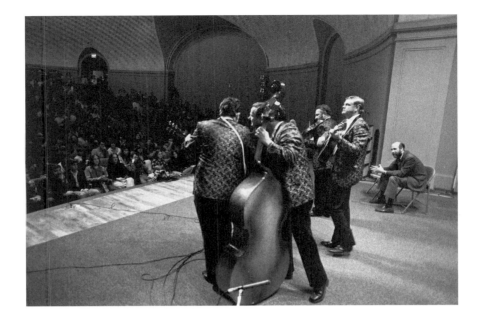

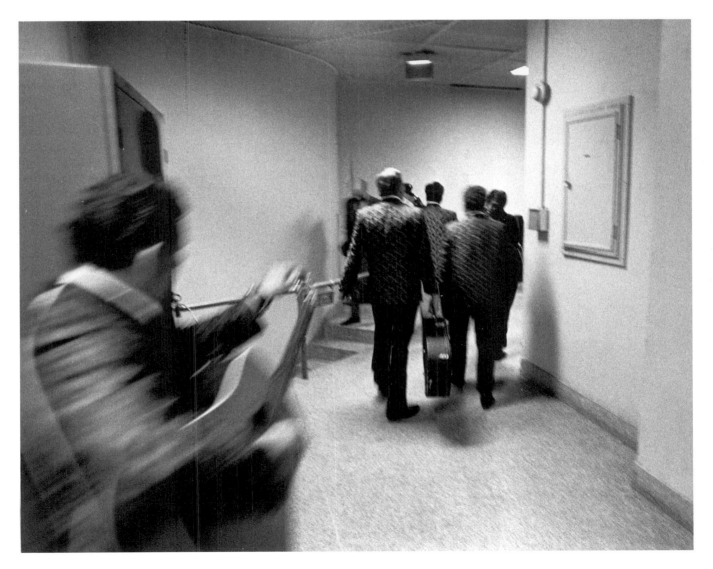

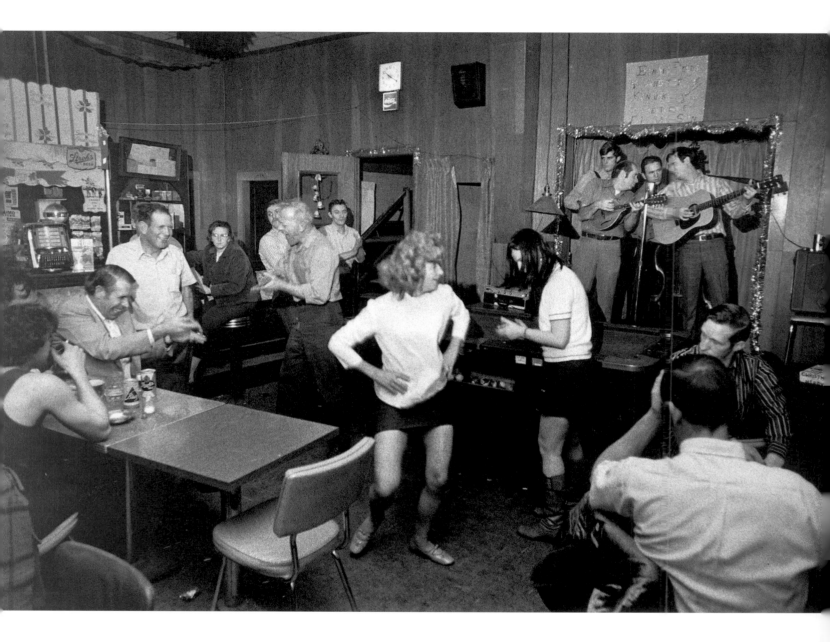

Columbus, Ohio, Christmas 1971.
The spirit of the season inside the
Blue Grass Palace. The band was led
by guitarist Bennie Fields and included
Lake Brickey on mandolin, Arvel
Dingess on bass, and Tom Dew on
banjo.

Destination

Excited by the intensity and virtuosity of bluegrass recordings, Carl and I wanted to try playing and singing this music. Learning from books didn't take us far: a few pages in Pete Seeger's banjo instructor, even less than that in a Flatt and Scruggs souvenir autograph booklet with photos of the band and words to their songs, which was sold at personal appearances and by mail order via their radio shows. I saw my first Flatt and Scruggs booklet several years before I ever saw Flatt and Scruggs. It belonged to a Kenyon College student I met right around the time I first met Carl. My Oberlin roommate, Franklin Miller, and I were visiting his home in Gambier, Ohio. We were already playing in a bluegrass band at Oberlin, but virtually everything we had learned came from records, tapes, and other Yankee folk music enthusiasts who were into bluegrass. This Kenyon student was from eastern Kentucky, and he'd bought a Flatt and Scruggs booklet when they played in his hometown. He was surprised and impressed that we were playing this music he loved. Although he was not himself a musician, he told me some things about how he heard the music that I hadn't thought of. For example, "Preaching, Praying, Singing," an early Flatt and Scruggs number, was attractive to me principally for Scruggs's neat guitar playing. But for this student

it was a vivid reminder of the small town he'd grown up in, where he'd witnessed "preaching, praying, singing, down on the public square." This was my first personal contact with the cultural world associated with bluegrass.

It took Carl and me a while to find our way in this world, to find the places in which bluegrass was at home. In the late 1950s and early 1960s information about it was almost entirely oral. We had to find the network that led to obscure records and live performances. This process made the music seem initially distant and exotic, and for us that enhanced its appeal. Learning about it this way drew us, as college students with an appetite for cultural issues connected with the arts, into studying and documenting it. As we took on this labor of love, we realized that where bluegrass was played was part of what made it what it was. Together and separately we traveled in the 1960s and 1970s to the shops, homes, jamborees, festivals, and other sites where bluegrass music was made, sold, and talked about. Many of the pictures in this book were taken during those trips as we looked in that time's present for bluegrass's past.

In the 1960s and 1970s some vital bluegrass sites remained from the music's earliest days: working-class bars, instrument shops, specialty record stores, country music parks. These places were known only to insiders, and the adventure of finding the music on its home ground excited us. This was new territory, distant from the college-town suburbs we'd grown up in and the neighborhoods of graduate student apartments that we'd passed through.

The storefront hillbilly bars in the working-class neighborhoods of Columbus, Ohio, on the edges of the old-city core, were constantly changing their names, going out of business, moving to other locations. But there, as in Detroit, Baltimore, Dayton, and other cities with neighborhoods of emigrants from the rural upland South, these bars provided a habitat, a home away from home, congenial to the blue-collar fans of the music. The musicians who kept picking in them out of love for the music kept their industrial day jobs out of plain common sense about the music's marginal economics.

On a hot summer afternoon in 1972, Carl and I cooled ourselves in the Blue Grass Palace and chatted with its owner-bartender. I investigated the jukebox's titles: mainly ten- to twenty-year-old bluegrass. Dropping a coin in, I filled the space with one of Bill Monroe's lonesome early fifties duets with Jimmy Martin—it might have been "Memories of Mother and Dad." One of the patrons, a middle-aged woman, came over and told me how much she loved that music.

We sought out these old storefront bars with working-class neighbor-

hood ties for reasons of nostalgia and because we wanted to document the role they'd played prior to bluegrass becoming what Alan Lomax, writing in *Esquire,* called "folk music with overdrive." Bluegrass had created a middle-class place for itself in the 1960s folk boom, so that now you might encounter it on a Holiday Inn sign, with its trademark star and arrow, welcoming fans to a local festival. Although these festivals, held just once a year, were more ephemeral sites than neighborhood bars, their promoters advertised them as cultural events, making them easier to find than the blue-collar taverns that featured live bluegrass every week.

Like the old storefront bars, locally owned record stores specializing in bluegrass and country music were more permanent but also harder to locate. To us they were vernacular museums that connected the past with the present. After we bought some obscure old records and talked music history with an owner-curator in Lexington, he gave us some dusty old songsters he thought we'd appreciate and helped us negotiate our way to the home of J. D. Crowe, then a young, cutting-edge bandleader. Raised on a farm six miles out of town, Crowe had been on the road playing bluegrass since his teens, notably as Jimmy Martin's star banjoist. Nearly every weekend he left his mobile home on the edge of town and traveled in his Caddy to gigs on the new bluegrass festival circuit. He told us of a radio jamboree past and of gambling on an electric bluegrass country future.

Festivals were not the only new sites for bluegrass in the 1960s. The folk boom that had welcomed bluegrass left a legacy of urban coffee-house-type clubs, often in neighborhoods where college students lived, that celebrated indigenous ethnic cultures. The painted murals in night spots like Louisville's Storefront Congregation contrasted with the stapled-on paper bricks of Columbus's Astro Inn. Many of the same bluegrass bands could be heard in both locations, though they attracted somewhat different audiences. Reporters writing about bluegrass festivals in the early 1970s wrote of "rednecks and hippies" when they sought to make sense of the different audiences that converged at the festivals.

Their outsider's view was often justified in terms of the makeup of those big festival crowds. By 1972 Marvin Hedrick, who'd been holding bluegrass and old-time jam sessions in his TV repair shop since the 1950s, didn't even take the ten-minute drive up to Bean Blossom in Brown County, Indiana, for Monroe's big festival in June. He claimed that too many people in the massive crowd there didn't appreciate or understand the music he'd grown up with. Hedrick had long been a

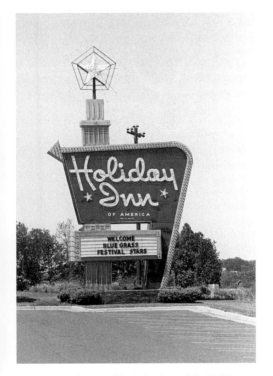

Culpeper, Virginia, June 10, 1972. The Holiday Inn provided lodging for performers at the nearby Blue Grass Folk Music Festival.

faithful patron of the country and bluegrass jamborees staged in Bean Blossom every summer weekend since the 1940s, and during the tourist season he played in a square dance band at the Abe Martin Lodge at a nearby state park. He'd hosted musicians from three counties at his jams and occasionally special visitors, including Monroe, who'd even brought the Blue Grass Boys in for a session one time. Not all the music played was bluegrass, though; you could also hear old-time fiddle, old-fashioned country, folk, and blues. Nor was it just an occasion for music. There was talk, too, sometimes about politics, scandals, or sports but more often about instruments, other musicians, new bluegrass recordings on the radio, and last week's show at Bean Blossom. Marvin taped the jams, just as he recorded bluegrass shows at Bean Blossom; in fact, his collection of tapes from the jamborees of the 1950s drew the attention of collectors such as Jerry Garcia and Sandy Rothman from the West Coast, who spent a day in 1964 dubbing arcane classics from Hedrick's archive.

From its earliest days country music has been performed at rural southern schools. Bluegrass festivals proliferated in the 1970s, but in many places bluegrass was still included as an unnamed part of country music. In one small western Virginia town, Carl visited what was called a "Country Music Show," part of the community's Maple Festival. It drew familiar local talent to perform on the basketball court, including a band from just over the border in West Virginia that was identified on the handmade poster as the Treasure Mountain Group—a reference to the legendary past of South Fork Mountain near the group's home in Franklin. Usually known as Grethel and the Bluegrass Buddies, their country music and regional connections outweighed their bluegrass associations at this site.

In October 1973 the American Folklore Society meetings took Carl and me to Nashville, Tennessee. The city's music industry was on the brink of big change: the Grand Ole Opry was moving soon to a new theme park in the suburbs. Bluegrass developed in Nashville and was nurtured on the Opry, but in this country music business center it had only recently grown strong and independent enough to support shops that catered to bluegrass fans. Old stores became instrument work sites—quiet, private, cluttered with banjo necks and specialized tools. These shops nestled in the decaying downtown, down the hill from the abandoned Gilded Age railroad station, not far from the Ernest Tubb Record Shop and the cheap tourist dives on Broadway.

Instrument stores are social clubs. Chairs and instruments on the wall invite musicians dropping by for strings or picks to stay, to try new axes,

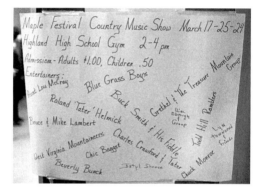

Monterey, Virginia, March 24, 1973. Sign for the Maple Festival music program at the Highland High School gymnasium. The "Blue Grass Boys" were not Bill Monroe's band but a local group.

and to share news and gossip with the salesclerks, who are usually musicians too. The old Ryman Auditorium, site of the Opry since the early 1940s, was just a few blocks away from the record and instrument shops. This converted tabernacle sustained not just the music in it and in these shops but nearby restaurants as well. The not-so-private form of privacy that we noted at festivals could be seen here as well. The Opry backstage was, and still is, a semipublic space filled with friends, family, and guests of the performers.

The tightly focused downtown Nashville music scene, where nearly everything could be reached on foot, was an old urban model. Out in California, freeway geography had changed all that. From the 1970s into the 1990s Paul's Saloon was *the* neighborhood bluegrass bar for the San Francisco Bay Area. People drove from the East Bay, the Peninsula, Marin, and beyond to hear groups such as High Country and the Good Ol' Persons. Nestled in the trendy high-rent Marina District, Paul's drew in tourists as well as the bluegrass faithful, a heterogeneous mix of sons and daughters of the Golden West with people who'd relocated from back East and down South. The instrument shops that catered to this dispersed community were mostly located in suburban sites, as was Campus Music in Berkeley. Nationally, this freeway-based culture was what made it possible for bluegrass festivals to boom in the early 1970s, when gas was cheap and RVs were a new way of traveling long distances in comfort.

In the Washington, D.C.–Baltimore area, the first bluegrass sites of the 1950s had been seedy downtown bars, many near the bus station, that catered to recently arrived working-class people from the rural South. Some of these places still existed in the 1970s. Like the Astro Inn in Columbus, The Shamrock depended not on a name that telegraphed "bluegrass" to attract outsiders but on a regular clientele. It drew bluegrass fans old and new who shared the secret of this anomalous working-class bar in a fancy Georgetown neighborhood. The success of the Country Gentlemen a decade earlier had fueled local gentrification of the music. This was reflected in new sites in the more-affluent suburbs, such as the Red Fox Inn in Bethesda, Maryland, and the Birchmere Music Hall in Alexandria, Virginia, where the Seldom Scene, successors to the Country Gentlemen's "progressive" rubric, packed them in every Thursday night. In its name this band propagated the idea that members were part-timers (with day jobs) who picked for the fun of it, though their success quickly took them away from that situation. The Birchmere and the Seldom Scene represented bluegrass to people who wouldn't have

McClure, Virginia, May 24, 1972. The grave of Carter Stanley of the Stanley Brothers, located in the family cemetery not far from the original location of brother Ralph's yearly festival in memory of Carter.

known about or found a comfortable place at Jim's Barber Shop in Sykesville, Maryland, about thirty miles north of Washington.

As the festival movement gathered steam and upscale sites like the Birchmere and Paul's opened, such bands as High Country and the Seldom Scene showed that the market for the music was not just old-timers from the backwoods. In the seventies bluegrass musicians who'd worked on the road as Opry sidemen and struggled in the hillbilly bars were now appearing in such nationally known country music bars as the Palomino in Los Angeles.

In the early 1980s our desire to document the bluegrass past in the bluegrass present took Carl and me to a lovely suburban setting outside Nashville where we visited a latter-day pioneer. On the banks of the Cumberland, a riverboat man by the name of John Hartford told us about his role in helping to create newgrass music in the late 1960s and early 1970s, during the same years that Ralph Stanley was working to fill his brother Carter's place in his music.

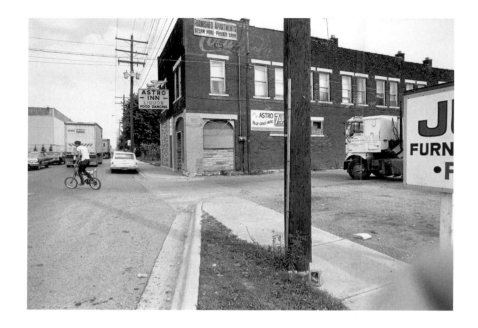

Columbus, Ohio, 1968 and August 17, 1972. In the 1968 photograph of J. D. Crowe and the Kentucky Mountain Boys at the Astro Inn, the band includes Paul Mullins, Doyle Lawson, Crowe, and Bob Morris. Carl photographed the exterior, with its 7Up sign announcing "Blue Grass Music," during our 1972 field trip to the Midwest.

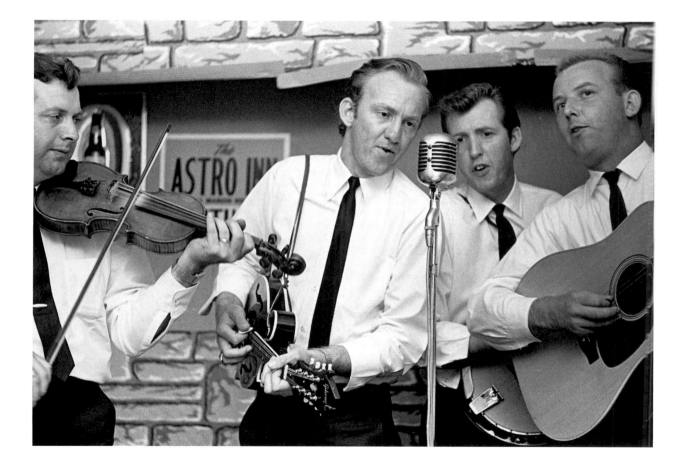

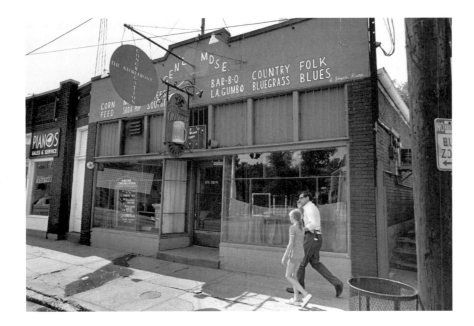

Louisville, Kentucky, August 15, 1972, and September 14, 1973. Carl photographed the exterior of The Storefront Congregation, home to a number of local bands, when we reached Louisville on our 1972 field trip. The following year he photographed the Bluegrass Alliance at the club: David Marshall, Lonnie Peerce, Steve Maxwell (hidden), Garland Shuping, and Chuck Nation.

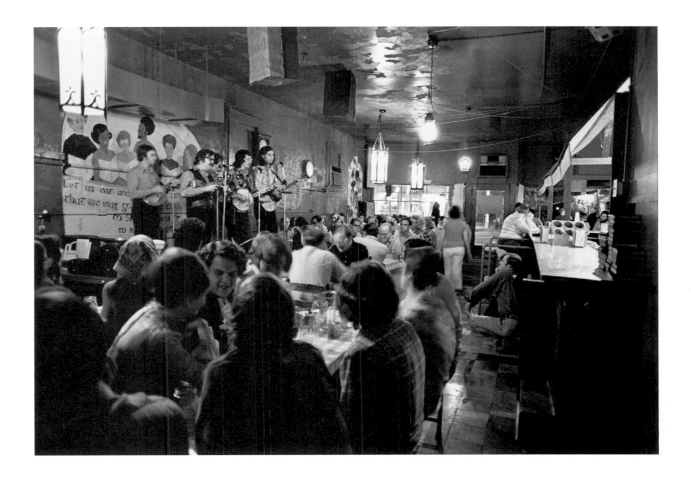

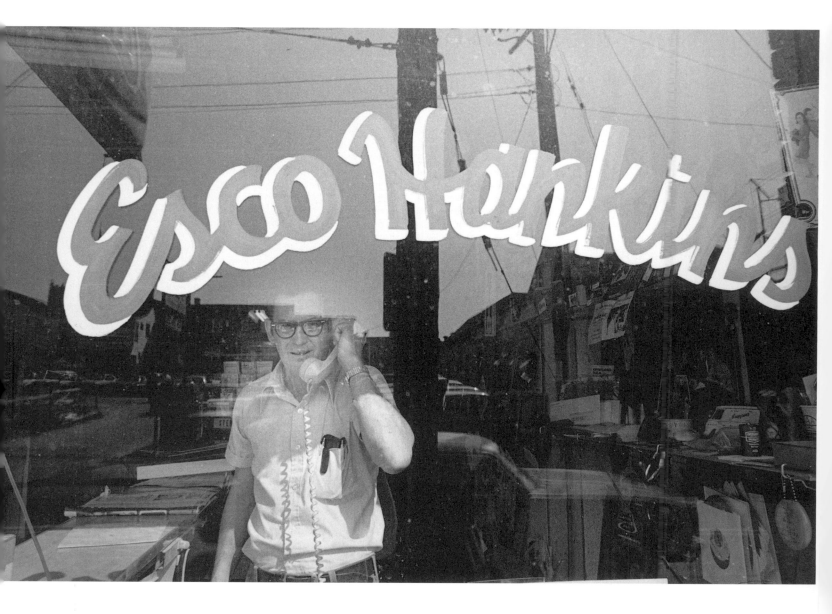

Lexington, Kentucky, August 14, 1972. Carl and I visited Esco Hankins in his record shop during our 1972 field trip. Before retiring and opening his store, Hankins was a popular regional country singer in the style of Roy Acuff and the employer of a number of young musicians who went on to become important bluegrass figures, including Josh Graves and J. D. Crowe. I asked Hankins if he could help arrange an interview with Crowe, and Carl photographed him as he called Lemco Records, for which Crowe was recording at the time; then he called Crowe and handed the phone to me.

Lexington, Kentucky, April 1972 and August 14, 1972. After visiting Esco and Jackie Hankins we went to J. D. Crowe's home, where I spent an hour interviewing him. Crowe showed us his newly electrified banjo but asked Carl not to photograph its experimental pickup. Carl had taken the exterior shot earlier that year.

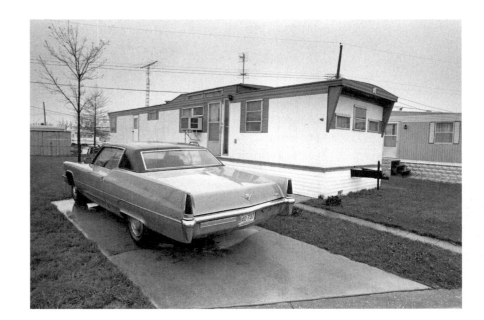

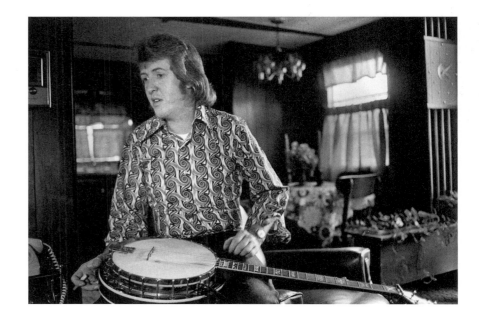

Right: Bean Blossom, Indiana, August 18, 1972. The front gate at Bill Monroe's Brown County Jamboree, my bluegrass home during the years 1961–68, when I was living in Bloomington, some twenty-five miles away.

Below: Nashville, Indiana, August 17, 1972. During our visit to Brown County, one of the last stops on my 1972 field trip with Carl, I sat in on the weekly jam session at Marvin Hedrick's radio and TV repair shop with Sandy McDonald, Gary Hedrick, David Hedrick, and Marvin.

Opposite: Bean Blossom, Indiana, June 1970. Bill Monroe at a late-night picking session in the jamboree barn during his annual Bean Blossom festival.

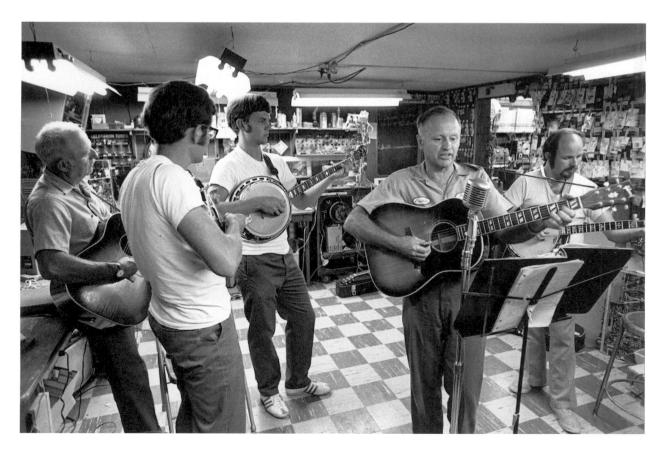

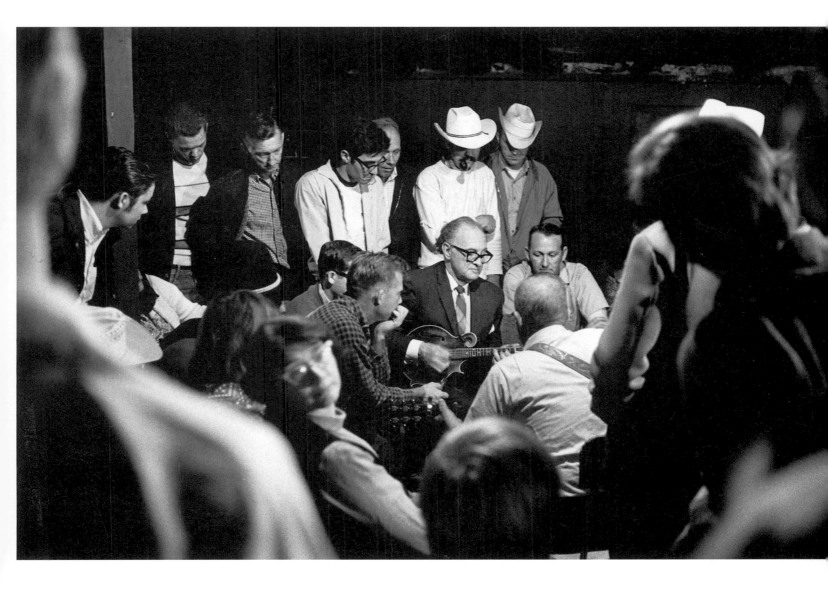

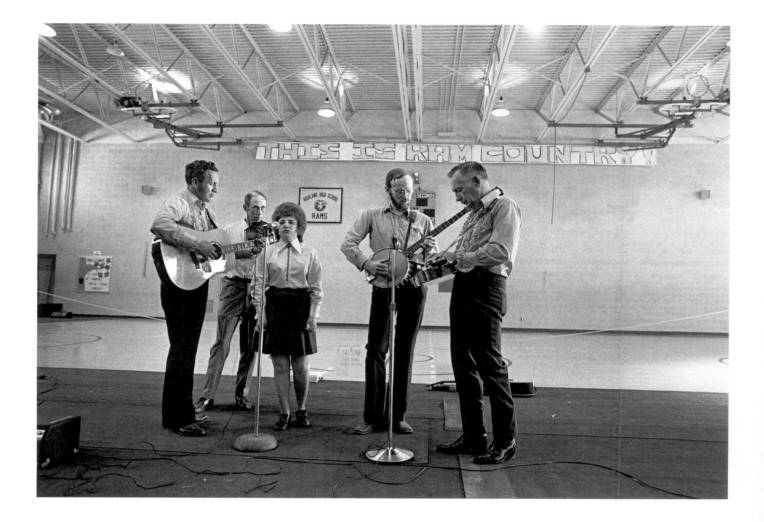

Above: Monterey, Virginia, March 24, 1973. The Bluegrass Buddies at the annual Maple Festival country music program in the Highland (County) High School gymnasium: Wilson Hoover, Hansel "Buck" Smith, Grethel Bennett, Kenny Sherfey, and Richard Eye. The band hailed from Franklin, West Virginia, twenty miles to the northeast and was sometimes called the Treasure Mountain Unit or Group.

Opposite: Sykesville, Maryland, March 11, 1977. A jam session at Jim's Barber Shop in Sykesville, a small town about fifteen miles west of Baltimore. Carl was introduced to these regularly scheduled sessions by folklorist and old-time fiddler Howard "Rusty" Marshall.

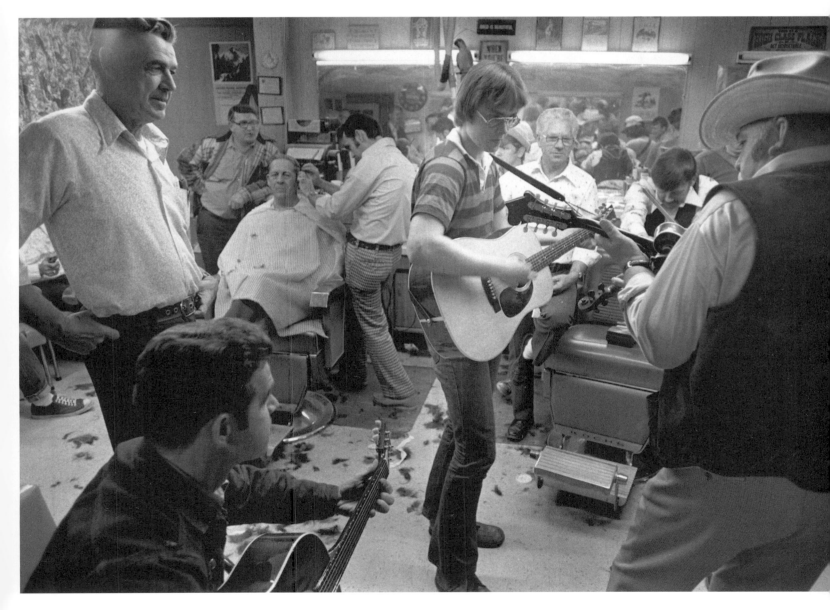

Nashville, Tennessee, November 1, 1973. Randy Wood (below) in his combination business a few blocks from the Ryman Auditorium, which in 1973 was still home to the Grand Ole Opry. Randy sits in one of the chairs provided for shopping pickers in the instrument sales and repair part of his operation. His entertainment club, the Old Time Picking Parlor, was in the store next door. Earlier, Randy had been the "R" in GTR, an instrument shop he founded in 1970 with George Gruhn and Tut Taylor that was located in another downtown Nashville storefront. Gruhn, by 1973 the sole owner of GTR, and repairman Marty Lanham are pictured in GTR's back room (opposite). Lanham, a respected luthier and musician and former member of the San Francisco Bay Area's Styx River Ferry, went on to start his own business.

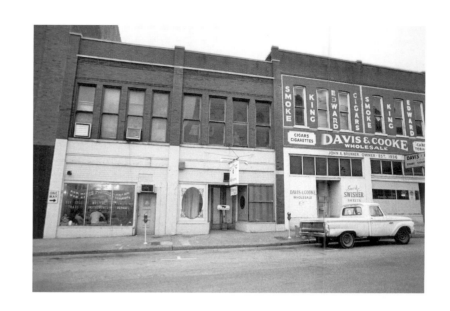

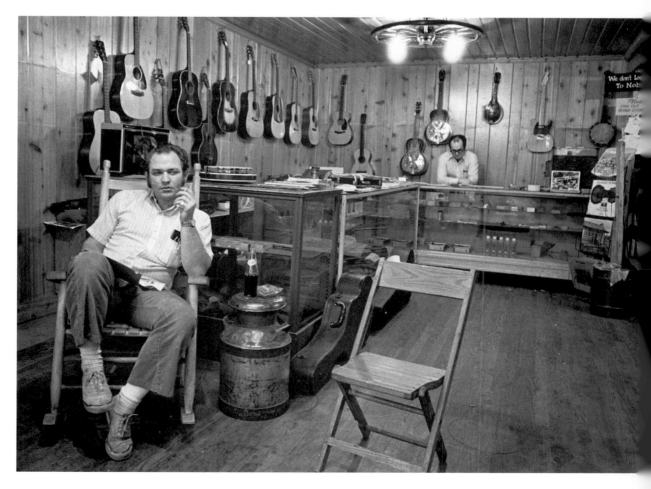

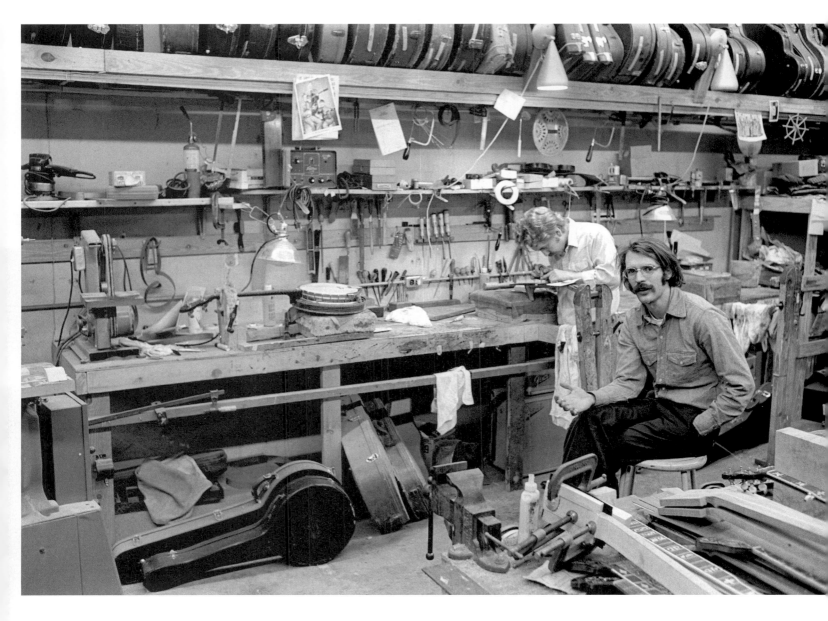

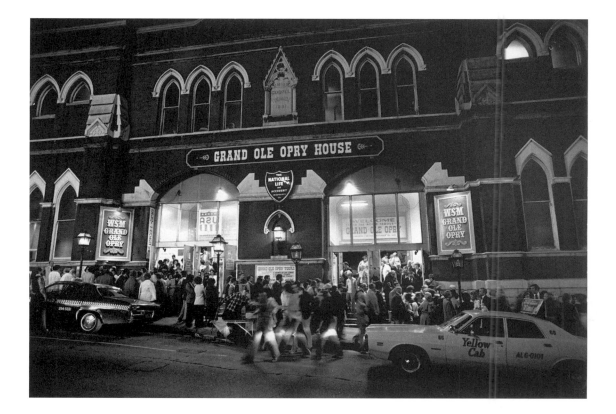

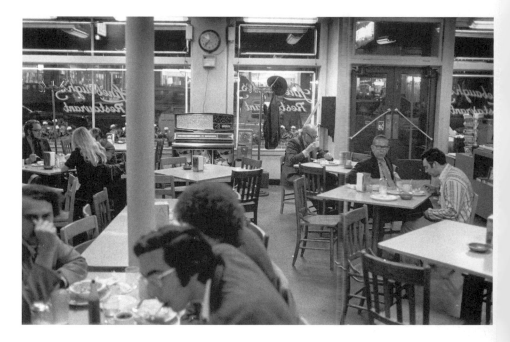

Nashville, Tennessee, November 2, 1973. Before joining the crowd at the Opry, Carl, a group of folklorists, and I had supper at Linebaugh's, a nearby restaurant immortalized by John Hartford in his *Morning Bugle* album the year before in a song called "Nobody Eats at Linebaugh's Anymore." Our experience belied Hartford's song, for after we'd settled in we noticed Bill Monroe seated alone at a table by the door having a piece of pie and a cup of coffee. Carl took this picture and I went over to say hello to Bill. We talked about the recent death of our Brown County friend Marvin Hedrick. Bill told me he'd gone to Nashville, Indiana, for Hedrick's funeral, where he'd sung "Swing Low, Sweet Chariot." "Hardest thing I ever had to do," he said. Later, Carl photographed Bill backstage at the Ryman. Opry member Billy Walker (with kerchief) is among those visible in the background.

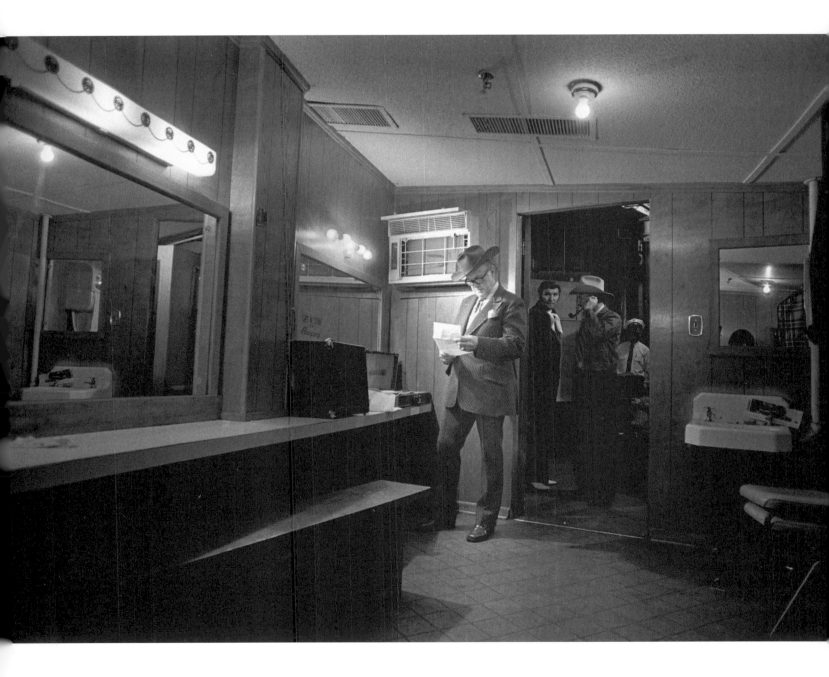

Right and below: San Francisco, California, November 6, 1974. High Country at Paul's Saloon in the Marina District, an elegant old place whose nightclub-style Victorian decor contrasted with that of many of the bluegrass taverns in the East. Still active today, High Country—Ed Neff, Larry Cohea, Chris Boutwell, Butch Waller (hidden behind Boutwell), and David Crummey—recorded for Warner Brothers in the 1970s and were northern California's best-known bluegrass band.

Opposite: Berkeley, California, November 20, 1974. Campbell Coe at his Campus Music instrument repair shop, on an alley near People's Park and Telegraph Avenue in Berkeley's university district. A Seattle native, Coe was not only a good (though slow) repairman but also a country disc jockey, a fine country lead electric guitarist, a practicing commercial photographer, and a charming raconteur. In the late 1950s, during the first years that bluegrass penetrated the San Francisco Bay Area, Coe was one of the few people of authority in the local folk scene who understood and supported bluegrass.

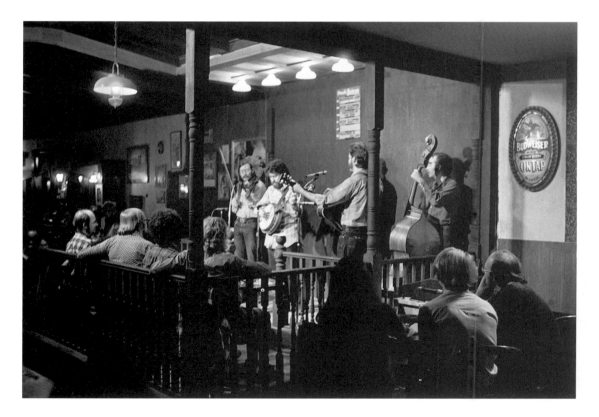

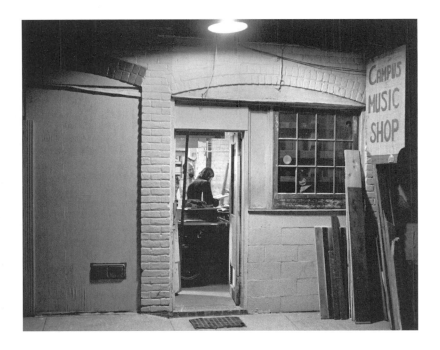

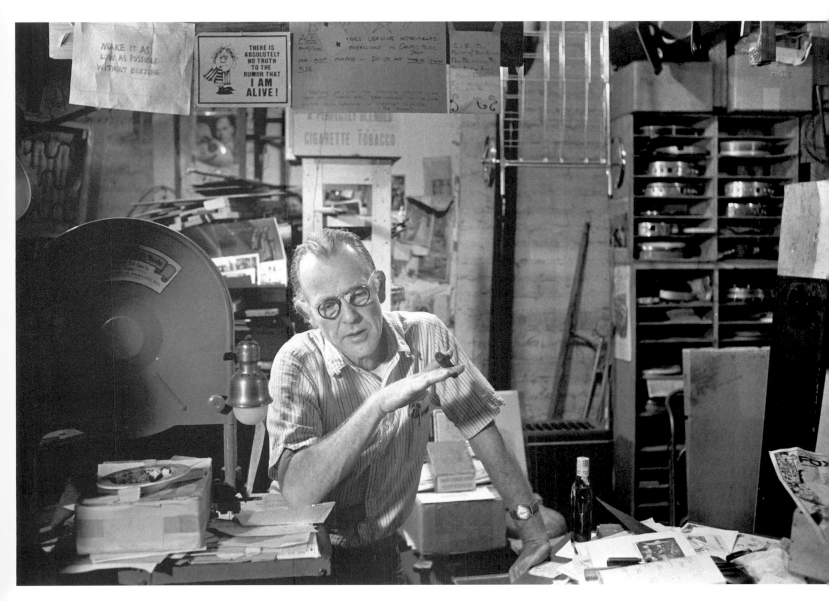

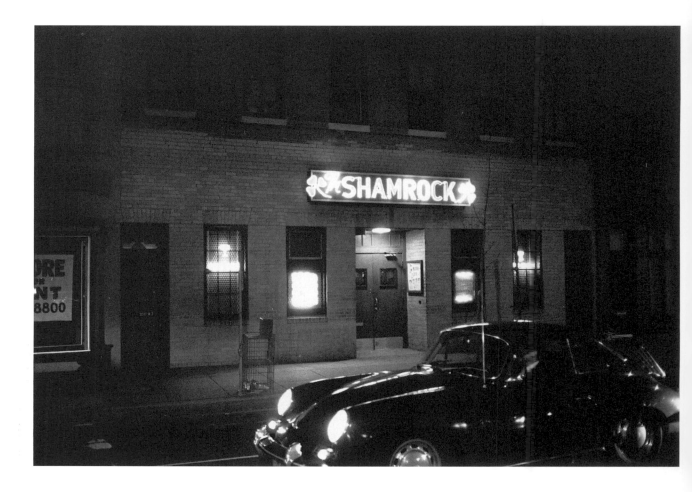

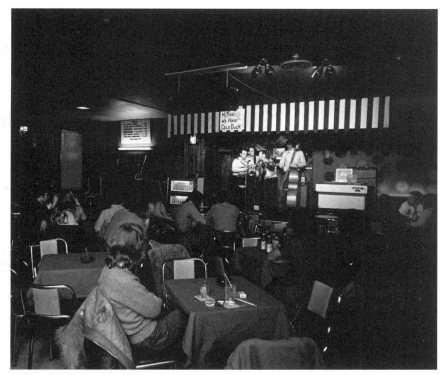

Washington, D.C., April 2, 1973. Leon Morris and the Bluegrass Associates—Dick Staber, Bob Wilkerson, Morris, and Ray Griffith—at The Shamrock in Georgetown. In 1973 Mitch Jayne—writer, bassist, and spokesman for the Dillards—called The Shamrock, where the Country Gentlemen played weekly from 1962 to 1969, "a dump" and said that he told the Country Gentlemen's manager, Len Holsclaw, that the Dillards would never play in a bar that had a sign reading "Hi There We Have Cold Duck" over its stage.

Bethesda, Maryland, January 10, 1976. Southeastern Ohio's Hutchison Brothers—Tim Sparkman, Tom Hampton, John D. Hutchison, and Robert "Zeke" Hutchison—at the Red Fox Inn in suburban Bethesda, a club that catered to an upscale D.C.-area bluegrass audience.

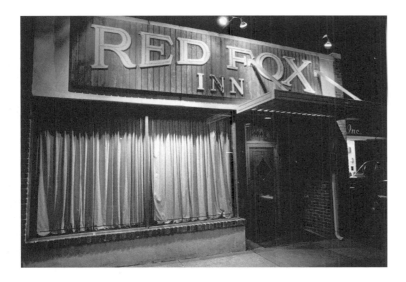

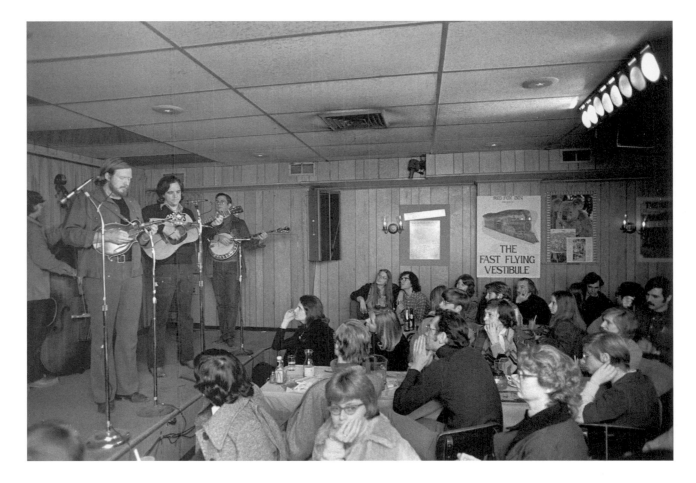

Alexandria, Virginia, Thanksgiving 1976 and May 15, 1981. Linda Ronstadt was an unannounced attendee at the Seldom Scene's regular Thursday appearance at the Birchmere Restaurant on Thanksgiving Day 1976. She had recently added her voice to the band's recording of "Bottom of the Glass" and joined the band—Ben Eldridge, John Duffey, John Starling, Tom Gray (hidden behind Starling, on bass), and Mike Auldridge—for a few songs. The photograph of owner Gary Oelze was taken five years later, after the club had moved from a shopping mall to a storefront on Mount Vernon Avenue and Oelze had renamed the establishment the Birchmere Music Hall. He's shown operating the sound board for a Bill Monroe show, mixing inputs from eight microphones.

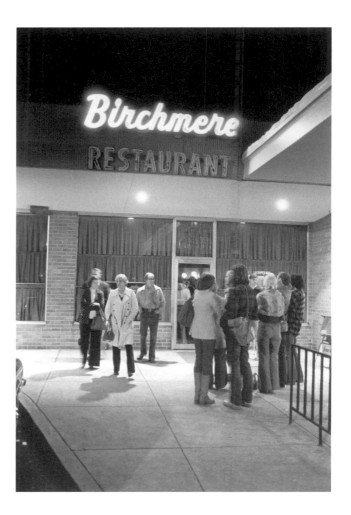

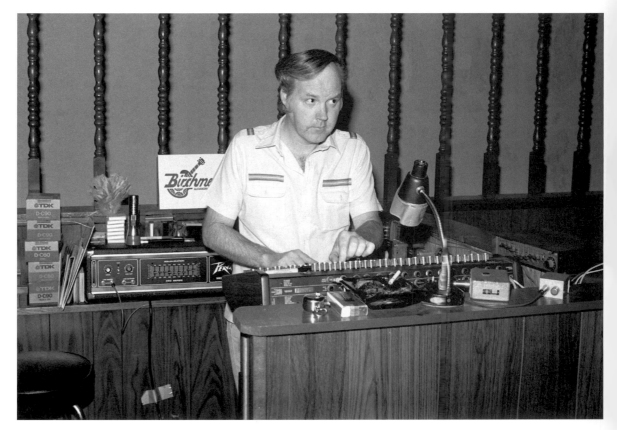

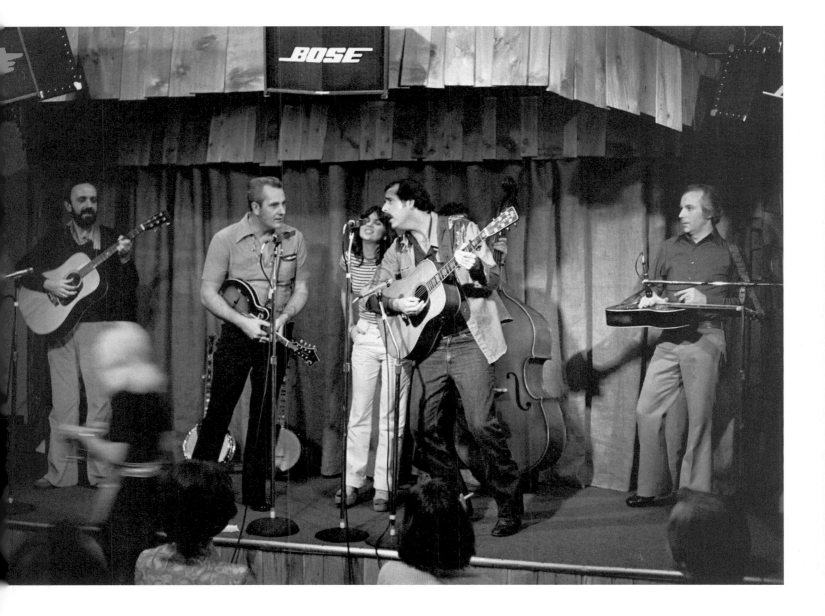

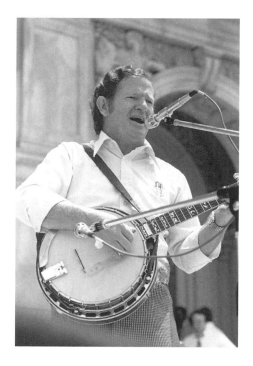

Washington, D.C., June 28, 1979, and April 25, 1977. Don Stover and the Bluegrass Cardinals at lunchtime concerts sponsored by the Library of Congress's American Folklife Center on the front steps of the Thomas Jefferson Building.

North Hollywood, California, October 22, 1979. Byron Berline and Sundance at The Palomino, a venerable country music nightclub in the Los Angeles area. The band included banjoist John Hickman, fiddler Bruce Johnston, bassist George Hickman (hidden), fiddlers Dennis Fetchitt and Byron Berline, drummer Mark Cohen (hidden), guitarist Greg Harris, and Dobro player Skip Conover.

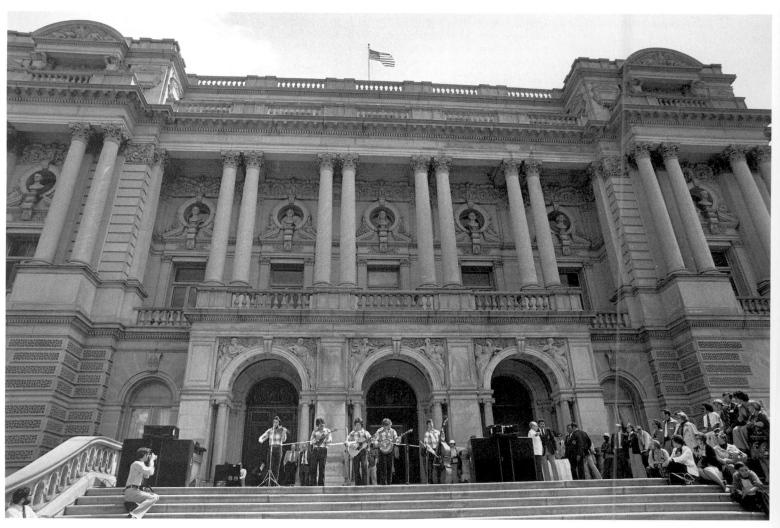

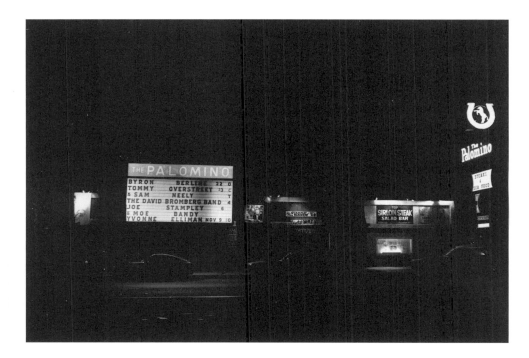

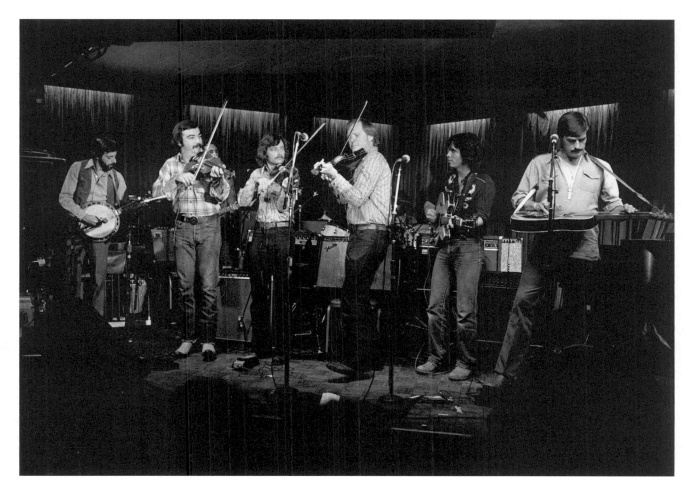

Madison, Tennessee, April 8, 1983. Charles Wolfe *(opposite, right)* joined me in a visit to John Hartford *(opposite, center)* at Hartford's home in a Nashville suburb on the banks of the Cumberland River. I interviewed Hartford about his role in shaping newgrass music while Charles asked a few questions of his own and Carl took some photographs.

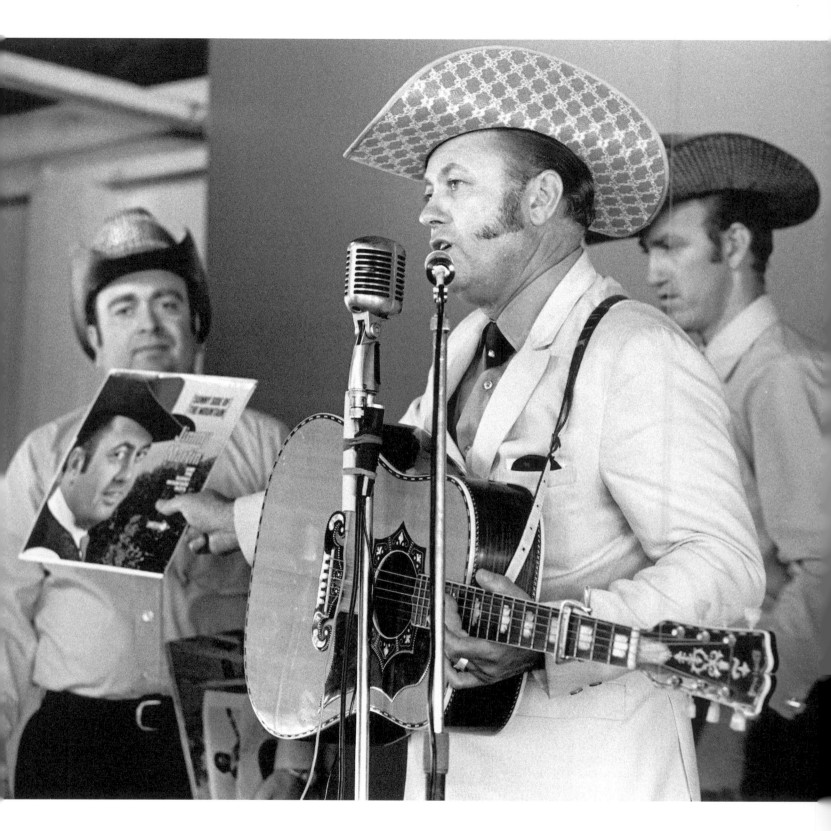

Logan, Ohio, 1969. Jimmy Martin informs the audience at a show in southern Ohio that they can purchase his Decca album *Sunny Side of the Mountain* after the set. In the background are Vernon Derrick and Doyle Lawson, members of Martin's band, the Sunny Mountain Boys.

Transaction

During our travels Carl and I were drawn into musical marketplaces. We'd noticed exchanges when we first heard bluegrass recordings: the vocal call and response of gospel quartets, the trading of instrumental hot licks, and much more. Since the 1960s those who've written about bluegrass have built on Alan Lomax's automotive metaphor of folk music with overdrive, recognizing that as an ensemble musical form bluegrass reflects and echoes not only its rural roots but also the urban and industrial life from which it emerged. As on an assembly line, each musician has a special part to sing and a special job to do on his or her instrument. This is the central transaction around which all others cluster.

On these journeys we gradually recognized and then sought to explore the webs of exchange among musicians, producers and consumers, and others. Often they are part of the fabric of musical performance. Bandleaders pause between songs to remind listeners that they can take home a musical memory by stopping at the band's sales table and purchasing the group's latest album or songbook, or a hat, or a keychain. Because the markup of about two dollars per album collected on each retail sale greatly exceeds the artist's royalties from those sales, direct sales become a major source of income on the road. Like many others,

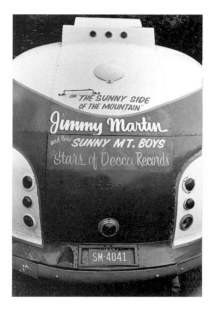

Reynoldsburg, Ohio, June 25, 1972. Jimmy Martin's bus at the Frontier Ranch bluegrass festival.

Jimmy Martin traveled with a public reminder of this possibility painted on the back of his bus: a popular record title along with the names of his band and his record company.

At festivals this kind of activity is multiplied as small businesses set up shop in an area resembling a medieval market or a contemporary flea market. In the mid-1960s enterprising young enthusiasts attracted to bluegrass at the dawn of the festival movement discovered that many of the needs and desires of musicians, fans, and collectors were not being met by existing businesses. These new entrepreneurs embarked on specialized ventures built on interests they shared with other enthusiasts. Record collector David Freeman began his mail-order record business, County Sales, in New York in 1963. By the 1970s he'd relocated to Floyd, Virginia, and was producing albums on his County Record label. Later he would acquire another bluegrass label, Rebel. Other young enthusiasts who came to work for Freeman, such as Gary Reid and Barry Poss, started their own successful companies—Copper Creek and Sugar Hill, respectively. In the early 1970s the founding members of the Rounder Collective, based in Cambridge, Massachusetts, who'd released their first albums in 1971, personally marketed their products at festivals. Two decades later Rounder had become one of the largest independent labels in the recording business.

A live performance is a very public transaction between musician and audience, but it usually coexists with other, more private exchanges. In creating set lists for an evening's performance at a place like the Birchmere Music Hall, a hidden framework, or script, is negotiated and constructed in advance to enable later "spontaneity." Such negotiations are about the aesthetic impact of the repertoire and the dynamics of the band: how to mix keys, tempos, textures, and song topics; how to spotlight the talents of each band member in a balanced way. The list isn't always followed once the band is onstage, as requests or broken strings or time constraints may alter the program; and some performers don't bother with lists at all. When Ralph Rinzler first went to work as Bill Monroe's manager in 1963, he made up a set list for one of the weekly jamborees at Bean Blossom. At this venue, which Monroe often spoke of as "like home to me," he'd previously played sets that opened with a few familiar tunes and then filled out the rest of the time with audience requests. Now, after each number Monroe would turn to guitarist Del McCoury, who had the list, and ask, "What's next?" Then he'd announce, "Next on the list we have . . . ," name the piece, and begin playing it. It soon became clear that he wasn't comfortable working with a script—it competed with the one in his head.[1] But other lists, like Opry

broadcast lineups and daily festival performance schedules, were essential even to Monroe. Festival lists command the attention of band leaders, who must contend with issues of hierarchy and timing. A bandleader once told me that he could tell who was attracting the most audience members at big country package shows like festivals by noting how many audience members got up and left after each band's set. If yours is not the most popular act, you hope to be on before the one that is. Ultimately, list making by musicians is aimed at improving the most private transaction that closes the day's work—the financial one.

The proscenium, which separates the performer from the audience, is a less formal, more easily crossed space in bluegrass (as in most country music) than it is in classical music or theater. Fans sometimes write requests for songs on slips of paper and boldly walk up to the stage to hand them to a band member. Such requests are received with a gesture or a nod, and they may or many not be honored; in any case, by the end of the set the slips lie discarded on the stage. Bill Monroe encouraged audience requests at his shows, which frequently led to fans shouting out their requests rather than writing them down. Once, while sitting in the front row at a Bean Blossom Jamboree, I shouted out a request for "Roll in My Sweet Baby's Arms," a song I knew Monroe had recorded many years before with his brother Charlie. "That's a good title," he remarked dryly, looking at no one in particular and smiling only when the audience laughed at this slyly bawdy observation. Such exchanges were part of Monroe's shows, a cultivated and distanced informality across the proscenium.

One of Carl's photographs caught the Country Gentlemen creating impromptu comedy when they playfully interrupted their musical performance and walked to the edge of the stage to purchase refreshments from a passing vendor. Such gestures bring performers and fans into a closer relationship, much like the speeches addressed to the audience by the character of the stage manager in Thornton Wilder's *Our Town*.

From the moment festival-goers enter the site, they are confronted with a spectrum of opportunities for transaction. Like the band pictured at the close of the first chapter, moving from the backstage area to begin their show, festival-goers are in a liminal world, an exciting music-centered carnival. Personal exchanges—chatting about favorite stars, trading addresses, swapping instruments, sharing meals—occur among individuals representing many contrasting identities: musician and fan, Yankee and Southerner, young and old, hippie and redneck, women and men, and so on. Such interaction is manifest in the improvised bands that jam in campgrounds and parking lots. These social exchanges in-

tertwine with commercial ones, both public and private. Commercial sites such as food concessions, located in the market area of the festival, become informal meeting places. Here musicians may encounter old friends or make the acquaintance of audience members. Meetings like these are reciprocations, ways for performers to thank valued fans for having earlier stopped at the gate to purchase a festival pass.

A successful festival experience is one in which the participants don't stop to reflect upon the overall framework of the event. Such thoughts are left to the promoter, who worries about bad weather, no-show bands, obnoxious drunks, and, worst of all, not enough paying customers passing through the gates. Within the framework of this principal transaction a host of smaller, optional transactions flourish. For example, in 1972 you could buy a special festival edition of *Muleskinner News,* which included the program for the festival, either at the gate or from your seat in the audience. At such festivals entrepreneurs sell not just magazines but recordings and souvenirs, including T-shirts, caps, patches, and other accessories. Such sales occur at many kinds of festivals, but at bluegrass festivals in particular the instruments and their technology have special prominence. At booths in the market area you'll find banjos, guitars, mandolins, Dobros, and fiddles for sale, as well as instruction books and tapes, tools, strings, inlays, bridges, tuning pegs, and other gear. Meanwhile, a lively private trade in instruments flourishes in the parking lot and campground.

Bluegrass instruments are the objects of intense interest. Metaphors for the musical form itself, they're often seen in logos. Treasured old instruments or distinctive new ones are much talked about. Most of those who play these instruments occasionally tinker with them to improve their sound or appearance. During the late 1950s some craftspeople tried their hands at building replicas of the rare Gibson and Martin instruments from the 1920s and 1930s that were used by the leading musicians. The most adept of these mostly self-trained artisans were patronized by musicians who either didn't tinker or didn't trust their abilities when the tinkering got complicated. By the 1970s some of them had become full-time professionals, including Mike Longworth, hired in the late 1960s by the Martin Guitar Company and both a historian and central architect of that company's growth in the following decades. Luthiers could be seen at many levels in the bluegrass marketplace. Some worked on their own projects, while others did custom work on a part-time basis, which sometimes led them to produce complete instruments or to manufacture custom replacement parts for factory-built instruments.

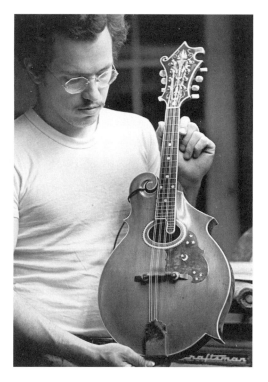

Near Athens, Ohio, autumn 1966. Ron Chacey with a turn-of-the-century three-point Gibson mandolin that he repaired for instrument dealer Harry West. In later years, Chacey specialized in custom inlay work and metal engraving.

Recording, like instrument making, pervades bluegrass at all levels. It can be a short step from jam session to recording session. A weekly radio show or a self-produced cassette might be recorded at the home of one of the band members. Ever since home recorders appeared on the market, bluegrass fans have been recording broadcasts and personal appearances by their favorite performers. For decades enthusiasts have collected and swapped such recordings. Even jam sessions can be the occasion for the creation of souvenir documents with tape recorders or cameras.

Often created in the same informal settings, the bluegrass photographs crafted by such professionals as Les Leverett, Jim McGuire, Becky Johnson, Ed Huffman, Phil Straw, and Penny Clapp are meant for public consumption rather than private collections. Their images have graced record jackets and shared the pages of magazines with those Carl has taken. The first bluegrass monthlies appeared in the 1960s; since 1970 there have almost always been at least two glossy illustrated periodicals for enthusiasts. Typically, they include a spectrum of amateur and professional photographs.

In the 1970s only a few of the writers for bluegrass monthlies were professionals. Most people who wrote for these new magazines did so because of personal interest in the music and its history, because of their enthusiasm for it and the desire to share their knowledge and feelings with others. The popularity of these magazine writers is judged by most readers in terms of the accuracy of the information they present and the sincerity with which they deliver it. Chance left Carl without photographs of some of the most energetic and capable writers of this time, such as Don Kissil and Bob Artis. For them and the others Carl did photograph, writing was just one aspect of a broad professional involvement in the music: part of an interest in identifying and preserving gems from the broad vein of American vernacular musics, or a deep and personal acquaintance with, and a flair for representing, the colorful lives and musical artwork of the leading bluegrass musicians past and present. In themselves and in their work they strove to bridge the downhome and the professional, to put on what Lester Flatt called "a sincere show."

Perhaps the most influential bluegrass disc jockey of the 1970s was Gary Henderson, whose afternoon and weekend programs on WAMU-FM at American University in Washington, D.C., were widely heard. Henderson, who was listed on the masthead of *Bluegrass Unlimited* when it first began publication in 1966, started broadcasting at WAMU in 1967. Unlike many disc jockeys he operated on his feet. He ran a free-wheeling program that took requests and welcomed visitors. Part of the show's

appeal for listeners was the fact that you never knew who you might hear when you tuned in. He told Carl that his intent was to educate listeners familiar with the progressive sounds of the Seldom Scene who didn't have an opportunity to hear the older and less well known bands that had shaped the music. "I feel that I'm trying to provide an alternative service," he said.[2]

The song lists Henderson used for his radio program, like the lists mentioned earlier in this chapter, highlight the transient and mediated nature of the musical experience itself. Festival audiences, performers, and producers are deeply involved in a kaleidoscope of transactions as the events unfold. The intense, long weekend is filled with a mixture of the anticipated and the unexpected that makes the experience memorable for everyone involved. At the end, those memories are taken away and empty spaces are left behind as the cleanup begins. The littered festival ground is itself a short-lived, ephemeral set of people tracks. Recordings, photographs, and souvenirs remind us of transactions binding together the community that sustains this music.

Notes

1. I discuss how Monroe structured his Bean Blossom shows in *Bluegrass: A History* (Urbana: University of Illinois Press, 1985), 234–38.
2. Gary Henderson, interviewed by Carl Fleischhauer, Washington, D.C., April 10, 1977.

McClure, Virginia, May 24, 1972.
Supper break between shows at the
Carter Stanley Memorial Festival.

Indian Springs, Maryland, June 2, 1973. Ken Irwin and Marian Leighton of Rounder records selling their wares (including an old-time album Carl coproduced) in front of their VW microbus at the *Bluegrass Unlimited* Festival.

Floyd, Virginia, November 1975. Although County Sales and County Records occupied a building in Floyd, owner David Freeman also set up an office at one end of the family room in his home, not far from Buffalo Mountain in Virginia's Blue Ridge. Not long after this photograph was taken Freeman and his family moved to Roanoke.

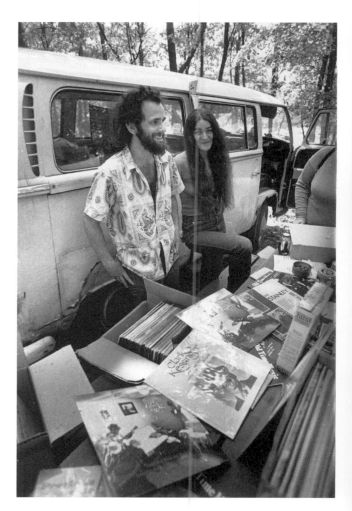

Springfield, Virginia, November 20, 1980. Producer Barry Poss, bandleader Doyle Lawson, and Bias Studio owner and recording engineer Bill McElroy at the console; in the studio are musicians Terry Baucom and Doyle Lawson. Poss, who had recently left Freeman's County Records to start his own label, Sugar Hill, was producing a session for Quicksilver's first gospel album, Rock My Soul. When Carl arrived to take some photographs, Poss warned that a distraction might break the concentration Lawson and the band needed to perform. The tension was palpable, and Carl stayed at the studio only long enough to shoot a single roll of film.

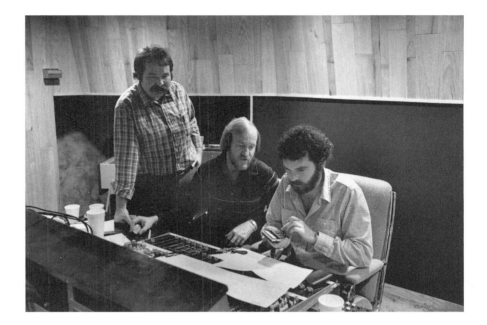

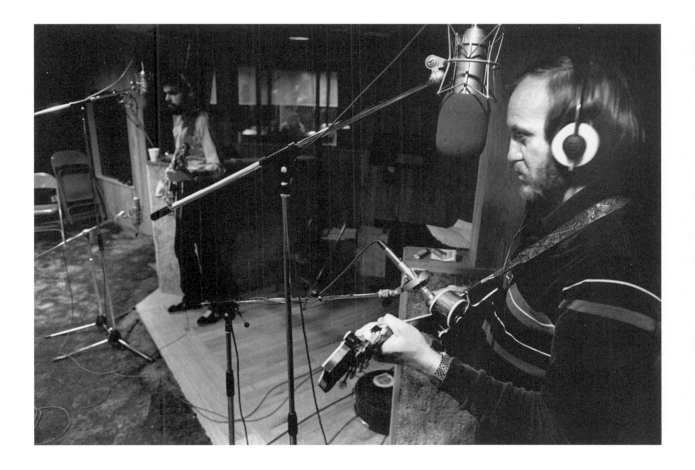

Right and below: Alexandria, Virginia, January 1980. Byron Berline, John Hickman, and Dan Crary compile a list of selections for the performance they are about to give at the Birchmere Music Hall. Carl first heard banjoist Johnny Hickman at Irv-Nell's Bar in Columbus, Ohio, in 1961; these pictures are a souvenir of their encounter twenty years later in Alexandria.

Opposite: Rosine, Kentucky, September 14, 1973. Backstage at Bill Monroe's Homecoming and Bluegrass Festival, his son James watches Melvin Goins draw up a list of the bands and assign each a forty-five-minute set.

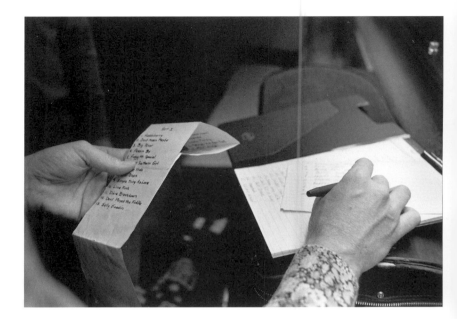

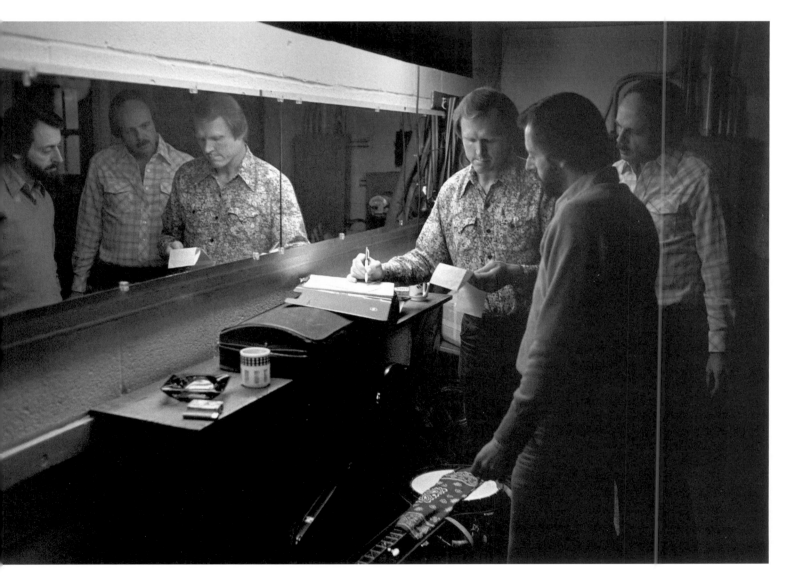

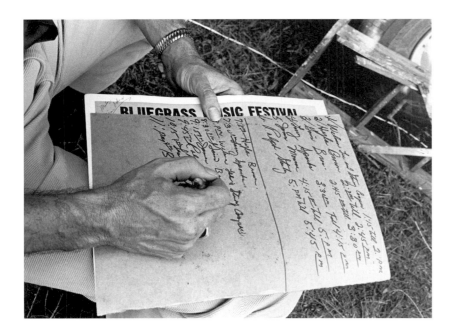

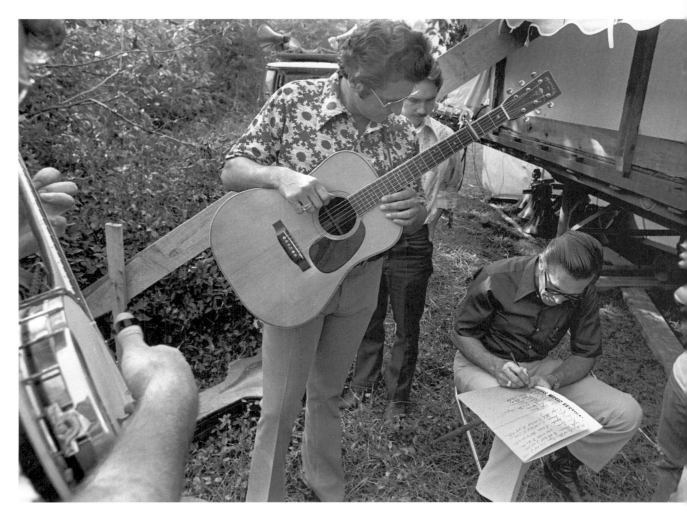

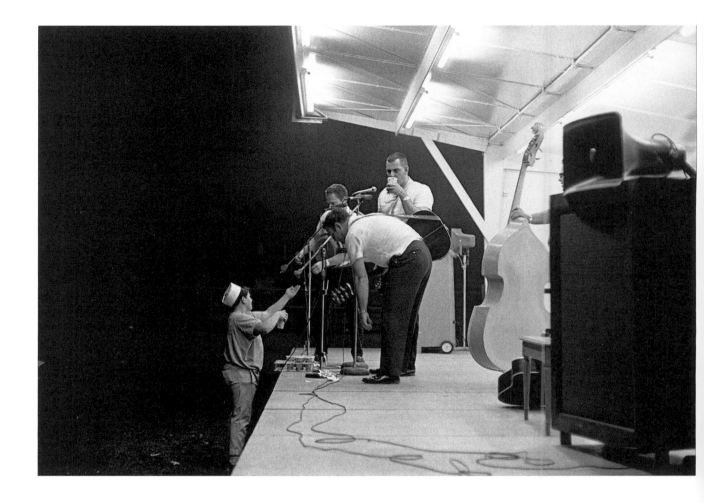

Columbus, Ohio, November 1967. During their set at a festival held at the Ohio State Fairgrounds, the Country Gentlemen—Eddie Adcock, Charlie Waller, John Duffey, and Ed Ferris (holding the bass)—pause to buy drinks from a vendor. In the 1960s the Country Gentlemen entertained their followers with iconoclastic humor that challenged the conventions of country music. Although other bluegrass or country performers might talk to fans or sell songbooks from the stage, it was unheard of for a more conventional act to stop in midperformance to purchase refreshments.

Jackson, Kentucky, August 1972. A slip requesting "Little Birdie" and "Who Will Sing for Me" lies abandoned near the stage at Bill Monroe's Kentucky Blue Grass Festival.

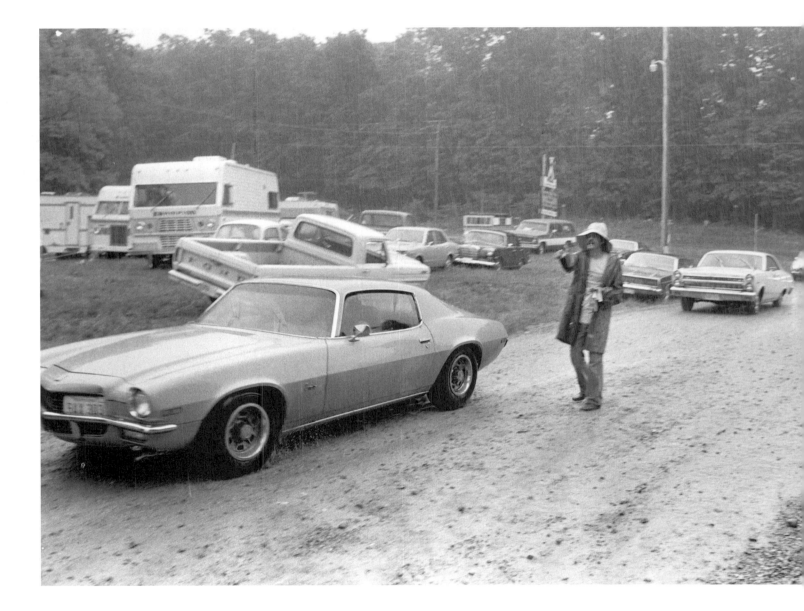

Indian Springs, Maryland, May 31, 1975. Selling tickets at the main entrance to the *Bluegrass Unlimited* Festival on a rainy afternoon.

Top: Culpeper, Virginia, June 10, 1972. *Muleskinner News* editor Fred Barten- stein in the audience at Jim Clark's Blue Grass Folk Music Festival selling *Bluegrass Summer 1972*, a special sixty- eight-page edition of the bluegrass bimonthly that featured festival lists, a who's who of bluegrass artists, a Blue Grass Music Awards ballot, and other features, all for just three dollars a copy.

Middle: Indian Springs, Maryland, June 2, 1973. Polly Lewis at the Lewis Family's record and tape stand at the *Bluegrass Unlimited* Festival.

Bottom: Merrimac, West Virginia, June 14, 1975. Bill Harrell (with the guitar case) and a friend in front of a food stand at the Fireman's Bluegrass Festival.

Opposite: Union Grove, North Carolina, March 27, 1970. Roger Sprung (right) had been playing bluegrass banjo in New York City and attending the Old- Time Fiddler's Convention at Union Grove since the 1950s. Here he sells his records and banjos from a table in front of his van.

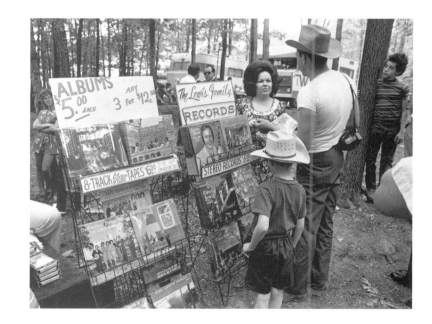

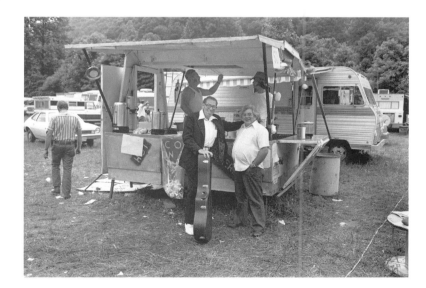

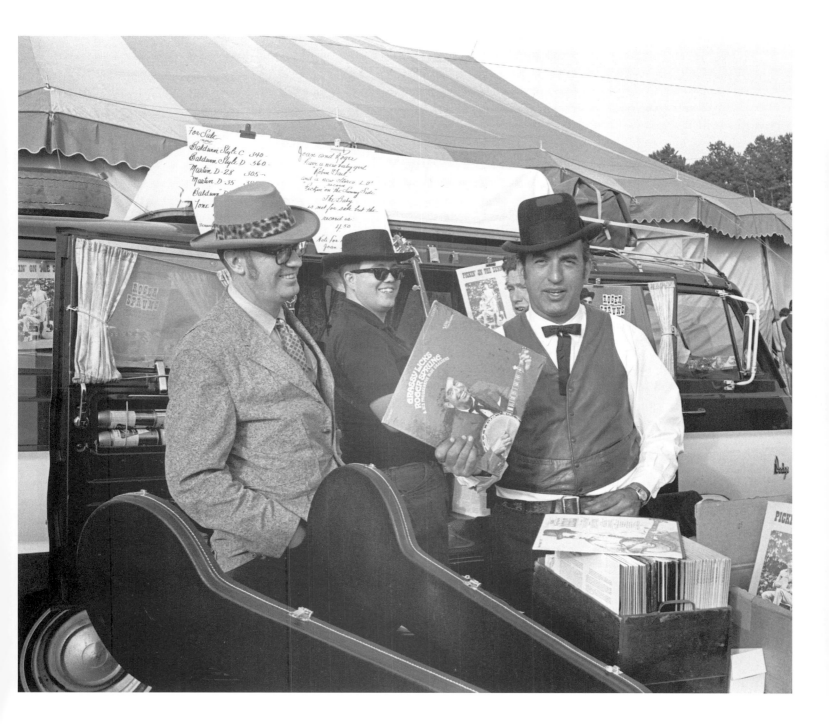

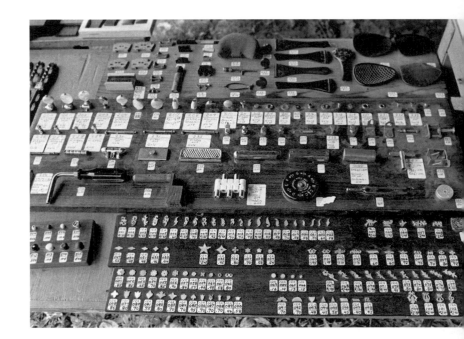

Jackson, Kentucky, August 1972. Between shows at Bill Monroe's Kentucky Blue Grass Festival, Ralph Stanley's bassist Jack Cooke examines the three-piece rosewood back of a Martin D-35 guitar. Its owner and would-be seller leans against the open trunk lid of his car.

Indian Springs, Maryland, May 31, 1975. Mike Holmes, editor and publisher of *Mugwumps,* a magazine devoted to old-time and bluegrass instruments, selling instruments, reprints of old catalogs, and his magazine at the *Bluegrass Unlimited* Festival. His antique Gibson banjo served as a conversation-starter with passersby.

Indian Springs, Maryland, June 1, 1974. Mother of pearl inlays and other instrument parts and accessories for sale at the *Bluegrass Unlimited* Festival.

Athens, Ohio, November 1967. Charlie Ogsbury poses with his girlfriend while visiting Creston E. "Kix" Stewart, whose Stewart-MacDonald Company was located in Athens. During the mid-1960s Ogsbury's Boulder, Colorado, company manufactured Ode banjos, used by a number of bluegrass musicians. He later sold the company and its designs to Baldwin and in the 1970s started a new banjo company called Ome.

Athens, Ohio, December 1978. After a stint working for Charlie Ogsbury's Ode banjo company in Colorado, Kix Stewart teamed up with Bill MacDonald to start an instrument company that sold parts, kits, and supplies to luthiers, both amateur and professional. This photo-

graph of Stewart and MacDonald was taken in the office at a converted chicken-house factory a few miles south of Athens before the company moved to the former Royal McBee typewriter plant in town. Always looking for ways to diversify, in 1977 Stewart-MacDonald introduced a line of cross-country skis—examples can be seen in this photograph—but dropped the product two or three years later.

Washington, D.C., February 17, 1980. Owner and recording engineer Bill McElroy of the Bias Studio in Springfield, Virginia, recording the multiband reunion concert put together by Birchmere Music Hall owner Gary Oelze at George Washington University's Lisner Auditorium. The main recording was made on the multitrack recorder behind McElroy, while a second tape was recorded on the stereo Nagra to the left of the mixer. This concert was published first on LP and subsequently as Sugar Hill compact disc SH-2201, *Bluegrass: The World's Greatest Show*.

Bean Blossom, Indiana, June 1970. Fans attend to tape recorders beside the stage as the Country Gentlemen—Charlie Waller, Bill Emerson, Jimmy Gaudreau (hidden), and Bill Yates—tune up between numbers at Bill Monroe's annual festival. Since the mid-1960s, when he traded Marvin Hedrick an old Gibson F-4 mandolin for a new sound system with special hookups for recording directly from it, Monroe had recognized and permitted fan taping at his park.

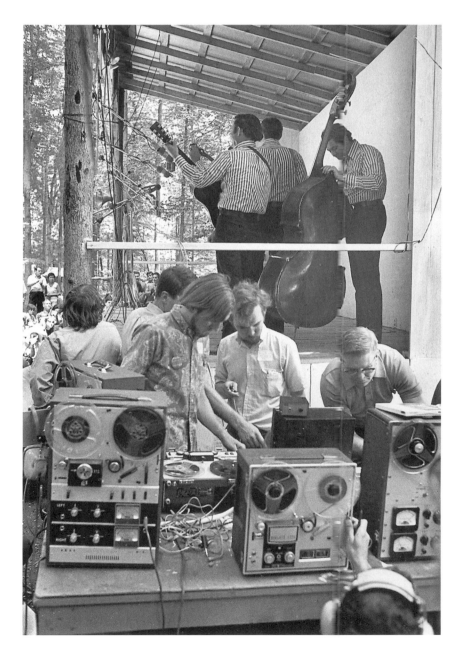

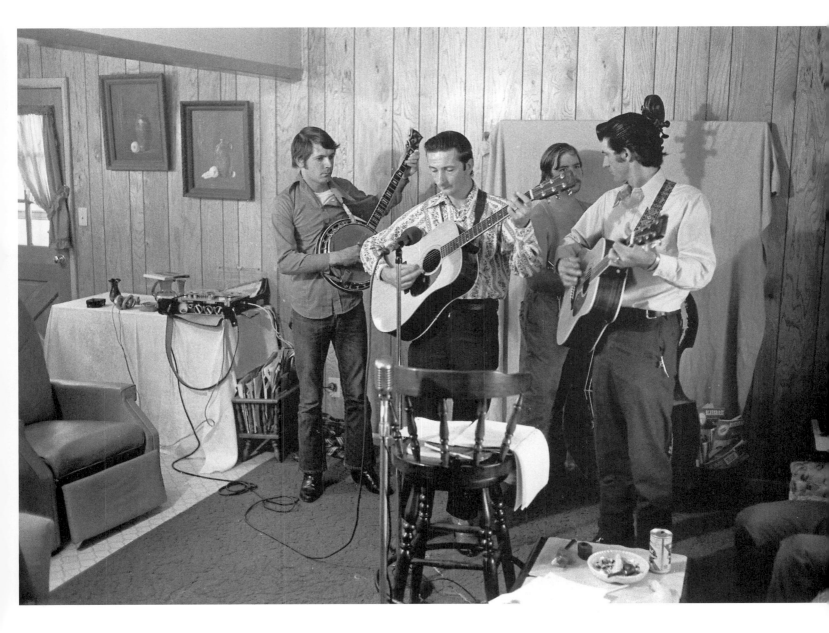

Near Hillsboro, West Virginia, November 1971. The Black Mountain Bluegrass Boys—Richard Hefner, Bill Hefner, Dwight Diller, and Harley Carpenter— record their weekly radio show at the home of banjo player Richard Hefner. The Saturday morning show was sponsored by Glades Building Supply and

ran on WVAR, Richwood, West Virginia. On this occasion, since Carl had a professional-quality portable Nagra tape recorder with him, it was used for the recording instead of the one the band normally used.

Sykesville, Maryland, March 11, 1977. One attendee at this jam session at Jim's Barber Shop captures the music with a cassette recorder while another takes photographs from the far side of the room.

Vienna, Virginia, July 28, 1979. Carl poses at the National Folk Festival at Wolf Trap Farm Park. He recalls that a friend—whose identity he no longer remembers—picked up one of his cameras and took this photograph.

Nashville, Tennessee, October 15, 1975. Les Leverett, the official photographer of the Grand Ole Opry, poses backstage at the Early Bird Bluegrass Concert in Opryland.

Vienna, Virginia, July 2, 1978. Photographer Phil Straw in the green room of the Filene Center at Wolf Trap Farm Park with members of Lester Flatt's Nashville Grass: Charlie Nixon, Curly Seckler, Tater Tate, and Pete Corum.

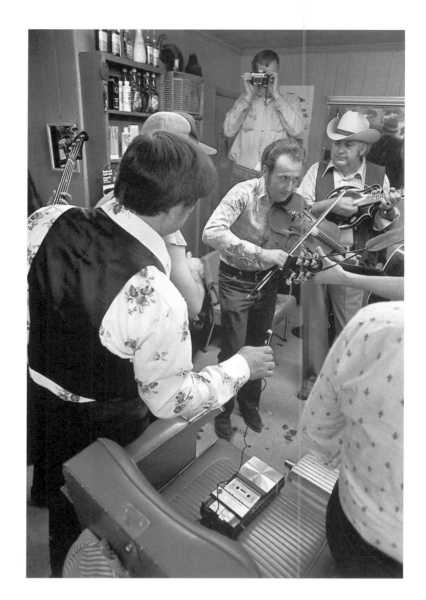

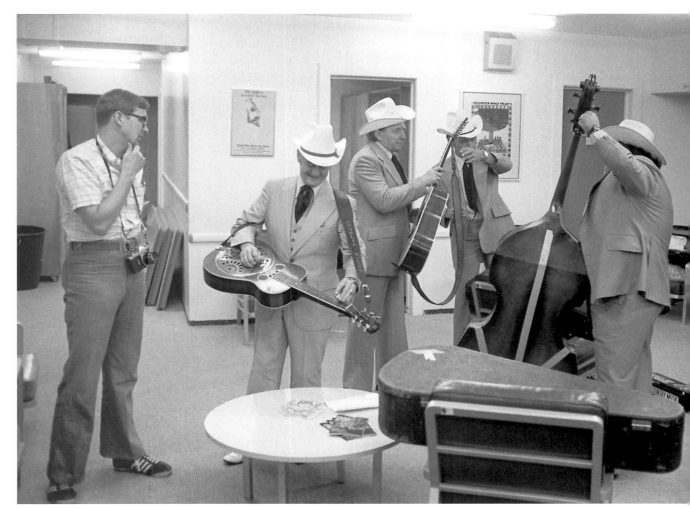

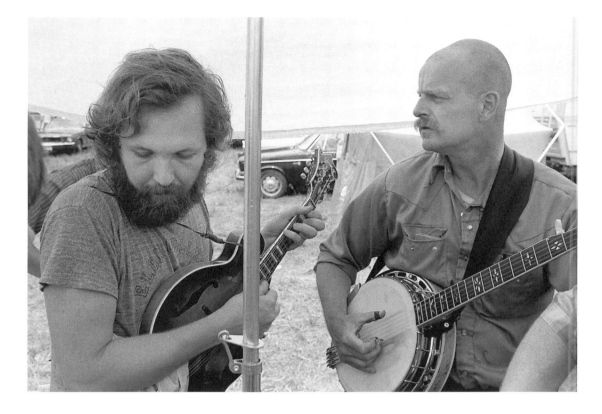

Indian Springs, Maryland, May 31, 1975. Dick Kimmel and Hub Nitchie at the *Bluegrass Unlimited* Festival. Kimmel, then resident in Morgantown, West Virginia, is a performer and record reviewer still active in the affairs of the International Bluegrass Music Association; he also works as a wildlife biologist. Nitchie published and edited the Annapolis-based *Banjo Newsletter.* Since his death in 1992 his wife and son have continued the publication.

Bean Blossom, Indiana, June 1970. Jim Rooney at the Sunday morning gospel sing at Bill Monroe's annual festival. At the time Rooney was completing work on his book *Bossmen;* in later years he worked as a record producer in Nashville, Tennessee.

Murfreesboro, Tennessee, October 1975. Charles Wolfe, in his office in the English department at Middle Tennessee State University, is a prolific writer on bluegrass, old-time, and country music.

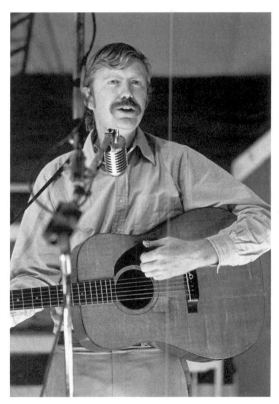

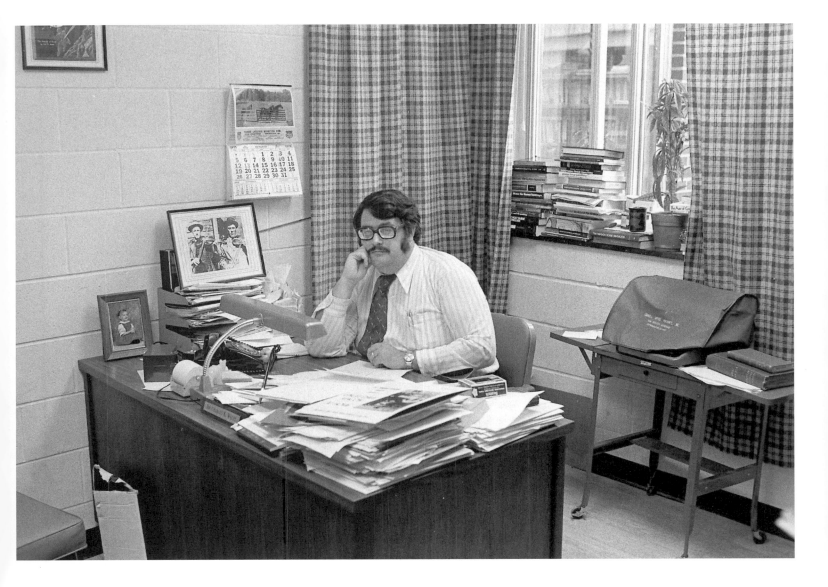

Left, top: Indian Springs, Maryland, June 2, 1973. Walt Saunders at the *Bluegrass Unlimited* Festival. A retired fireman, Saunders was a keen follower of bluegrass long before 1985, the year he began his monthly "Notes and Queries" column in *Bluegrass Unlimited.*

Above: McClure, Virginia, May 24, 1972. Norm Carlson at the Carter Stanley Memorial Festival. As a student at Purdue University in the mid-1960s, Carlson wrote for *Bluegrass Unlimited* and was a mainstay of the Stanley Brothers (later Ralph Stanley) Fan Club. He retired from active involvement in bluegrass in the mid-1970s.

Left, bottom: McClure, Virginia, May 24, 1972. Bill Vernon at the Carter Stanley Memorial Festival. Vernon authored liner notes for bluegrass recordings from the early 1960s, served as record review editor for *Muleskinner News* from 1970 to 1976, and was for many years a popular bluegrass disc jockey in Rocky Mount, Virginia.

Above: McArthur, Ohio, December 1979. Ivan Tribe, seen here at home, has written extensively about the bluegrass and old-time country radio and recording stars he listened to as a youth in southern Ohio.

Right: Silver Spring, Md., November 1975. Dick Spottswood, seen here at home, was the first review editor for *Bluegrass Unlimited.* A record collector and former record company owner, he is best known today as a discographer of ethnic recordings and one of the D.C. area's most distinctive disc jockeys.

Washington, D.C., March 27, 1977. Gary Henderson doing his "Stained Glass Bluegrass" show, broadcast from the WAMU-FM studio at American University on Sunday mornings. Songs from old 45- and 78-rpm phonograph records were often played from Henderson's personal tape copies; the list propped up on the control panel inventories one such tape. The radio voice for bluegrass in Washington during the 1970s, Henderson contributed much to the popularity of the music in the national capital region.

Washington, D.C., July 1972. Ralph Rinzler at his desk at the Smithsonian Institution's Office of Folklife Programs.

Rinzler shaped the nation's understanding of bluegrass music through his skills in communication, introducing Bill Monroe and others to urban audiences in the 1960s and using the vehicle of the festival, first at Newport and later at the Smithsonian, as a forum for performances of music and other representations of traditional culture.

Nashville, Tennessee, October 1975, and West Finley, Pennsylvania, June 9, 1970. Two trios, simulated and live: a diorama representing three of the "original" Blue Grass Boys of 1945–48—Lester Flatt, Bill Monroe, and Earl Scruggs—at the Country Music Wax Museum near the Ryman Auditorium, then home for the Grand Ole Opry. Brothers Bobby and Sonny Osborne and band member Dale Sledd sing a trio at the Fifth Annual Pennsylvania Bluegrass Festival.

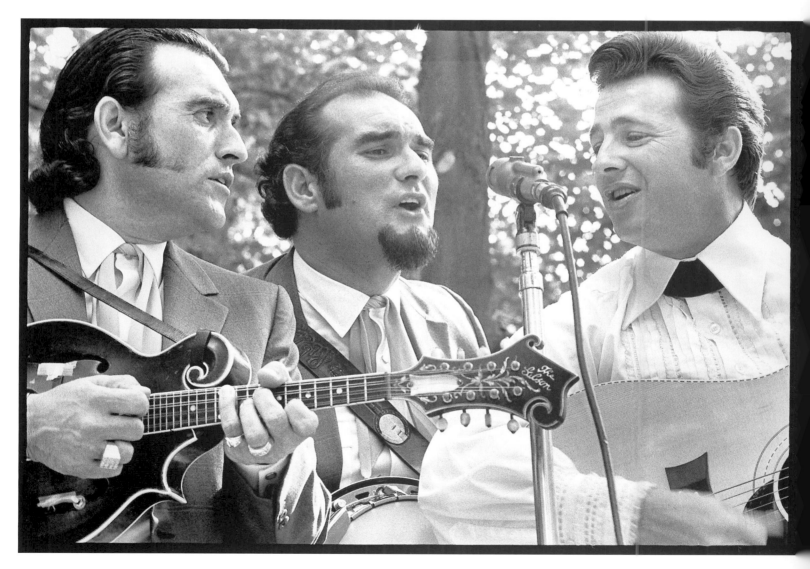

Community

In 1975 Carl photographed a trio of mannequins in a Nashville, Tennessee, museum. Meant to represent the three most influential people in bluegrass, they seem both odd and amusing—clearly, something is missing. Flawed not only by physical inaccuracies in faces or instruments, the tableau fails to communicate the *personal* interaction that is at the center of bluegrass music making.

This interaction—or at least its surface aspects—immediately struck us when we began to discover bluegrass scenes in taverns, clubs, festivals, and jams. Music that was new to us seemed to be created even as we listened. But first impressions can be misleading. Some of the most important interactions in musical performance are not apparent. Even in jam sessions musicians don't invent the whole thing. Their negotiations are not about totalities but concern details. What was hidden to us at first was the social and historical depth of this musical genre. Firmly established, it served as a framework and shared goal for each performance. Beyond the creative spark associated with new details or spontaneously invented motifs in the performance lies the felt reality of community. Shared values and a sense of connection with the past—of tradition—is an essential part of every bluegrass scene. Equally essential

is a shared sense of the rules of the music and its culture and about how the immediate future, including the tune at hand, ought to be shaped.

The vocal trio, a key form in bluegrass, is a metaphor for the sense of community that the music projects. The harmonies and textures in trios, whether impromptu or polished over decades, must be "tight." Every phrase or word should be a three-note chord, and there shouldn't be any unplanned tonal unisons or overlapping musical phrases. Accomplishing this calls for careful coordination and skill in execution. From its beginnings bluegrass was imagined and realized by rural people steeped in the harmonies of old-fashioned church hymnody. But many of its early proponents also had moved to urban locations to work in factories and offices—places where close coordination and cooperation were necessary.

Trio singing draws on the pleasures of past associations and the challenge of present skills. From the Holy Trinity to the three notes that compose a basic chord in our musical systems, the number three permeates Western culture, prompting us from an early age to become accustomed to its company. So it's not coincidental that many of Carl's photographs of the bluegrass community have focused on triads, from representatives of different generations offstage at a festival or jamming at a party to classic trios in action. Turning away from the stages at festivals, Carl encountered shop-talking leaders from different sectors of the contemporary business, reminiscing old-timers who had dominated the music's early years, visiting fans in the homey privacy of the bus, impromptu workers helping a stranded motorist—all in trios.

Vocal duets also have their symbolic dimension. Hillbilly brother duets of the 1930s and 1940s, such as the Monroe Brothers and the Blue Sky Boys, shaped the sound of popular early bluegrass duos, including the Lilly Brothers and Jim and Jesse, who flourished beginning in the 1950s. A favorite form in early country music, the brother duet had a certain mystique because the natural timbre of sibling voices often seemed to blend particularly well; because of this some nonsibling duos took stage names that suggested they were brothers. But even when the vocal textures blend, duet parts can become countermelodies, echoing the tensions that strain fraternal bonds. In her autobiography, Minnie Pearl recalls "a wonderful story going around the Opry . . . about Bill and his brother [Charlie]" in the early 1940s. "They said if Bill had to travel east to get to a booking, he would go out of his way to go by his brother's house in Kentucky and get him out of bed in the middle of the night just so they could have a fight. Rumor had it that Bill loved to fight and could handle himself well if the going got rough."[1]

West Finley, Pennsylvania, June 8, 1970. Six years after their split, Don Reno and Red Smiley recreate a duet from the period when the pair led the Tennessee Cut-Ups.

Duets showcase a range of relationships; they can even be antiphonal, like ritual fights. After he left his brother to start his own band, Bill Monroe tended to treat his lead singers (who, like Charlie, played rhythm guitar) like brothers. After Lester Flatt and Earl Scruggs left the Blue Grass Boys in 1948, their relations with Monroe were at first congenial. But after they returned to Nashville in the early 1950s as a competing act on the Grand Ole Opry, Monroe didn't speak with either man for almost two decades. Eventually, following the split of Flatt and Scruggs, separate rapprochements took place. Instead of fighting, Monroe and Flatt now sang, even danced, together.

Duets and trios are familial units of discourse and interaction that lie at the core of the bluegrass community, much as the family lies at the core of the small town. Festivals are manifestations of the larger community. Emerging and prospering in the 1960s and 1970s, festivals developed their own structures and conventions. They became temporary small towns sharing a number of characteristics that we still see today. The formal center is the stage area. At its sides and back musicians mingle before and after performing. In front the audience sits on the ground, in their own chairs, or, at some sites, on rough benches. To the sides and back of the audience area are the concession stands, where food, recordings, instruments, and souvenirs can be purchased. Fans can meet performers around the concession stands or backstage, seeking autographs or communicating requests. For the entire community the stage and audience area is a downtown of sorts, bustling with activity during business hours.

During the many hours when music is performed onstage, both the musicians and the audience members move back and forth between "downtown" and what is commonly called the parking lot or the campground. These are the "suburbs," where parked vehicles and tents form campsite homes as groups of friends, relatives, and bands cluster together to create neighborhoods. Friends and strangers from other neighborhoods visit, share meals, and make music together. At bigger festivals there are multiple "suburbs." I attended a festival in 1998 where the campers shuttled between the "suburbs" and "downtown" on golf carts and all-terrain vehicles. Sometimes there are special areas for the performers. Groups of faithful attendees claim the same adjacent sites year after year—some have acquired nicknames, like "Woo-ville" at the Festival of the Bluegrass in Lexington, Kentucky, which gives them a degree of permanence.

Like all celebratory gatherings, bluegrass festivals are liminal sites— places at the edge of the everyday world in which community becomes,

in the words of the anthropologist Victor Turner, *communitas.* Onstage the music's past is reenacted as it is performed, making concert into ritual. The campsites also have their symbolic and ritualistic aspects. Here the "backyard" or "patio" is open to view rather than hidden, generally in front of or beside the vehicle or tent, which permits passersby to take pictures or stop for a visit. The friendships that characterize these offstage gathering places are marked by shared music, talk, drink, and food. In such settings even the chore of cooking supper, lightened by music, becomes a ritual to be observed and enjoyed by old and new friends alike. Annual festivals become rites of passage, much like birthdays. The liminal festival context encourages overindulgence—not just a surfeit of food but also roaming drunks, all-night jam sessions, fights, and other unpoliced exuberance that adds an element of risk and excitement to the experience.

Depending on the context, when groups of bluegrass musicians gather they form circles or lines. Backstage and in jam sessions the circle is preferred, since inward-facing musicians can hear each other better and quickly catch visual cues to coordinate their music. Jam sessions in particular can be read as intense, playful, fluid social gatherings, like meals or fights. In more formal, onstage performance settings the musicians line up and face the audience across the proscenium, which improves the audience's ability to hear the instruments and voices. But such an arrangement makes it more difficult for the musicians to hear each other and forces them to depend more on their own expectations and experience—how they're supposed to sound, where the parts fit. Onstage performances are more like scripted theater and less like informal play.

When musicians gather before the show to warm up or to plan the concert, circles are common. Lines may be transformed into circles or even surrounded by them when shared experience or identity bridges the dividing line between stage and audience, affirming friendships among those onstage and those offstage or mutual interests among inner and outer circles backstage. Jam session circles can grow into large, dense crowds at festival parking lot sessions, particularly when well-known musicians are involved. Some of the most exciting sessions bring together people of different ages, some of whom know each other and others of whom are meeting for the first time. Like lively dinner parties, they feature witty and engaging musical conversation.

Note

1. Minnie Pearl with Joan Dew, *Minnie Pearl: An Autobiography* (New York: Simon & Schuster, 1980; Pocket Book, 1982), 171–72.

Oakland, California, December 20, 1980. Jack Liederman plays backup fiddle as Laurie Lewis, Mayne Smith, and Beth Weil concentrate on a trio during a jam session at Smith's home. An author, editor, and musician, Smith defined bluegrass music for an academic audience in his 1965 article "An Introduction to Bluegrass" (*Journal of American Folklore* 78:245–56). Lewis and Weil were members of the original Grant Street String Band based in Berkeley.

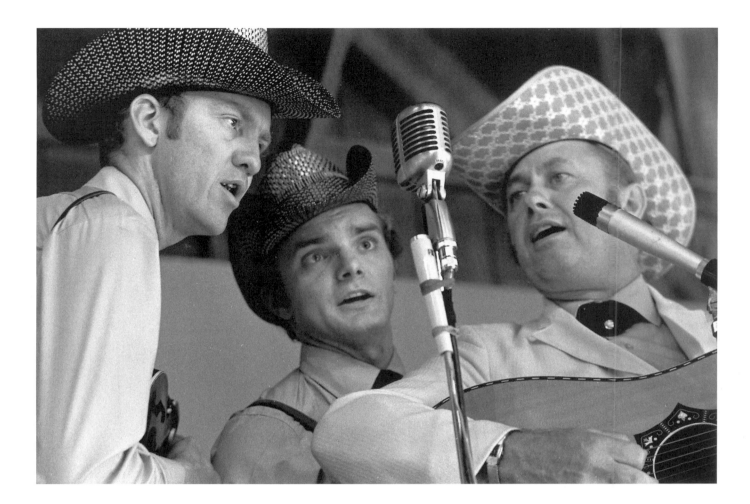

Logan, Ohio, 1969. Doyle Lawson, Chris Warner, and Jimmy Martin sing a trio at a show at a small country music park.

Bean Blossom, Indiana, June 1970. Alice Gerrard and Hazel Dickens help Bill Monroe install a new set of cufflinks he had just been given by his sister Bertha Monroe Kurth at the annual Bean Blossom festival. Gerrard and Dickens were members of an extended group of Monroe devotees from the world of folk music. During the 1960s they broke new ground in the world of bluegrass by creating the first bluegrass band led by women.

Rosine, Kentucky, September 14, 1973. Larry Sparks greets visitors on his bus at the Monroe Homecoming and Bluegrass Festival. At festivals, performers' buses are treated like private homes: strangers gather at the door; friends are invited in; family members move in and out as they please.

Jackson, Kentucky, August 13, 1972. Following a rainy Saturday night at Bill Monroe's Kentucky Blue Grass Festival, Carl noticed Monroe and another man trying to help a local authority get his car out of the mud. After taking this picture Carl went over to help out. Several attempts were made to move the car, but in the end Monroe commented that the driver didn't know how to drive in mud and left the vehicle where it was.

Culpeper, Virginia, June 10, 1972. Dick Freeland, John Duffey, and Carlton Haney at Jim Clark's Culpeper Blue Grass Folk Music Festival. When this photograph was taken Freeland was the head of Rebel Records, Duffey was a member of the Seldom Scene (which recorded for Rebel), and Haney was a promoter of musical events (including one at Culpeper), visiting another promoter's festival on a busman's holiday.

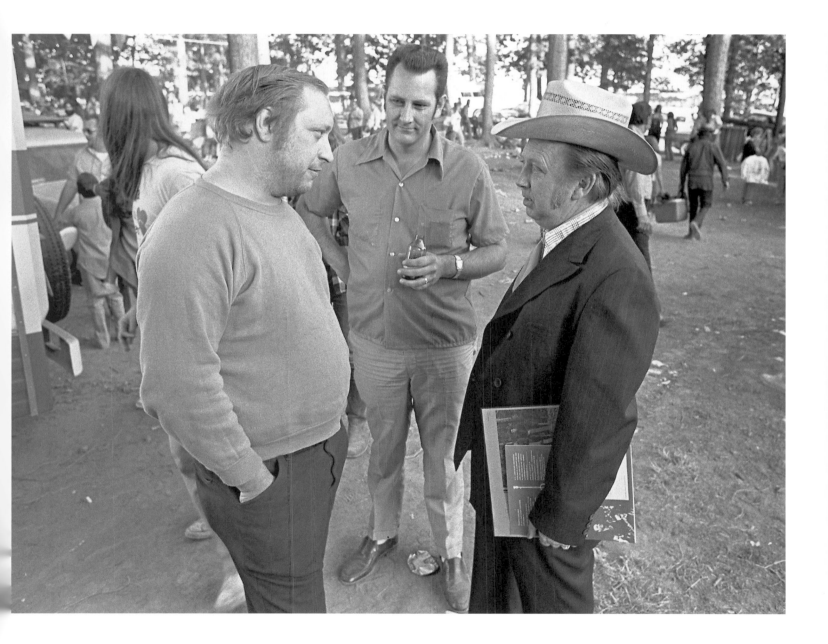

Alexandria, Virginia, December 4, 1981. Peter Rowan and Bill Monroe backstage at the Birchmere Music Hall, where former Blue Grass Boy Rowan was opening for Monroe. In recent years Rowan has incorporated Monroe's patriarchal comments to him in his songs and album notes, such as, "Pete, don't go too far out on that limb, there are enough flowers out there already!" (from Sugar Hill SHCD 3859, *Peter Rowan: Bluegrass Boy*).

Philadelphia, Pennsylvania, October 1976. Ralph Rinzler and John Herald jam at an after-hours session in the Hotel Benjamin Franklin during the annual meeting of the American Folklore Society. In the late 1950s and early 1960s Rinzler and Herald were partners in New York's Greenbriar Boys, the first bluegrass band from the folk revival to achieve national prominence. At the time this photo was taken, Rinzler was directing the Smithsonian's Festival of American Folklife, while Herald continued to play bluegrass.

Jackson, Kentucky, August 13, 1972. Bill Monroe and Lester Flatt dance during a massed-band festival finale at Monroe's Second Annual Kentucky Blue Grass Festival. The other performers on stage include Curly Ray Cline, Bill Harrell, Buck Ryan, Kenny Baker, Paul Warren, Don Reno, Jim McReynolds, James Monroe, and Melvin Goins. When Monroe and Flatt danced together in the 1970s it symbolized the end of more than two decades of bad feelings that began when Flatt and his bandmate Earl Scruggs, who had quit Monroe's band in 1948 to found the Foggy Mountain Boys, returned to radio station WSM and the Grand Ole Opry in the early 1950s.

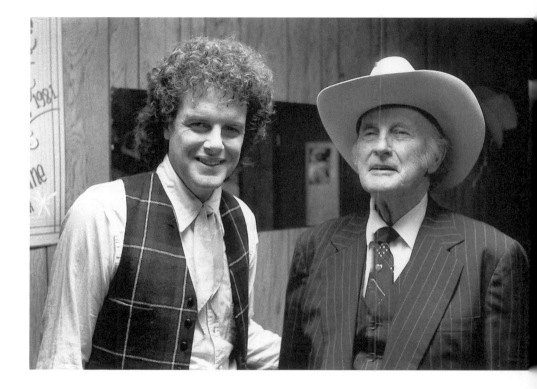

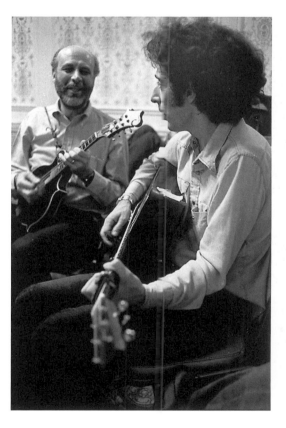

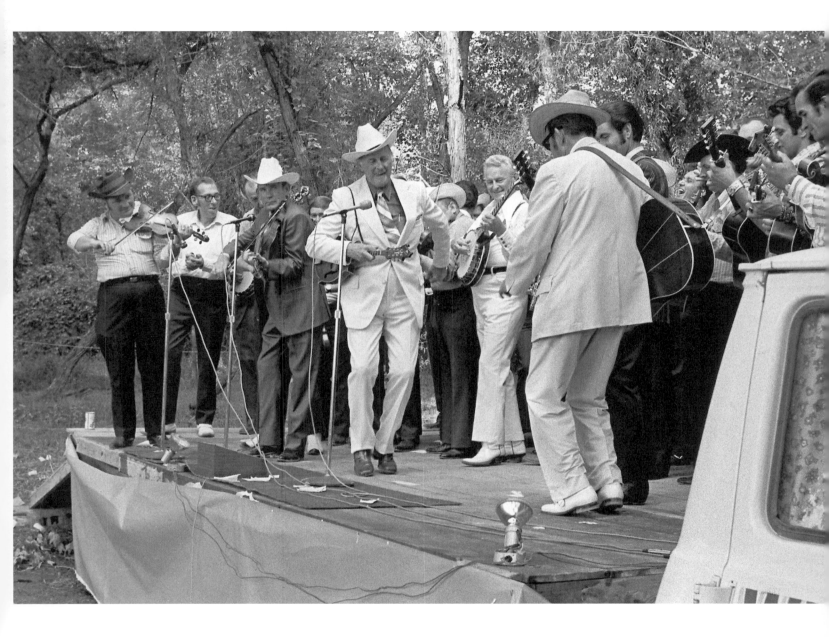

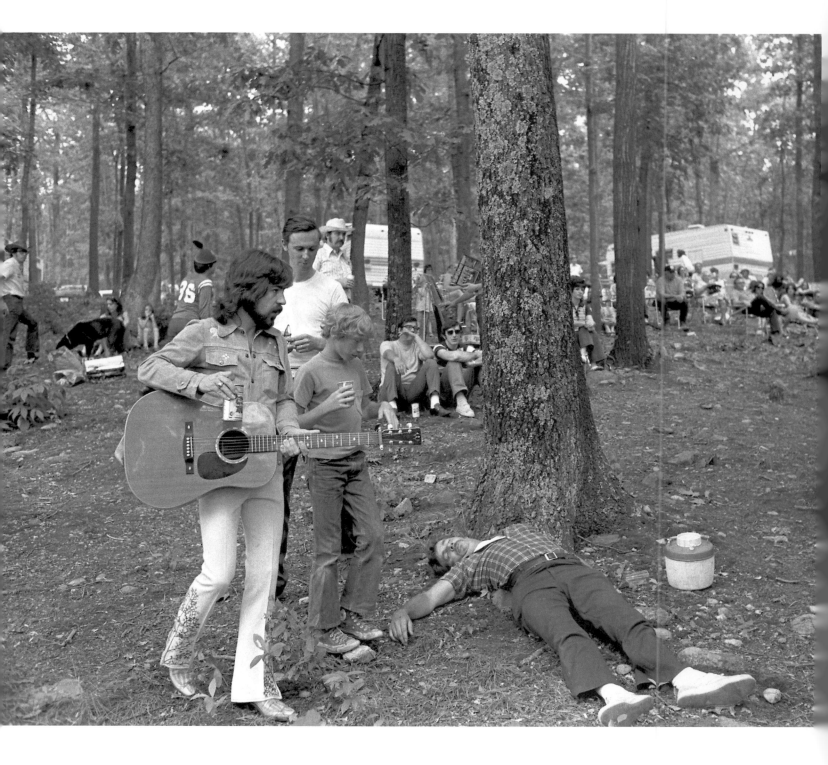

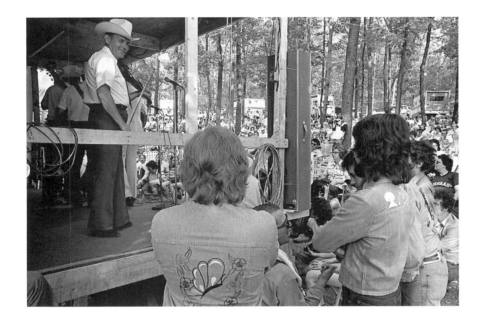

Indian Springs, Maryland, June 2, 1973. Clarence White strolling with Lamar Grier and Lamar's twelve-year-old son David at the *Bluegrass Unlimited* Festival. White pioneered the style of bluegrass lead guitar most often heard today, was killed in an accident a few weeks after this event. David Grier won many awards in the 1990s for his lead guitar playing and has cited his time with Clarence in 1973 as influential in his development.

Indian Springs, Maryland, June 2, 1973. Between numbers at the *Bluegrass Unlimited* Festival Bill Monroe's fiddler Kenny Baker grins at fellow musicians Eric, Clarence, and Roland White, sharing an identity that breaks the onstage/offstage demarcation. Baker got acquainted with the White brothers in 1963 when the Blue Grass Boys played the Ash Grove, a coffeehouse in Los Angeles and home base for the Kentucky Colonels, a band founded by the Whites.

Culpeper, Virginia, June 10, 1972. A group of insiders and old-timers from the Washington, D.C., area bluegrass scene in the performer's backstage parking area at the Blue Grass Folk Music Festival. Nancy Duffey is on the tailgate; her husband, John, sits in the lawn chair to her left. Eddie Adcock and photographer Ed Huffman sit and kneel between the couple; standing at the right are Pete and Marion Kuykendall.

McClure, Virginia, May 24, 1972. In a scene reminiscent of a hunting or fishing camp, a moccasin-clad man grills hot dogs and hamburgers in the parking lot of the Carter Stanley Memorial Festival while behind him the jam goes on.

Merrimac, West Virginia, June 14, 1975. Melvin Goins (seated at the back), his wife, Willa (to his left), and other couples at a family picnic at the Fireman's Bluegrass Festival, about a hundred miles from the Goinses' home in Bramwell, West Virginia.

Reynoldsburg, Ohio, June 24, 1972. Kenny Baker, fiddler with the Blue Grass Boys through the festival glory days of the 1970s, and fellow band member Joe Stuart play a few tunes for a U.S. Army sergeant at the annual Frontier Ranch festival. The sergeant earned the impromptu concert by bringing a cake to celebrate Baker's forty-sixth birthday, two days hence.

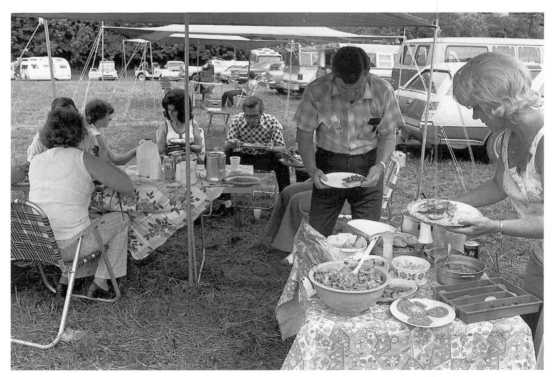

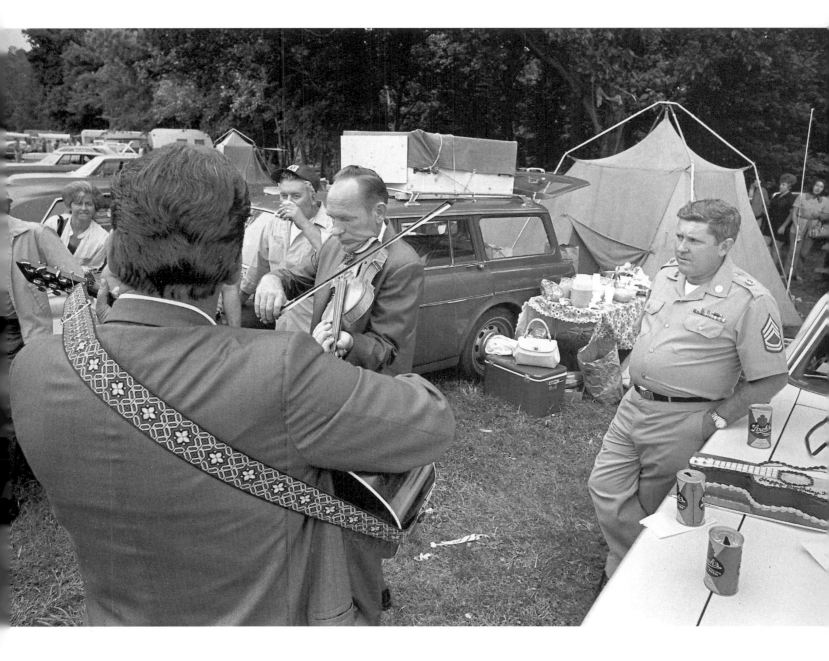

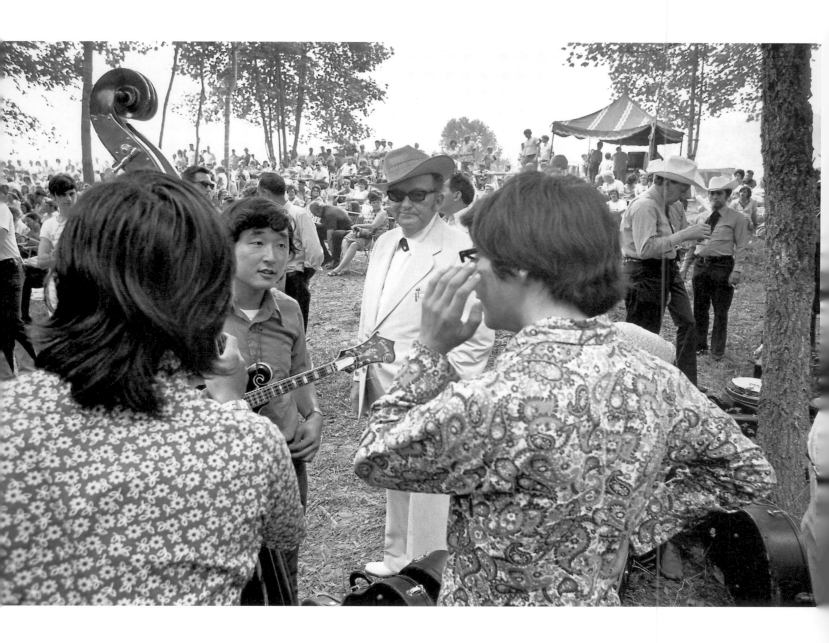

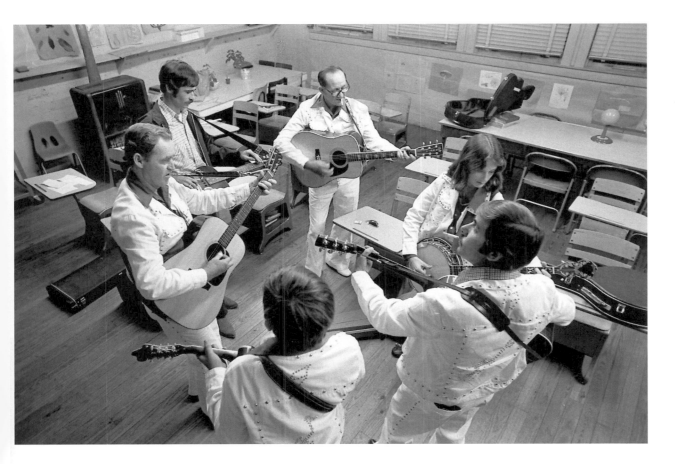

Jackson, Kentucky, August 12–13, 1972. Lester Flatt joins the rehearsal circle of It's a Crying Time near the stage of Bill Monroe's Second Annual Kentucky Blue Grass Festival. It's a Crying Time was only the second Japanese band to appear at American festivals.

French Camp, Mississippi, October 1975. The Magnolia Bluegrass Boys, including banjoist Vickie Cook, form a circle as they warm up before performing at a fund-raiser at a local private school. The band consisted of members of the Cook and Sanders families from Eupora and Philadelphia, Mississippi.

Nashville, Tennessee, October 15, 1975. Like a coach giving a pep talk before the big game, Bill Monroe huddles with his players—Carl Story, Carl Tipton, Margie Sullivan, Betty Fisher, Raymond K. McLain, and son James—before the curtain rises on the Early Bird Bluegrass Concert at the Grand Ole Opry. Bluegrass festivals came late to Nashville; this festival-like event was part of the annual Opry birthday celebration during the 1970s.

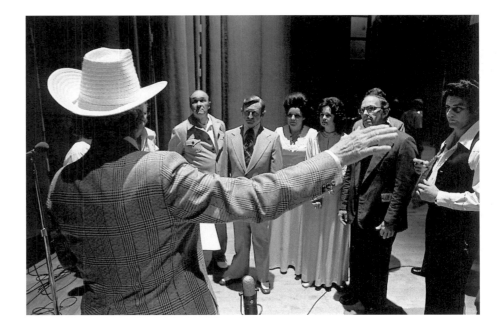

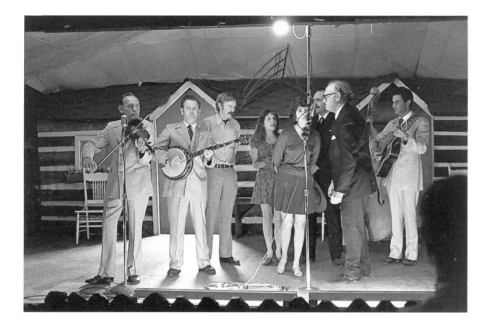

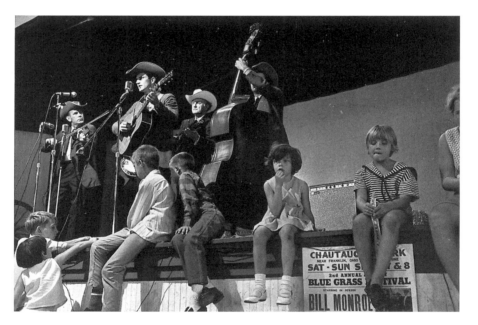

Top: Bean Blossom, Indiana, June 1970. Bill Monroe, with Blue Grass Boys Kenny Baker and Rual Yarbrough, is joined by friends Jim Rooney, Alice Gerrard, Hazel Dickens, Tex Logan, Skip Payne, and son James for a Sunday morning gospel sing at the annual Bean Blossom festival.

Bottom: Franklin, Ohio, September 8, 1968. Bill Monroe and the Blue Grass Boys at the Chautauqua Park Bluegrass Festival. Bill's son James was the bass player but traded instruments with guitarist Roland White for this tune; other band members included Kenny Baker and Vic Jordan (hidden).

Opposite: Merrimac, West Virginia, June 14, 1975. Bill Monroe and his Blue Grass Boys—Randy Davis, Ralph Lewis, Monroe, Bob Black, and Kenny Baker—onstage at the Fireman's Bluegrass Festival.

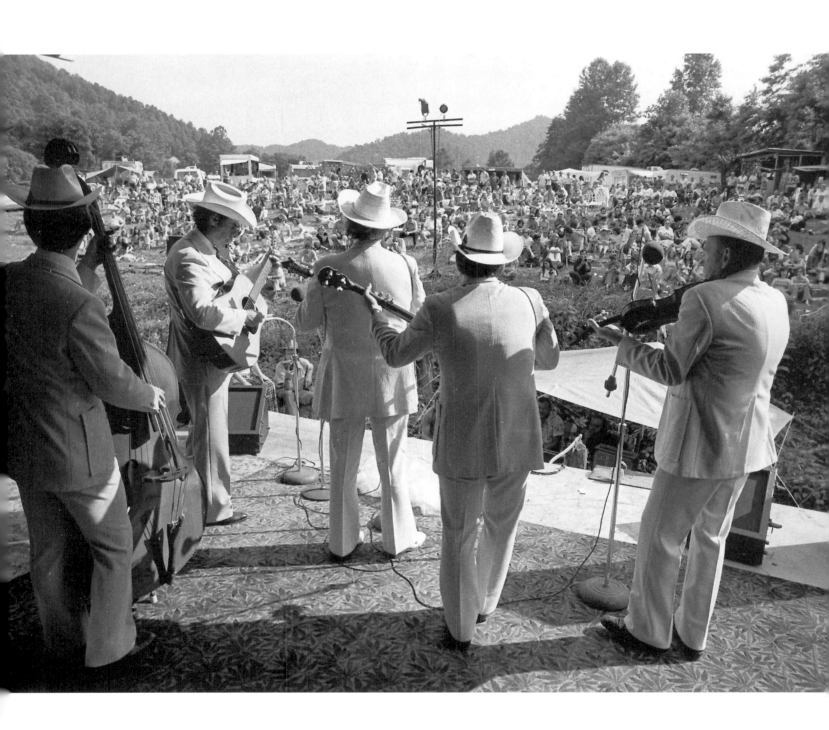

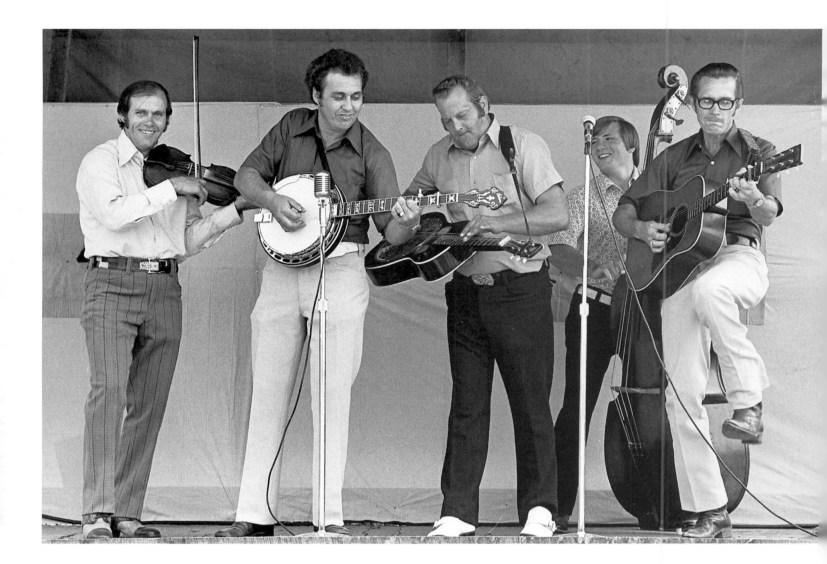

Rosine, Kentucky, September 14, 1973. The Goins Brothers—Joe Meadows, Ray Goins, Harley Gabbard, George Portz, and Melvin Goins—at the Monroe Homecoming and Bluegrass Festival. Abetting the flow of the music, Melvin Goins stomps his foot to punctuate brother Ray's banjo solo; rhythm and lead meld together as Gabbard concentrates on supporting the banjo with his Dobro.

Marlinton, West Virginia, December 1970. The Black Mountain Bluegrass Boys jamming in the bay of a service station, facing a small group of fans outside the photograph's frame. The band's regular members included Bill Hefner, Harley Carpenter, and Richard Hefner. Glen "Dude" Irvine (seated), who had contracted polio at age five, taught music to his nephews Bill and Richard Hefner when they were young and occasionally performed with the band between 1968 and the mid-1970s.

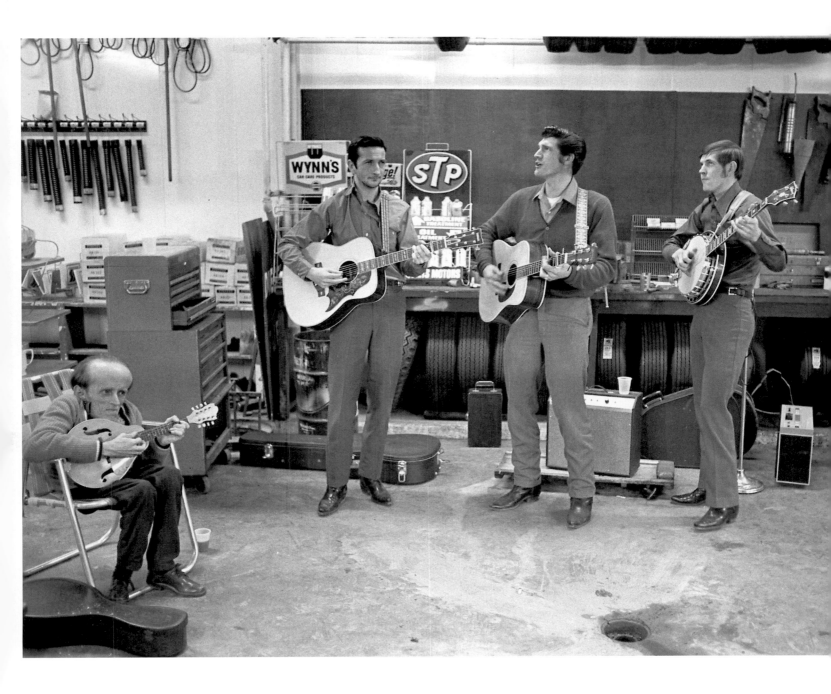

Columbus, Ohio, June 1970. Friends from central Ohio's bluegrass and folk music community: top row: musicians Mike Fletcher and John Hutchison, instrument builder Ron Chacey and his wife, school administrator Windsor Chacey; second row: musician Sandy Rothman; third row: musician Jerry Middaugh and husband-and-wife folk music store proprietors Carol and Roger Johnson; bottom row: Phyllis "Peaches" Malmaud and her boyfriend, musician Jack May, along with fellow musician Stuart "Stoo" Peck.

Columbus, Ohio, December 1971. Landon Rowe at home with his Martin D-45, a custom left-handed version of the fanciest guitar Martin made. Rowe was for many years a regular performer in various Columbus, Ohio, bands. During the day he worked at Porcelain Steel, a subsidiary of the White Castle System and the manufacturer of the exterior sheathing used in the chain's distinctive fast-food restaurants.

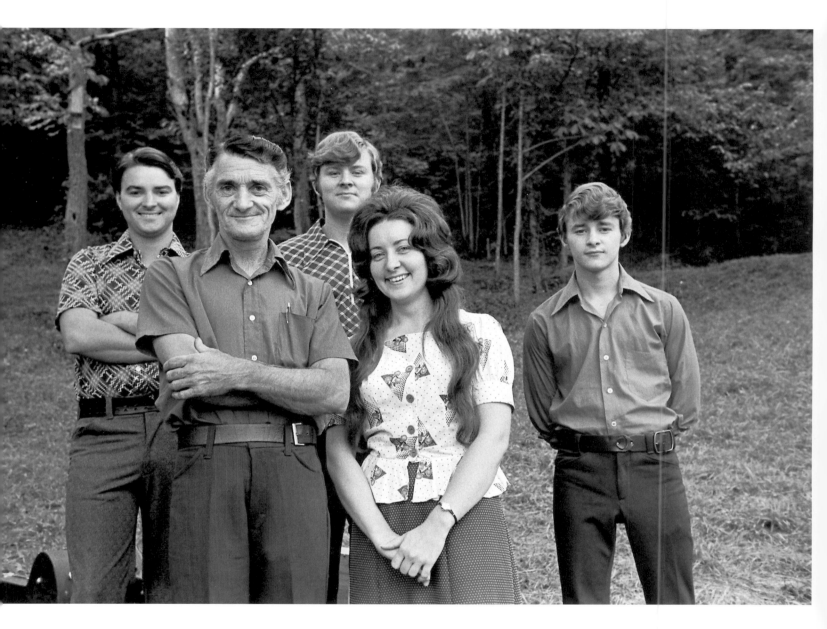

Stumptown, West Virginia, August 8, 1974. The Marshall Family—David, "Pop," Ben, Judy, and Danny—shortly before their performance at Bill Monroe and Ralph Stanley's First Annual Old-Time West Virginia Bluegrass Festival at Aunt Minnie's Farm.

Family

During bluegrass's formative years, the postwar decade, the country music of which it was a part focused mainly on individual stars, with brother duets being the only widespread exception. The bluegrass of the 1940s included bands with names that highlighted sibling connections: the Stanley Brothers, the Sauceman Brothers, and the Murphy Brothers were among the very first to embrace the sound of Bill Monroe's postwar band. But the family links in a few other early bands were not publicized. People who bought the RCA Victor recordings of the Lonesome Pine Fiddlers in the early fifties couldn't learn from the band name that leader Ezra Cline worked at various times with his nephews Curly Ray and Charlie.

In the 1950s, as the term "bluegrass" became familiar to consumers and marketers and the music itself began to drift away from the country music mainstream, bluegrass bands with "family" in their names started to gain prominence. When Starday, the feisty new Nashville independent record label, began pushing bluegrass in the late 1950s, the all-gospel recordings of the Lewis Family were among its best sellers. In the early 1960s Starday added the Stoneman Family to its roster. Ernest V. Stoneman, a native of Galax, Virginia, was one of the most prolific of

the pioneer hillbilly recording artists of the 1920s. Back then his wife, Hattie, along with several other relatives worked with him. Ernest and Hattie continued to perform when they moved to the Washington, D.C.–Baltimore area after his recording career ended. By the early 1950s many of their twenty-three children had played music in public with them at one time or another. In the mid-1950s the Bluegrass Champs, a band formed by Stoneman children, won first prize on the "Arthur Godfrey Talent Scouts" TV show. In the early 1960s they incorporated their father, now billed as "Pop" Stoneman, into the act. Their Starday records were the first to use the Stoneman Family name. "Pop" worked with them until his death in 1968.

By the 1970s family bands were more prominent in bluegrass than ever before. Festival venues were a lot more conducive to family participation than the bars or the jamboree and show circuits, where earlier bands had begun their careers. Held at wholesome rural sites on weekends, they could be experienced as camping trips with plenty of time and space for family socializing and much of the music making taking place during daylight hours. Special festival events offered encouraging new opportunities for public performance to entry-level family groups, particularly in band contests and at Sunday morning all-gospel shows. Many family groups followed the lead of the Lewis Family by specializing in religious songs. To the new fans introduced to bluegrass at these festivals, many of whom were in attendance with their own families, there was something appealing about the way a family looked onstage. Physical resemblances were noticed—not only smiles but subtle lines of eye and hair and arm and stance—as were vocal resemblances when family members sang together—shared accents, timbres, and singing styles that facilitated the blending of voices in harmony.

Whatever we may really be seeing or hearing, bluegrass ideology encourages us to think of the family as playing a central role in the music. The pantheon of bluegrass, harking back to hillbilly music ancestors, is filled with families. A prominent gesture in this direction was Flatt and Scruggs's best-selling 1961 tribute album to the Carter Family. For many listeners it linked bluegrass with a popular act that had lasted from 1927 to 1943, newly discovered on reissue albums by young folk music enthusiasts. Flatt and Scruggs helped to enshrine the family as a symbolic unit in early country music.

The bluegrass repertoire is also filled with lyrics that convey the idea of family, with references to mother, dad, home, brother, sister, uncle, wife, and babies. Many lyrics celebrate the ideal of the family together or recall separation and loss of family members. Well-known instrumen-

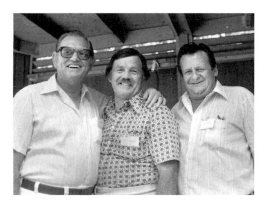

Vienna, Virginia, July 29, 1978. Brothers Carl and J. P. Sauceman and band member Joe Stuart just before a performance of the Green Valley Boys at the National Folk Festival in Wolf Trap Farm Park.

tals make similar allusions in their titles—such as Earl Scruggs's "Randy Lynn Rag," named in honor of a child, or Bill Monroe's "Jerusalem Ridge," referring to a favorite fox-hunting site near his childhood home.

The family unit is a potent symbol in American culture and politics, where elections can be won or lost over issues of "family values." To most people the image that springs to mind when "family" is mentioned is the nuclear family—mom, pop, and the kids. Contemporary Western cultures venerate the energy and promise of youth rather than the experience of elders, and family bands can be seen as forums that promote this process by placing the children in the foreground. Because family members tend to spend more time together than most groups of unrelated people, the family band has many opportunities to practice and blend well. The Stoneman children got a head start on their careers by working from a very early age with their father at clubs and dances, long before festivals provided family bands with a more congenial setting.

Musicians who spend most of their time on the road, such as Ralph Stanley, seek to live the ideal of family togetherness. But the reality is that family bands rarely last long. After his brother Carter—his musical partner— died, Ralph Stanley built a new music on their old one by seeking lead singers who could duplicate Carter's vocal textures. At the same time he also began a family of his own. Today his son, Ralph Stanley II—known to insiders as "Two"—helps front his band. For most performers the bonds of family are at the very least a source of pride and strength. But they can be much more than that. In 1969, when Earl Scruggs left Lester Flatt, his partner of more than two decades, there was much speculation about the cause of their breakup. But Scruggs, looking to his past *and* his future, spoke positively of his reasons for forming a band with his sons. He told his own story: childhood memories of a father who died young; the sadness of growing up without a father. He mentioned more than once that when he was working with Flatt, Lester was "like a brother to me." Now he stressed the intense pleasure felt in working with his own boys.

Family music scenes typically mix levels of skill, taste, ability, and dedication; and as with the families themselves, they're constantly evolving and subdividing. So the family band is often a stage in the lives of family members, a kind of rite of passage. As children grow to adulthood in family bands, some go farther than others in the business. Newly prominent family bands have helped open the way for young women to become bluegrass musicians. Pioneers in this respect were mandolinist Donna and banjoist Roni of the Stoneman Family, the first women to gain recognition in bluegrass as specialists on their instru-

ments. Along with their fiddling brother Scott, they emerged as the "stars" among a large group of siblings. For eleven years the McLain Family ran a bluegrass festival at their farm in Berea, Kentucky, that featured exclusively family bands. The family band—called the McLain Family and consisting of father, sons, and daughters—disbanded after several of the children married and the parents' marriage ended. In 1997–98, two McLain sons who had been in the family band and went on to work in nationally known bands fronted their own family band.

The quality of music performed by the family bands has sometimes been great—especially in the case of the brother acts—but more often only good. It's hard not to see the appeal of these groups, particularly parent-child aggregations, as strengthened by their symbolic weight, perhaps intensified in a time when religious leaders and the popular press decry the disintegration of the family unit. Likewise, imagining the open-air, rural setting of a festival, it's easy to embrace the family values perceived in the images of these bands and their song lyrics, with the promise of security and repose, the old family home, and the beginnings of life.

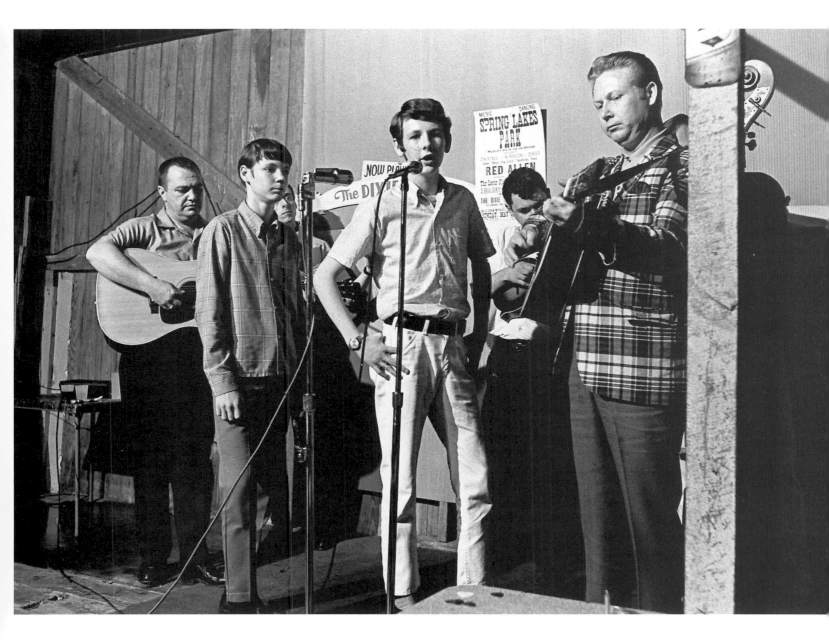

Columbus, Ohio, May or June 1968. Red Allen (right) with his sons Greg (at the microphone) and Harley (to Greg's right) at Spring Lakes Park, accompanied by (left to right, behind the Allens) Sid Campbell, John Hickman, Bob White, and Ray Wills (hidden behind Red Allen). A third son, Neal, was also present at the concert. Within two or three years the Allen brothers formed a band that weathered Neal's death in 1972 but splintered in the mid-1980s when Harley embarked on a solo career.

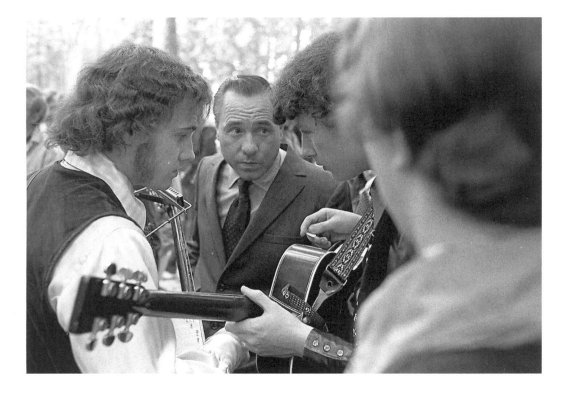

Bean Blossom, Indiana, June 1970. The Earl Scruggs Revue—Earl and sons Gary, Randy, and Steve (with his back to the camera)—at Bill Monroe's annual Bean Blossom festival. This photograph was taken just before the newly formed group mounted the stage for one of its first public performances. Carl remembers that the audience's anticipation was matched by the band's pre-performance nervousness.

Rosine, Kentucky, September 14, 1973. Ralph Stanley, his wife, Jimmie, and their daughters Tonya and Lisa at the record and souvenir sales table next to their camper at the Monroe Homecoming and Bluegrass Festival.

McClure, Virginia, May 25, 1972. The Lewis Family at the Carter Stanley Memorial Festival: Roy "Pop" Lewis, daughters Miggie, Janice, and Polly, and sons "Little" Roy, Talmadge, and Wallace. Since the late 1950s the Lewis Family of Lincolnton, Georgia, have proudly carried the sobriquet "The First Family of Bluegrass Gospel Music." They took religious song, which had previously occupied a niche in bluegrass repertoire, and made it their entire focus.

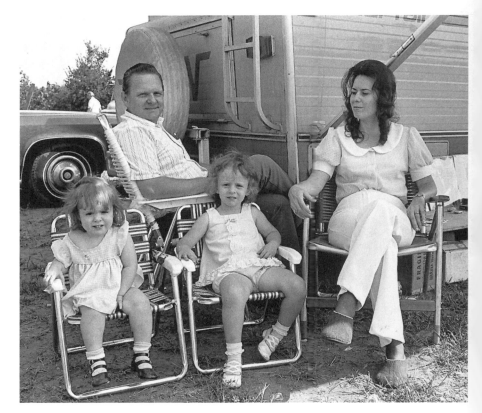

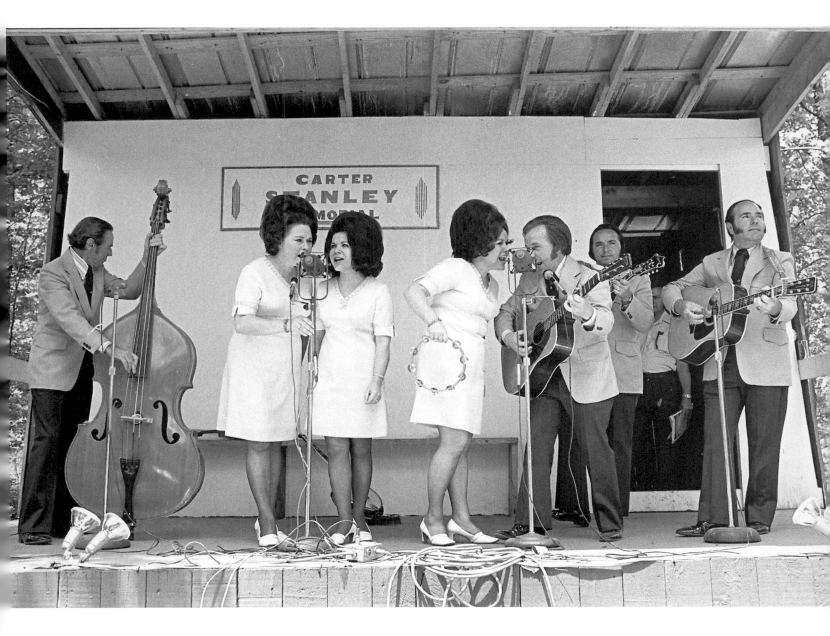

Bean Blossom, Indiana, June 1970. Jim *(top)* and Jesse McReynolds at Bill Monroe's annual Bean Blossom festival.

Rosine, Kentucky, September 15 or 16, 1973. The McLain Family—daughters Alice and Ruth, son Raymond W., and Raymond K.—at the Monroe Homecoming and Bluegrass Festival. With a folklorist grandmother and a college president grandfather, the McLains represented a venerable southern intellectual tradition not often found in the bluegrass bands of the era. McLain was teaching at Berea College when the group was "discovered" by composer Gian Carlo Menotti, who brought them to his Festival of Two Worlds in Spoleto, Italy.

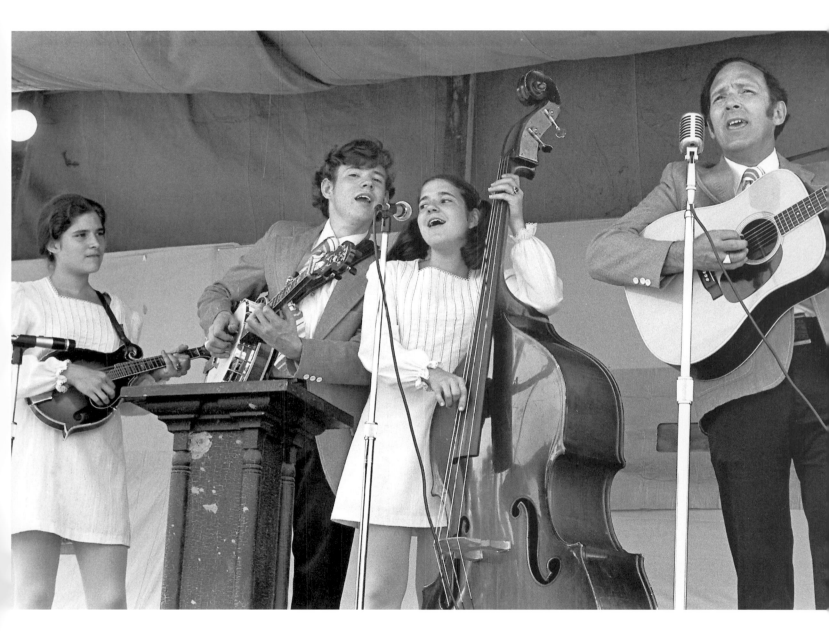

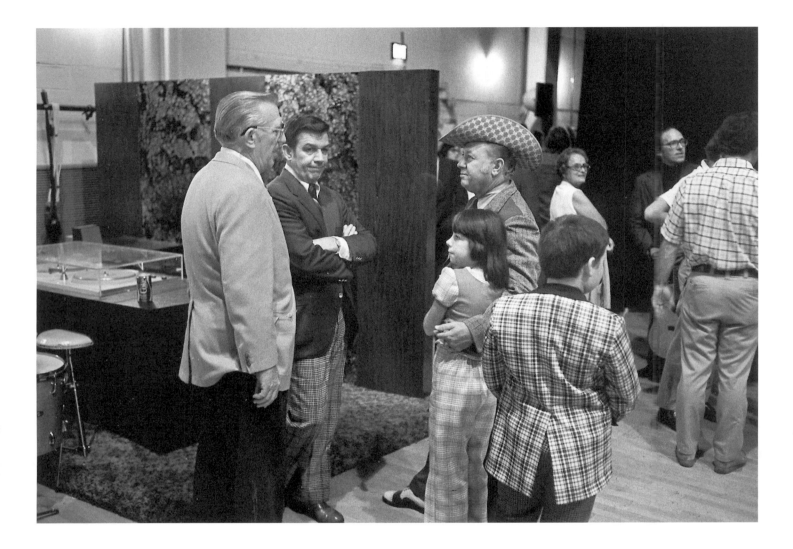

Nashville, Tennessee, October, 15, 1975. Owen Bradley and Bud Wendell with Jimmy Martin and Martin's daughter Lisa and son Timmy, backstage at the Opry House, just before the annual Early Bird Bluegrass Concert. Martin, often high-strung and raucous on stage, appears serene and at ease as he chats with Bradley, the producer of a number of Martin's recordings on Decca and MCA, and with Opry director Bud Wendell. Facing the camera on the far right is Raymond K. McLain.

Annandale, Virginia, April 1974. The editorial office of *Bluegrass Unlimited* magazine, where Pete and Marion Kuykendall ran a friendly mom-and-pop operation in a modest suburban house. Marion died in 1984.

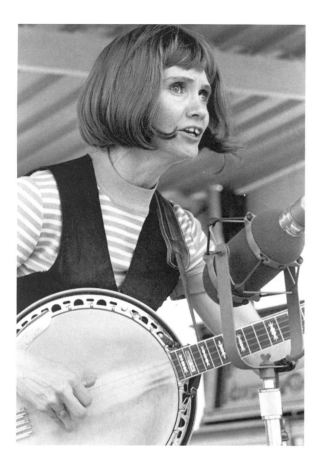

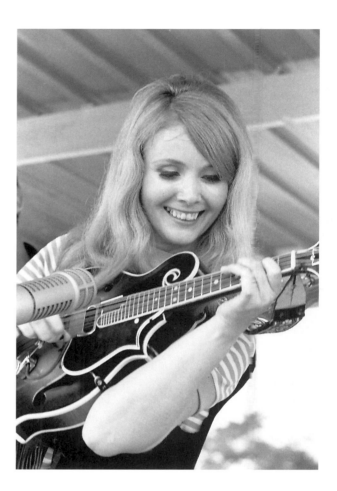

West Finley, Pennsylvania, June 8, 1970. The Stoneman Family at the Fifth Annual Pennsylvania Bluegrass Festival: guitarist Patsy, banjoist Roni (Veronica), guitarist Van, mandolinist Donna, and bassist Jimmy. Ernest V. "Pop" Stoneman of Galax, Virginia, was one of the most prolific of the early hillbilly recording artists; after his death in 1968 his sons and daughters continued to perform. Donna and Roni were the first women to gain recognition in bluegrass as featured instrumentalists. Donna not only worked in the family band but also played on a number of high-profile recordings, including the bluegrass albums of Rose Maddox and Tom T. Hall. Roni later became familiar to television viewers through her appearances as a cast member on the long-lived syndicated comedy show "Hee-Haw."

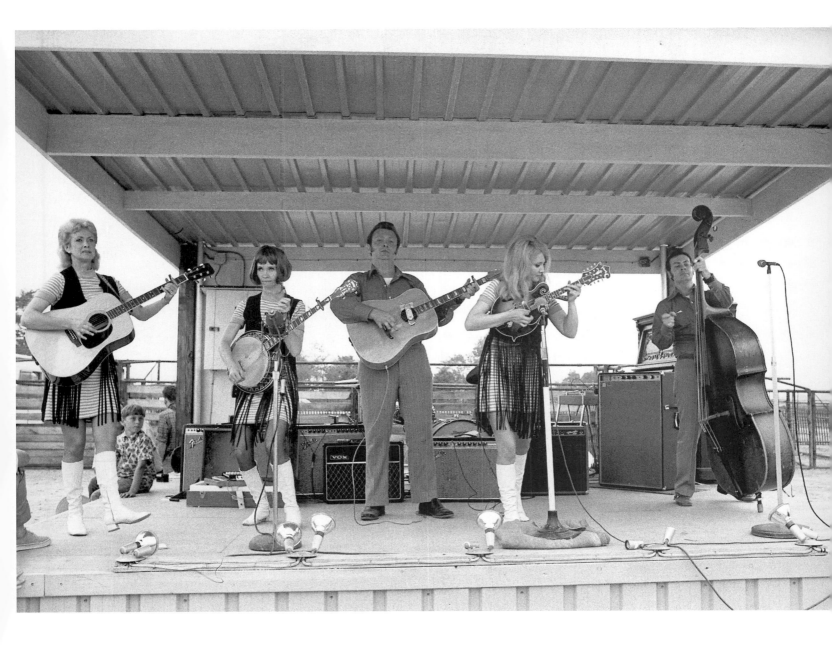

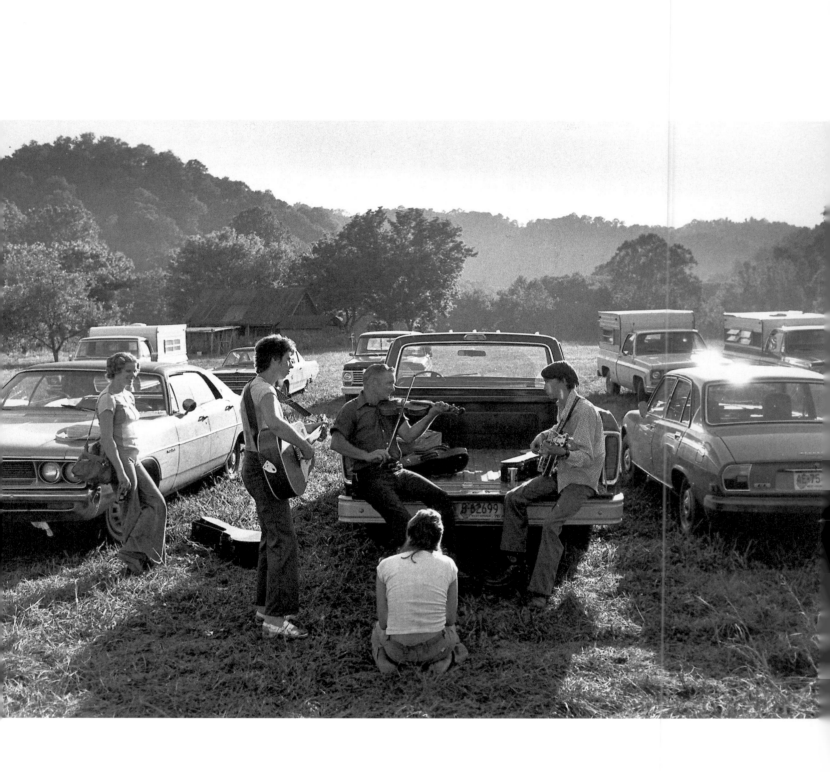

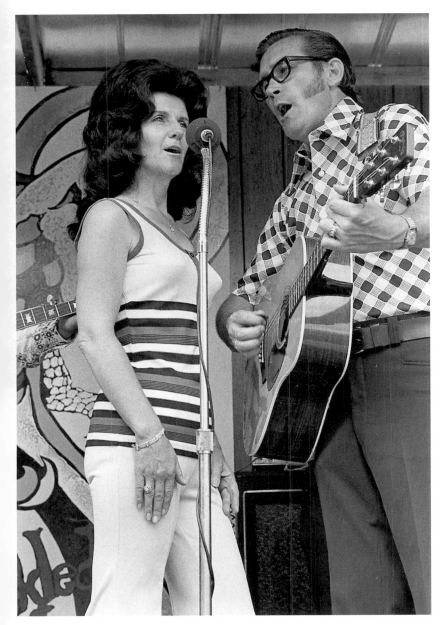

Stumptown, West Virginia, June 1976. Jamming on the back of a pickup truck in the parking lot of Bill Monroe and Ralph Stanley's First Annual Old-Time West Virginia Bluegrass Festival at Aunt Minnie's Farm.

Near Barnesville, Ohio, summer 1970. Extended family at the home of Robert Hutchison: brother William and his wife, Lorraine, and daughter Dawn; mother Emma Jane Harper Hutchison; father John William; brother John D.; brother Robert L. "Zeke" and his wife, Linda, and son Robert E. John William Hutchison was an old-time fiddler who never recorded commercially; brothers J.D. and Zeke perform and record as the Hutchison Brothers.

Merrimac, West Virginia, June 14, 1975. Melvin Goins and his wife, Willa, at the Fireman's Bluegrass Festival.

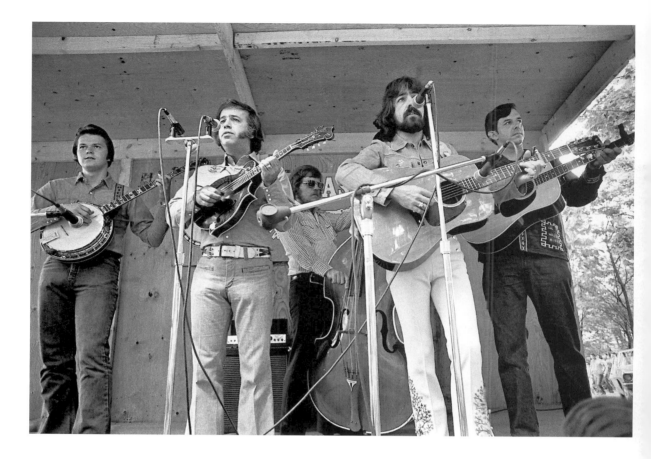

Indian Springs, Maryland, June 2, 1973. Roland and Clarence White and their band at the *Bluegrass Unlimited* Festival: Jack Hicks; brothers Roland, Eric, and Clarence White; and John Kaparakis. Hicks and Kaparakis stood in with the band during this performance. The White brothers' 1973 tour, which also included venues in Europe, reunited guitar virtuoso Clarence, who'd been playing rock music with The Byrds, with Roland, who'd been playing bluegrass with Bill Monroe and then Lester Flatt, and Eric, who'd remained at home in Los Angeles where he worked with Gib Guilbeau's band and other groups. About six weeks after this photograph was taken Clarence was killed by a drunken motorist outside a Palmdale, California, bar after a gig.

Clear Creek, West Virginia, March 22, 1975. Son and father Mark and Everett Lilly at the Workman's Creek Methodist Church Cemetery. The grave in the foreground is that of Everett's son Jiles; other graves hold the remains of Everett and Bea Lilly's father and brother.

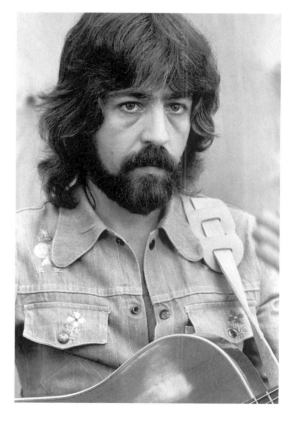

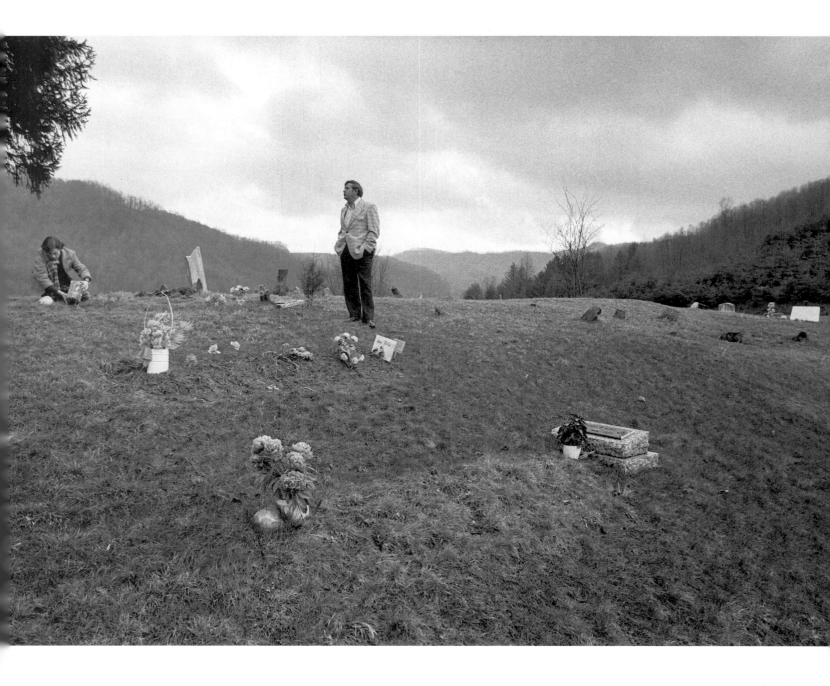

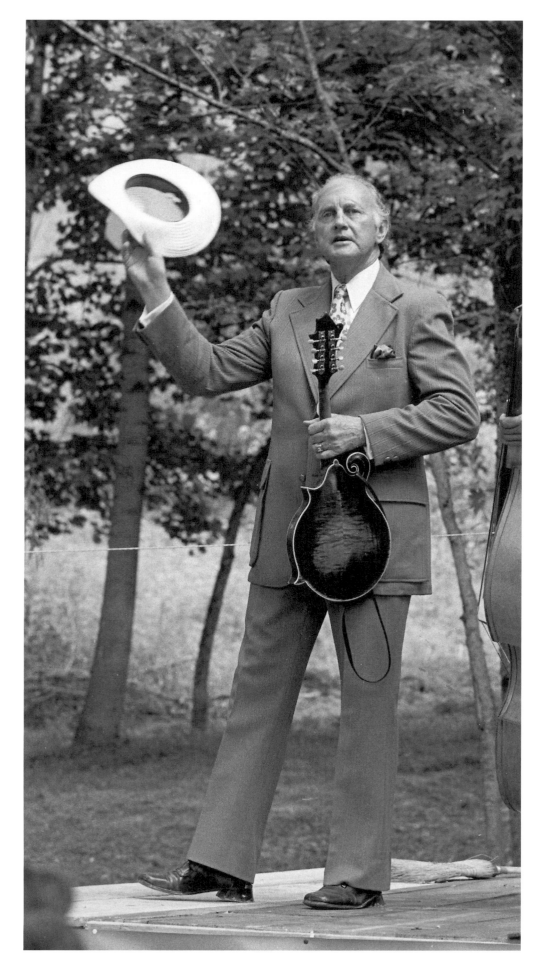

Jackson, Kentucky, August 12–13, 1972. Like a modern Buffalo Bill, Monroe salutes the audience at his Second Annual Kentucky Blue Grass Festival. Monroe often used this grand stage gesture following performances of his first hit "Muleskinner Blues" and also at the end of his shows.

The Monroe Myth

By the time Bill Monroe died in September 1996, just a few days shy of his eighty-fifth birthday, he'd become the center of his own myth. I'm not suggesting something false here, for to me myth is a narrative genre. Myths are stories that give people a way of talking about mysteries of nature in their own lives, of identifying concepts that transcend yet permeate their own experiences. Through his music Monroe narrated his own life: rural past, seasons, love won and lost, family, religion, home.

Monroe's music may have been about the past, but he didn't intend for bluegrass to be a recreation of that past, a musical museum reproduction. He wanted to distill in it things of value from his experiences in a new way that would touch others. So, for example, he took new songs like "Mule Skinner Blues" and filled them with the feelings he'd learned from old-time pieces like "John Henry." Jean Ritchie, born to a famous musical family in eastern Kentucky eleven years after Monroe, remembers hearing his new sounds as a teenager: "Bill used the old music, but he invented bluegrass with it. In that day it was Punk, it was Hip-Hop. He took the old music and he made it new."[1] Much of the power in his music was nonverbal. His mandolin breaks covered a wide dynamic

range: from gentle, soft caresses to harsh, rough-edged assaults. As he grew older he most often poured his feelings into simple but elegant new tunes. From the very beginning of his career he'd been recognized as a mandolin virtuoso, a player who opened new vistas on his instrument. He rarely used this ability to showboat; rather, it enabled him to develop his own musical language. If he wanted to say something with the mandolin, he always found a way to say it.

Until the final decades of his sixty-five-year career Monroe rarely spoke in public. Much of what he said when he fronted his own shows was brief and formulaic. He was known to insiders in the tight-knit Nashville country music scene of the 1940s and 1950s as a stern fighting man of few words. He was virtually never mentioned in the newspaper and magazine articles about his contemporaries, hillbilly stars of this era such as Roy Acuff, Ernest Tubb, and Hank Williams. No interviews with him were published until 1963. He was fifty years old when he first spoke with Ralph Rinzler, who crafted pieces that explained him to those who hadn't known about him or heard his music as well as adding to the knowledge of those who had.[2] From this point on Monroe began to speak more to his audiences about his music—its history, what it meant to him—and those statements helped to make his music more widely accessible.

Accessible does not mean easily comprehended, however. Monroe's dedicated followers—and I count myself among them—responded to his music in a visceral way, comprehending emotionally what he was doing with voice and mandolin. Indeed, the mandolin was part of his mythology, much like the man himself: worn rough, sturdy but delicate, its powerful sound lived in his hands as his fingers deftly danced over the strings, seeming barely to touch them.

The dedicated fans of Bill Monroe include the many Blue Grass Boys who played with him over the years, drawn to the man and his music in a way that transcended mere employment. The men who sang duets with him and traded licks and runs with his mandolin sacrificed to learn from him and to share their musical ideas with him. Over the years hundreds of young men, first from the South and later from other parts of the country and other countries of the world, came to experience his music making.

Bill responded to these musicians with intense personal relationships. His energy was palpable, and his very presence had a way of making a music session come to life. Even in these situations he spoke little. The first time I sat in as a Blue Grass Boy, Bill stood beside me pounding a frightening rhythm on the mandolin right into my ear. Later I came to

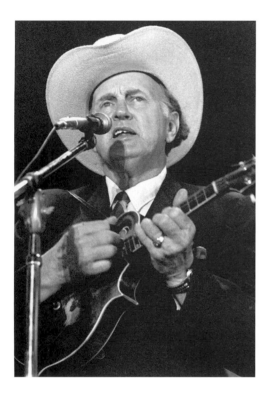

Franklin, Ohio, June 30, 1969. Bill Monroe at the Chautauqua Park Bluegrass Festival.

believe that he was working to instill in me a proper respect and visceral understanding of what he called "timing," a crucial aspect of his music. On another Sunday afternoon I walked into the back room at the Brown County Jamboree to find Bill teaching his fiddler a recently recorded tune. He played it on the mandolin, encouraging the fiddler to follow his fingering. The guitarist, who'd been at the recording session, provided a framework of chords; the banjo player wasn't there yet. Bill motioned to me to get out my banjo and play along. After I finally got enough of the tune in my head to try a break, he listened closely and, when I had finished, shot me a brief nod of approval. Boy, did that feel good!

Roger Smith, who played on the road with Bill in the 1950s, worked for him at Bean Blossom, and later drove the band bus, the Blue Grass Special, once told me of the vital difference between working for Bill and for his brother Charlie. With Bill there was music all the time—on the bus, in the back room before shows, and more. Then Roger went to work for Charlie. Just before their first show, as he and the other band members were getting into a jam session, Charlie walked in. He told them to put their instruments away. "Save it for the show, boys," he said. Roger quit Charlie's band after a week.

Bill's close relationships with his musicians seldom ended with the music. They hunted coons together and worked his farm and went to church and shared meals and talked baseball and played fox and geese (a game played with checker pieces on the back of a checker board). For Bill, making music and sports had something in common: they both involved entertaining, competitive teamwork and presented a challenge to excel. It's no wonder that in the 1940s the Blue Grass Boys were sometimes reconstituted as a baseball team that took on local sandlot teams.

Over the years some veterans of the Blue Grass Boys would visit Bill. Hubert Sizemore, who'd had a brief stint with the band as a guitarist and lead singer, spent several vacations traveling with Bill on the Blue Grass Special and was invited onstage at some shows to sing a duet with him. Charlie Smith went to Nashville each Christmas and filled in on fiddle with Bill at the Opry while the current regulars in the Blue Grass Boys took their holidays at home.

Just as Bill drew men to him with his music and engaged them with his work and play, so too did he draw women to his side. Although some became close companions and lovers, only one, Bessie Lee Mauldin, played music onstage with him. Another, Virginia Stauffer, wrote songs for him, though more often than not it was Bill who wrote songs about his relationships with women. He also would dedicate songs or tunes in his shows to them.

Bill's intense personal relationships sometimes ended in angry silence and sometimes just faded through circumstance. Many of his songs speak obliquely of such matters. Afterward, there might be a rapprochement, though not always. Season after season those who came regularly to his shows would notice newcomers among the Blue Grass Boys and different women with him after the show. Never seeming to tire of music, he drew strength and energy from these new relationships and from the life on the road that he described in one of his early songs, "Heavy Traffic Ahead." He had his own farm in Goodlettsville, Tennessee, but until the last decade of his life this fact was not widely known. Indeed, while old, close fans knew something of the intensity of his relationships, telling stories of his estrangement from Flatt and Scruggs and whispering legends of his turbulent times with Bessie Lee, these were not things he spoke of outside of his own song lyrics. When Doug Green asked him about the story behind one of his songs, "Along about Daybreak" ("This morning along about daybreak / You quarreled at me the whole night through"), he replied, "Well, there is a true story behind that song, but it don't need to be printed! It was a good song back in its day. It's a true story."[3]

In the early 1950s Bill began recording songs about his own past, about the home he'd left while still a teenager. Some of these were songs he'd written earlier and saved for the appropriate moment to record. By the time he wrote about his old home in Rosine it was empty: "There's no light in the window / That shined long ago where I lived," he sang in "I'm on My Way to the Old Home." The youngest in a large family, he'd lost his parents by the time he was sixteen. He wrote movingly about his visits to their graves during the time when he lived with his mother's fiddle-playing brother, Uncle Pen. These songs became part of his public mythology. They marked loss: an empty homestead, graves of parents. The final line of the last verse of his song about the death of Uncle Pen, "He knew it was time for him to go," was true for Bill too. When Pendleton Vandiver died, Bill left Rosine. Although he'd return from time to time, he did it knowing there would be "no light in the window."

By the early 1970s only fragments remained at the sites of the memories Bill had mined for songs about his home and those people closest to him. Members of his extended family were still alive, some right there in Rosine, others nearby. But like his songs Bill now moved between Rosine and the past it represented and the wider, contemporary world. His visits to the old homestead were fleeting. He seemed less connected to Rosine than to Nashville, the Opry, or Bean Blossom. He stayed in

touch with his brother Birch, his sister Bertha, and other members of the older generation, but his closest family relation was his son and business partner, James, who was based, like Bill, in the vicinity of Nashville, Tennessee.

Bill and James returned to Rosine in 1973 for a homecoming bluegrass festival that celebrated Bill's sixty-second birthday. The centerpiece of the event was the dedication of an impressive headstone for Uncle Pen's previously unmarked grave. Bill's siblings and sister-in-law were front and center at the dedication. In 1951 he'd written "Memories of Mother and Dad" and borrowed from his parents' headstones for the lyrics; with this new monument he made his song about Uncle Pen into an epitaph. Through this ritual Uncle Pen's grave became a symbol of Bill Monroe's fame.

When Carl visited Rosine in 1972 with Sandy Rothman they found a modest west-central Kentucky village making an effort to present itself as a historic site. A sign at the town limits proclaimed Rosine as the home of Bill, Charlie, and Birch Monroe, "the first family of bluegrass music." But Rosine's most visible features were two small stores, the Baptist and Methodist churches, and the mill where hardwood was shaped into blanks for Louisville Slugger baseball bats. The Monroe connections emerged only after Carl and Sandy began talking to the residents. They soon met family members, traveled a short distance to visit Charlie's former home and then to see Bill's childhood home, and even had Uncle Pen's cabin pointed out to them.

Pendleton Vandiver's former log home stood on high ground at the edge of town. Townspeople said that Vandiver had also lived in other houses in the area. The sided-over log house was still being used as a private residence when Carl and Sandy visited, but within a few years it had become embroiled in a local controversy. In 1991 Bill and James Monroe had begun assembling a bluegrass music museum on the former site of the old jamboree barn at Bean Blossom, and they had Uncle Pen's cabin moved there, prompting a peevish editorial in the newspaper that served Rosine. "Now we're being told," the editor complained, "that Uncle Pen's cabin, one of the last visible vestiges of the history of Bluegrass Music, will be yanked out of Ohio County for purely monetary reasons and be re-built in Nashville, Indiana."[4] Sad to say, the cabin was not in good shape. When I visited Bean Blossom in 1994, the centerpiece of the museum was a newly built log structure called "Uncle Pen's Cabin." Placed in one corner, like a saint's bones in a reliquary, though much more casually arrayed, were two of the original logs from the cabin in Rosine.

Nashville, Tennessee, October 15, 1975. Bill Monroe's "master model" F-5 Gibson mandolin backstage at the Grand Ole Opry during the Early Bird Bluegrass Concert. Designed and personally tested by legendary Gibson engineer Lloyd Loar, who signed his approval on the mandolin's label on July 3, 1923, this is the instrument heard on most of Monroe's recordings since he bought it in a Florida barbershop in 1945. In the early 1950s he sent it to Gibson for repairs. It was returned four months later and, according to Monroe, "they hadn't done what I wanted. . . . I got so aggravated that I just took the Gibson name right off it." The groove left after he dug out the mother-of-pearl inlay can be seen on the instrument's headstock, just to the left of the tuning keys. Around 1980, after this photograph was taken, Monroe patched things up with the company and they in turn patched up the instrument. In 1985 the mandolin was badly damaged by a vandal at Monroe's home, and once again Gibson restored it.

Bill Monroe's concern with the story of his life and the creation of bluegrass music is evident in his songs, in the stories he told, in the patterns and rituals of his life, and in the physical monuments dedicated to his uncle Pen. These expressions, together with the explications of Ralph Rinzler and those who followed him, have made the Monroe myth more understandable and concrete for those who love the man and his music. There is a welcome closure in knowing that his remains now lie in the Rosine graveyard along with those of his parents, uncle, and other kin. But the power of myth depends in part on mystery, perhaps even in a sense of the supernatural, and for this we must return to the whole body of his music, not just his autobiographical compositions. The intensity of bluegrass, the real spark, the mythological power remained with the man, and it still lives in the music he created.

Notes

1. Nicholas Dawidoff, *In the Country of Country* (New York: Pantheon, 1997), 109.
2. As we were completing this book, a new biography of Bill Monroe and a new compendium of articles about his life and art were published: Richard D. Smith's *Can't You Hear Me Callin': The Life of Bill Monroe, Father of Bluegrass* (New York: Little, Brown and Co., 2000); and Tom Ewing's *Bill Monroe Reader* (Urbana: University of Illinois Press, 2000).
3. Bill Monroe, interviewed by Doug Green for *Bill Monroe and His Blue Grass Boys: The Classic Bluegrass Recordings,* vol. 1 (County CCS 104, 1980).
4. The quote is from "Ohio County Gets Another Kick" (editorial), *Hartford and Beaver Dam (Kentucky) Times-News,* Oct. 31, 1991. See also "The Cabin's Gone" (news feature), ibid.

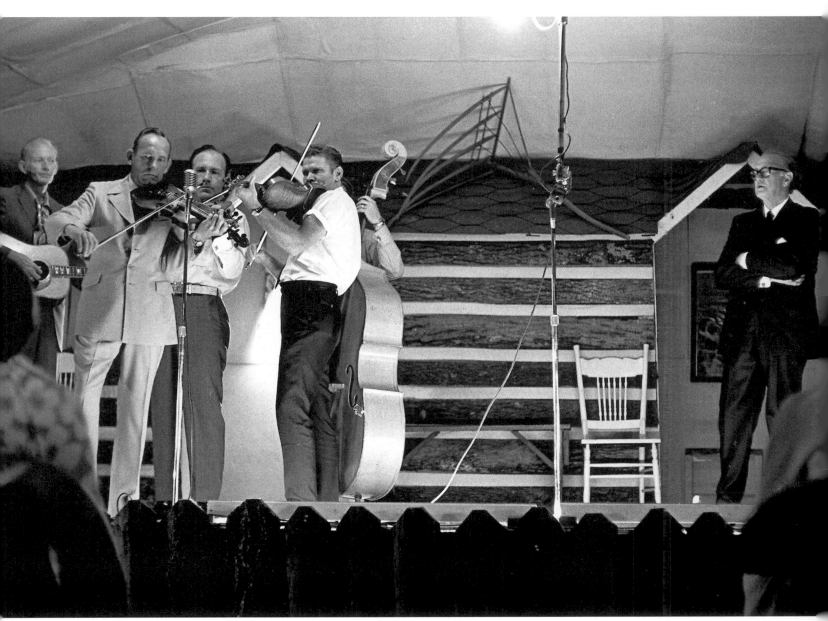

Alexandria, Virginia. November 25, 1979. Bill Monroe and harmonica player Charlie Sayles at a bluegrass concert at Hammond High School. Ralph Rinzler (seated) had brought his friend Sayles backstage to see Monroe.

Bean Blossom, Indiana, June 1970. Bill Monroe listens as Red Smiley, Kenny Baker, Tater Tate, Vassar Clements, and Bill Yates (on bass), perform an instrumental version of a hymn in the Brown County Jamboree barn during the Sunday morning program at Monroe's annual festival. Looking at this photograph in 1998, veteran Blue Grass Boy Tom Ewing said that the hymn was probably "Pass Me Not."

West Finley, Pennsylvania, August 7, 1970. Bill Monroe and Doc Watson at the Fifth Annual Pennsylvania Bluegrass Festival. Monroe and Watson performed together on special occasions, recreating many of the duets Bill had sung in the 1930s with his brother Charlie and trading hot licks on old-time instrumental tunes.

Alexandria, Virginia, November 25, 1979. Bill Monroe, Butch Robins, John Duffey, and Charlie Waller at a concert at Hammond High School. Duffey and Waller, partners in the Country Gentlemen from 1957 to 1969, were performing with their bands, the Seldom Scene and the current version of the Country Gentlemen. When they joined Monroe onstage, Duffey and Waller borrowed cowboy hats like those worn by the Blue Grass Boys, amusing fans who knew that the pair had always eschewed western outfits.

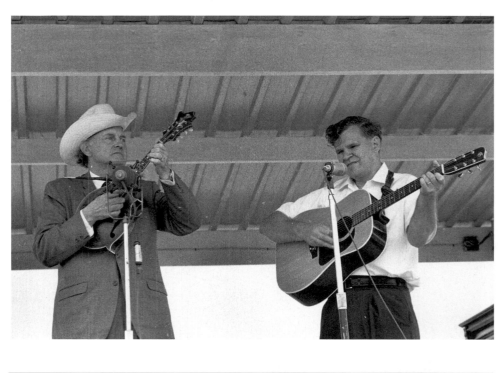

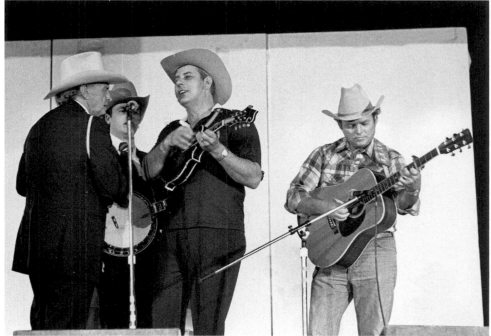

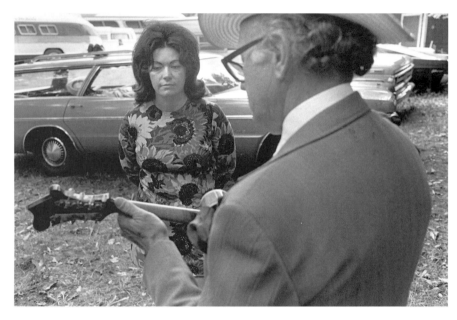

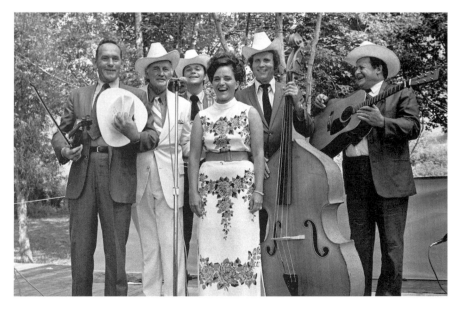

Rosine, Kentucky, September 16, 1973. Hazel Smith and Bill Monroe at the Monroe Homecoming and Bluegrass Festival. Smith, a country music publicist and songwriter based in Nashville, Tennessee, wrote an article on the festival for *Bluegrass Unlimited* that was illustrated by Carl's photos.

Reynoldsburg, Ohio, June 25, 1972. Mary Starkey listens to Bill Monroe trying a newly acquired Gibson F-5 at the Frontier Ranch festival.

Jackson, Kentucky, August 13, 1972. Bill Monroe and the Blue Grass Boys—Kenny Baker, Jack Hicks, Monroe Fields, and Joe Stuart—with Jewel Breeding. After performing "My Old Kentucky and You" at his Second Annual Kentucky Blue Grass Festival, Bill interrupted the show, drew the band together, and called Carl to come over to take a photo. As they posed, Carl shouted, "Smile, Bill!"

McClure, Virginia, May 24, 1972. Kenny Baker, Jack Hicks, Joe Stuart, Monroe Fields, Bill Monroe, and Jewel Breeding at the Carter Stanley Memorial Festival. Breeding was the inspiration for Monroe's new release "My Old Kentucky and You," which contains the line "You're the jewel of all the bluegrass girls" and features a distinctive guitar lick, being played here by Stuart. Monroe featured the song at nearly every show that summer, and whenever Breeding was present he invited her onto the stage.

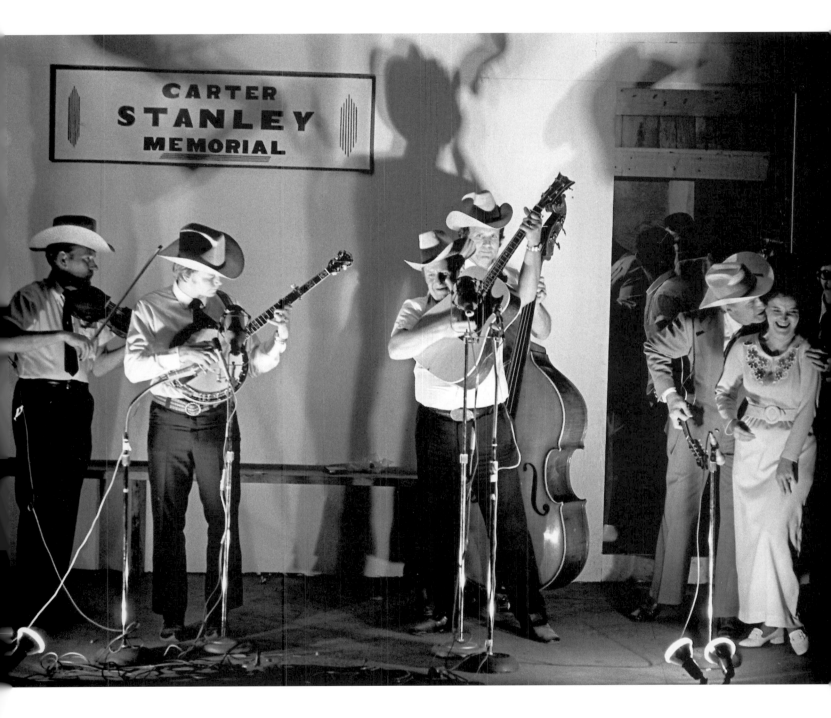

Near Rosine, Kentucky, April 1972. Using a self-timer, Carl took this photograph of himself and Sandy Rothman during a pilgrimage to the central Kentucky community of Rosine and the Monroe family's former home a short distance from town. When Monroe was a child the road in front of the house was a public right-of-way. Today the entire tract is private and no longer owned by the Monroe family. The subject of his 1950 song "I'm on My Way to the Old Home," Monroe's childhood home is a fascinating example of vernacular architecture, consisting of five nearly identical room-units, each with an exterior door, arranged in a T. In the distant view, the house is seen across an area eroded as a result of strip mining. Monroe's father, James Buchanan "Buck" Monroe, and his brother Charlie mined coal on the property.

Rosine, Kentucky, April 1972. Inscribed at the bottom of James B. Monroe's headstone are the words "We will meet again" and on Malissa A. Monroe's, "Gone but not forgotten." In 1952

Monroe incorporated these inscriptions into the chorus of his song "Memories of Mother and Dad," a fact noted for the first time in print by Ralph Rinzler in his liner notes to the reissue of the song on Monroe's 1967 album *The High Lonesome Sound.*

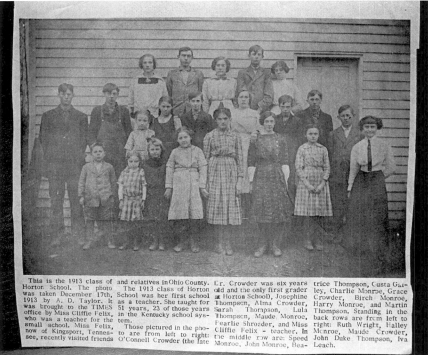

This is the 1913 class of Horton School. The photo was taken December 17th, 1913 by A. D. Taylor. It was brought to the TIMES office by Miss Cliffie Felix, who was a teacher for the small school. Miss Felix, now of Kingsport, Tennessee, recently visited friends and relatives in Ohio County. The 1913 class of Horton School was her first school as a teacher. She taught for 51 years, 23 of those years in the Kentucky school system.

Those pictured in the photo are from left to right: O'Connell Crowder (the late Mr. Crowder was six years old and the only first grader at Horton School), Josephine Thompson, Alma Crowder, Sarah Thompson, Lula Thompson, Maude Monroe, Fearlie Shroader, and Miss Cliffie Felix - teacher. In the middle row are: Speed Monroe, John Monroe, Beatrice Thompson, Custa Gailey, Charlie Monroe, Grace Crowder, Birch Monroe, Harry Monroe, and Martin Thompson. Standing in the back rows are from left to right: Ruth Wright, Halley Monroe, Maude Crowder, John Duke Thompson, Iva Leach.

Rosine, Kentucky, September 15, 1973. The Rosine Centennial Celebration Parade, part of a separate event that took place on Saturday during the same weekend as the Monroe Homecoming and Bluegrass Festival. The Ohio County Marching Band is shown here on the state highway that serves as Rosine's main street. Other events at the centennial were a flea market and a square dance.

Rosine, Kentucky, April 1972. Wendell Allen and Sandy Rothman in Allen's kitchen. When Carl and Sandy expressed an interest in the history of Rosine, they were directed to Wendell, known as the unofficial mayor of Rosine, who welcomed their interest and shared his knowledge with them. Carl rigged a tripod and camera so he could copy selected documents.

Rosine, Kentucky, April 1972. This clipping from Wendell Allen's collection portrays the 1913 class of Horton School, which included six of Bill Monroe's siblings, from twenty-year-old Harry to twelve-year-old Birch. Bill was two years old at the time.

161

Rosine, Kentucky, April 1972. Pendleton Vandiver's former residence—one of several occupied during his lifetime—was a log cabin protected by siding on a rise of land at the edge of Rosine. Bill Monroe spoke frequently of his maternal uncle's strong influence on his music. The chorus to Monroe's 1951 tribute song "Uncle Pen" locates the fiddler's home "high on the hill, above the town." At the 1973 Monroe Homecoming and Bluegrass Festival, Monroe's son James presented this three-and-a-half-acre site to his father as a birthday gift. In 1991 James and Bill had the cabin disassembled and moved to Bean Blossom, Indiana.

Rosine, Kentucky, April 1972. Pendleton Vandiver's fiddle, owned by the Stogner family. In recent years this instrument has been on display at the International Bluegrass Music Museum in nearby Owensboro.

Martinsville, Indiana, August 18, 1972. Birch Monroe (1901–82) on his front

porch. Birch settled in Martinsville in the early 1950s after Bill bought the country music park at nearby Bean Blossom. For many years he managed the park, looking after the Brown County Jamboree on Sundays and playing old-time fiddle for the square dances on Saturdays. He occasionally performed with Monroe and the Blue Grass Boys.

Columbus, Ohio, fall 1972. Charlie P. and Myrtha "Mert" Monroe at the Country Palace tavern. Charlie (1903–75) and Bill performed as the Monroe Brothers from 1934 to 1938. After they split up, Charlie formed his own band, the Kentucky Pardners. He retired in 1955, moved back to Rosine, bought the old homestead, and lived there for about ten years before moving to Tennessee. In the 1970s, after the death of his first wife, Betty, Charlie began performing again.

Rosine, Kentucky, April 1972. A photograph of Bill's brother Speed V. Monroe (1894–1967) in his World War I army uniform. The picture was hanging on the living room wall at the home of Speed's widow, Geanie, when Carl took it down to make this copy.

Reynoldsburg, Ohio, June 25, 1972. James William Monroe (Bill's son) backstage at the Frontier Ranch festival.

Bean Blossom, Indiana, June 1970. Bill Monroe and his sister Bertha Monroe Kurth (1907–97) at the annual Bean Blossom festival. Bertha was the widow of railroad engineer Bernard Kurth.

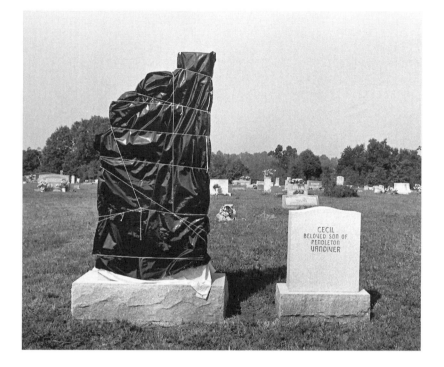

Rosine, Kentucky, September 15–16, 1973. The dedication of the new tombstone at the previously unmarked grave of Pendleton "Uncle Pen" Vandiver on the final day of the Monroe Homecoming and Bluegrass Festival. The shrouded stone was photographed on Saturday and the ceremony on Sunday evening. Monroe family members at the dedication included brothers Bill and Birch, sister Bertha, sister-in-law Geanie, and Bill's son James.

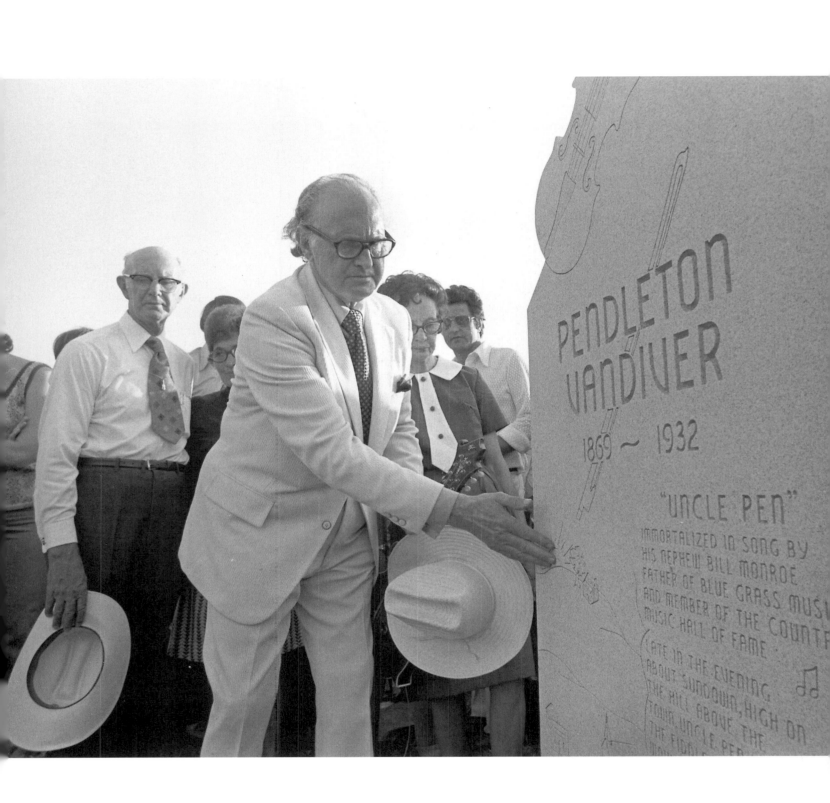

The monument reads:

PENDLETON
VANDIVER
1869 ~ 1932

"UNCLE PEN"
IMMORTALIZED IN SONG BY
HIS NEPHEW BILL MONROE
FATHER OF BLUE GRASS MUSIC
AND MEMBER OF THE COUNTRY
MUSIC HALL OF FAME

LATE IN THE EVENING,
ABOUT SUNDOWN, HIGH ON
THE HILL ABOVE THE
TOWN, UNCLE PEN

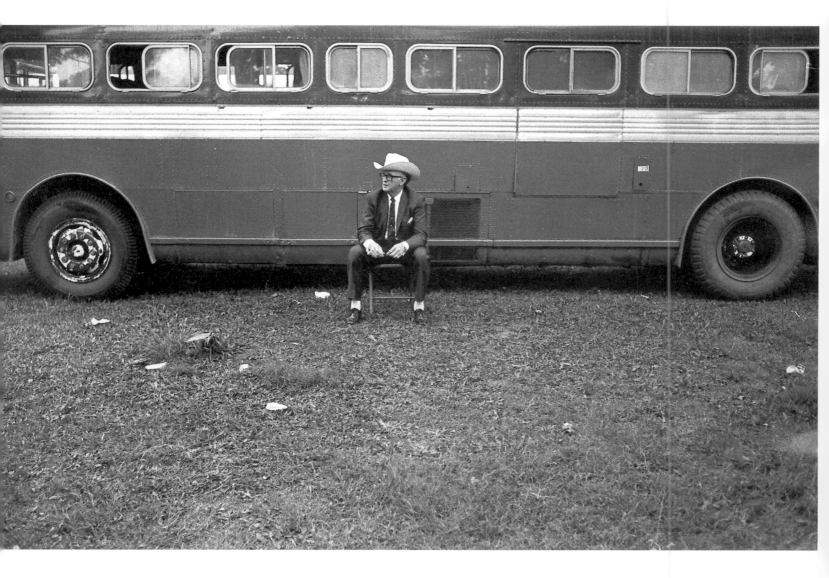

Franklin, Ohio, September 8, 1968.
Bill Monroe and the Blue Grass Special
at the Chautauqua Park Bluegrass
Festival.

Afterword

My first photographs of bluegrass musicians were taken in 1966 and 1967 while I was studying photography and film at Ohio University. These efforts had more to do with the acquisition of technical skills than with documentation. At the time I had no thoughts of doing a long-term project, as evidenced by the fact that after I photographed Sid Campbell and his band in Athens, Ohio, in 1966 I gave Sid my negatives. (I retrieved them in 1974 after my documentary effort was well under way.)

Looking at that proof sheet today, I see that the fifteen negatives I retrieved from Sid (there may have been a few that were lost) consist entirely of medium shots and closeups, clearly focusing on the musicians. This aspect of my photographic coverage of bluegrass has continued ever since. Closeups of individual musicians and close-in portraits of duets, trios, and bands have been my most salable photographs, at least after magazines such as *Bluegrass Unlimited* began using my work. Like most photographers, I was drawn to such intimate views because of their artistic impact. Whether flowers or faces, closeups have strong graphic values, and when they depict a person in the expressive throes of performance, they convey a dramatic sense of the individual.

I was a little slower in getting to wide shots. A handful of wide-angle photographs appear in my 1967 coverage of a festival in Columbus, Ohio, but, looking back at my proof sheets, I see that I took more care to make wide shots the following year, at a festival at Chautauqua Park, just south of Dayton. One of my favorite pictures was shot on that

occasion: Bill Monroe between sets, seated on a folding chair in front of his bus.

My increasing use of wide-angle photography marked my growing interest in context. Like many photojournalists and documentary photographers I combined an ethnographic impulse with an artistic one. On the ethnographic side, the folding chair and slightly down-at-the-heel bus in the photograph of Bill Monroe suggest the level of his financial outlay for road travel in 1968 and convey a sense of bluegrass music's characteristic lack of fancy trappings. On the artistic side, the viewer's eye is caught by the symmetrical, mechanical pattern produced at the horizon line by the windowed façade of the bus, while the emptiness of the scene connotes the isolation, independence, and even stand-offishness for which Monroe was famous.

Wide-angle photographs can show a scene whole, or at least as whole as the camera's angle of view and the photographer's position permit. A wide shot can document a tavern interior, outdoor stage, or living room, providing a thorough description of the space's material culture—that is, the objects that are present and their arrangement. A wide-angle photograph that includes people can also document visible aspects of human relationships: facial expressions, gaze direction, posture, and how close or how far people are from one another.

The documentation of visible aspects of human relationships in still photographs, of course, is less trustworthy than the recording of material culture. Anyone who appears in a snapshot with eyes closed or mouth wide open knows that the timing of the exposure is critical and that photographs can be misleading. Social scientists with a serious interest in what Edward Hall called the "silent language" prefer to study carefully produced motion picture footage, presumably further enhanced by the presence of sound.[1] I suppose that my still photographs of bluegrass music scenes fail to record all the details of nonverbal communication (to say nothing of the music), but they're not intended to serve the social science laboratory.

I worry more about the effect of another characteristic of photographic documentation: the need to edit for an audience. Like a documentary filmmaker who sees the most comprehensive reflection of yesterday's happenings in the uncut rushes from the shoot, a documentary still photographer feels closest to what really happened when poring over the dozens (or even hundreds) of exposures made at a single event on his or her proof sheets. A succession of ten nearly identical frames of a band performing onstage, for example, invariably provides a more complete report of the ensemble's postures, gestures, movements, and facial

expressions than the best of the individual photographs. But photographers don't reach their audiences by displaying proof sheets. The customary photographic exhibition or picture book tells its story in a sequence of judiciously selected images, just as a finished documentary film represents the reduction and rearrangement of hours of footage.

Like many other photojournalists and documentary photographers I try to produce reasonably comprehensive coverage of an event. For example, after shooting a mix of wide, medium, and closeup shots at an indoor event, I generally try to get pictures of the building's exterior and in some cases the adjacent neighborhood. I follow maxims learned from colleagues, as when photojournalist Jon Webb told me, "Carl, if you want good ones, be sure to walk all the way around." Jon, who worked for several years at the Louisville *Courier-Journal,* was teaching me that back or side views often make the best pictures.

When photographing bluegrass festivals I had a rough-and-ready checklist in mind. The first item, of course, was photographing the performers. My typical pattern was to try to capture the whole band or at least the members up front (bass players standing behind the rest of the band are *always* a problem), each individual member, vocal duets and trios, and especially band members gathered at a single microphone. I found that quartets at a single mike presented special problems: the singers' heads and the microphone crowd and overlap one another, and there is rarely enough depth of field to keep all four faces in reasonable focus. Finally, remembering Jon Webb's advice, I tried to find a way to get backstage or behind the stage to take reverse-angle or over-the-shoulder shots in which the musicians frame a view of the audience.

In my photographs of musicians I watch for opportunities to compose shots that include the person, the instrument, and both hands at work. Such pictures not only portray the player but also provide helpful information to those interested in playing styles and musical instruments. The exigencies of the situation, however, often thwart me. Either I'm in the wrong position, the lenses in reach are of the wrong focal lengths, microphone stands and booms are in the way, or spotlights or stray shafts of sunshine create bright hot spots on a musician's arm or banjo neck. While photographing bands on stage I watch for special or unusual things. For example, my files contain a dozen attempts to take a good picture of Bill Monroe raising his hat and bidding the audience farewell as the last number in a set by the Blue Grass Boys wound up.

I also keep a checklist in my head of canonical festival elements that I need to cover: parking lot picking, hustling record albums, camping and cooking, getting autographs or a snapshot with a star, and selling

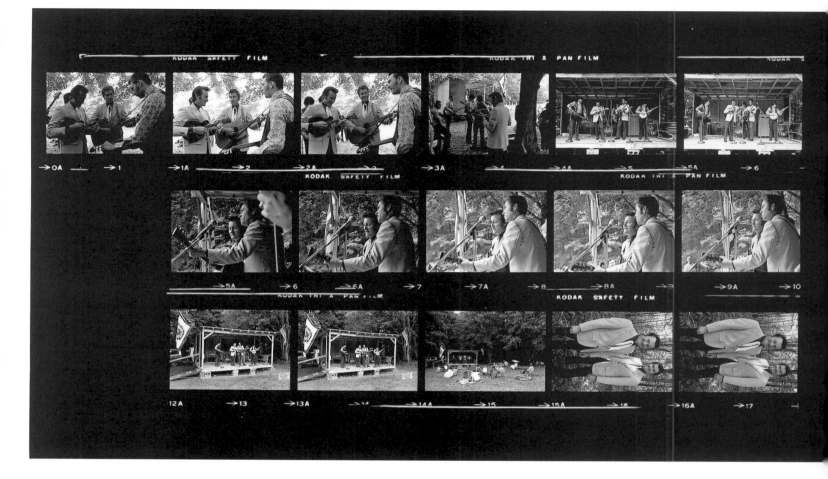

Webster Springs, West Virginia, July 5, 1974. Jim and Jesse and the Virginia Boys at the Mountain State Bluegrass Festival. My coverage of the band at this event includes fifty-five exposures, sixteen of which are reproduced here: the band tuning up before the set (1–4, 35mm wide-angle lens), a medium-wide shot of the band on stage (5–6, 35mm wide-angle lens), a profile view of the brothers performing (5A–9A, 85mm telephoto lens), two variants of a wide shot of the entire stage area during the band's set (13–15, 35mm and 24mm wide-angle lenses), and posed portraits of brothers Jesse and Jim McReynolds after the set (16–17, 35mm wide-angle lens). The band members include Dobro player Donald Earl, electric bassist Keith McReynolds, and banjoist Tim Ellis.

or trading instruments, to say nothing of the drunks, the dancing hippies, the behind-the-scenes people, and the inevitable rainstorms, muddy grounds, and cars in need of a push. I've never had any trouble getting these sorts of pictures; the trick is always to enliven the image by taking advantage of lighting effects or by including an animated person or a telling signboard.

Offstage, I keep an eye open for the new, the unexpected, or a combination of special elements. One favorite is my 1973 shot of Clarence White in his Nudie-style bellbottoms, followed by banjo player Lamar Grier, gingerly stepping around a passed-out fan under a tree (page 116). Only in 1992 did I learn this picture's bonus value: the young man between White and Grier is Lamar's twelve-year-old son David, now a recognized guitar whiz, captured at a time when his music was being shaped by Clarence's in an important way.

The coverage approach produces many more pictures than can be presented to an audience. So why take so many shots? First, it's often necessary to make several exposures in the quest for a single successful image. When shooting human activities, the variables of action and

setting rule out "previsualizing" the finished photograph, the approach Ansel Adams espoused for producing his marvelous landscapes. Second, photojournalists and documentary photographers typically cover events in a manner that will provide layout options for the printed page. Picture editors assembling a book or magazine article demand "visual variety" and hope for a closeup of this and a wide shot of that. Since it's impossible to predict which element will be needed close and which at a distance, experienced photographers try to shoot multiple, varying images of the key elements.

Although picture editors don't reproduce the photographer's complete coverage, they know that readers are sometimes willing to study one or two groups of nearly alike photographs. The most familiar example is a set of closeups of a face in which the expression changes from frame to frame; for this book's version, see the four photographs of Sonny Osborne and Marty Stuart (pages 38–39). Readers have a greater tolerance for varied coverage of the same scene, where the still photographs run parallel to the customary montage in a motion picture: wide shot, medium shot, closeup, reverse angle.

Journalistic and documentary photography books and exhibitions also achieve visual interest by variety of scene and, sometimes, of time and place. This book, for example, is a retrospective of my own peregrinations from the 1960s through the 1980s and includes pictures taken in different settings, years, and locations—that is, coverage not of a single event but of a number of events. When I took up the camera I was already a bluegrass fan. My first exposure to the music played live was hearing Neil in 1961, and my pursuit of bluegrass thereafter was informed by reading and by conversations with the scholars and aficionados who were part of my circle of friends (several of whom are pictured in this book). During the two decades in which I was active I documented the far-flung bluegrass community, which may occupy one virtual space but is found in hundreds of geographical places. My affection for portraying these places and my penchant for wide shots led me to title my September 1992 exhibition at the International Bluegrass Music Museum in Owensboro, Kentucky, "The Bluegrass Landscape."[2]

* * *

Documentary photographs are often presented in books that are very nearly devoid of text; Walker Evans and James Agee's *Let Us Now Praise Famous Men* is a notable exception. My own contribution to the near-mute category is the book *Blue Ridge Harvest,* coedited with photogra-

phers Lyntha and Terry Eiler and published by the Library of Congress's American Folklife Center in 1979. I recall discussing this book with colleagues afterward and hearing their disappointment over the near-absence of text. At the time I responded that people should learn to "read" the photographs, to study them as you would an event seen during fieldwork in order to extract meanings from them.

These exchanges reminded me of parallel conversations I'd had as a film student regarding the cinema verité style of motion pictures produced in the 1960s. In a quest for naturalism some of these films not only eschewed commentary recorded on the sound track—the sort of running verbal explanation that reaches its apogee in nature programs on public and cable television—but also made no effort to use interviews or quasi-interviews in which the people being documented offered their explanations of the activity at hand. The filmmaker who kept to this style into the 1990s is Frederick Wiseman (*Titicut Follies, High School, Hospital,* and many others). Watching his films can be like doing fieldwork, albeit fieldwork in which you're not empowered to ask questions, and they require the viewer to interpret complex events based on close observation. I'm fond of Wiseman's films, but I know that viewers who expect the more familiar documentary-as-essay find Wiseman's work frustrating and often incomprehensible.

How much verbal explanation is needed to accompany documentary images? Can pictures be the main text with words playing a supporting role? Will audiences take the time to read pictures? When do captions or explanations take over and become the main text, relegating the photographs to the status of secondary illustrations, as they do in television programs about nature? Is there a point of balance, a point at which neither text nor picture is primary?

Neil and I struggled with these issues in assembling this book. When writing the text portion of each chapter, Neil sought a voice that spoke at higher levels of generality or abstraction, although his writing contains specific illustrative references. In the captions that accompany the photographs we tried to be more specific, providing what some art museum professionals call "tombstone data"—date, identification of place, people, or events—and a sentence or two to illuminate some aspect of each photograph. We tried to minimize saying in words what can be clearly seen (e.g., "Women dancing in the barroom as the band plays"). Captions of this type inhibit readers, we believe, from studying the photograph for themselves.

In the final analysis *Bluegrass Odyssey* is weighted heavily toward pho-

tographs. Neil and I determined their quantity and sequence in a series of discussions, after which Neil drafted the text portion of the chapters. In some cases the logic of the sequence is clearly articulated in the words or in intimate relationships among images, as, for example, the exterior and interior views of taverns and other night spots. Sometimes the sequence is governed by graphic elements, while at other times it's arbitrary or based on ineffable principles. Neil and I tried to construct a work that modulates between a photo essay and a picture poem.

<p align="center">* * *</p>

My photographic technique was shaped by my schooling in Ohio University's fine arts program from 1966 to 1969, when I received my M.F.A. (Today, a second photography program exists in the School of Communications.) I was one of a half dozen or so graduate students who pursued photojournalism and documentary photography under the tutelage of a faculty member named Betty Truxell. In Betty's "picture story" class we tried to master the vocabulary of wide, medium, close, and reverse-angle shots, always striving for the "decisive moment" epitomized by photographer Henri Cartier-Bresson. Our homework assignments consisted of multi-image magazine-style layouts, in contrast to the single, matted photographs produced in other classes. We were avid readers and imitators of *Life* magazine (old and new), *Look* (where Paul Fusco, who had recently graduated from Ohio University, was then active), *National Geographic,* and Robert Frank's book *The Americans,* first published in the United States in 1959 by Grove Press.

When I arrived in Athens in 1966, the Nikon F single lens reflex camera was only a few years old and, along with the rangefinder Leica, the journalist-documentary student's camera of choice. My toolkit resembled that of my cohorts: two Nikon camera bodies and two basic lenses: a medium-wide-angle 35mm and a portrait-telephoto, first a 105mm and later an 85mm. And the ever-present light meter. We carried two camera bodies because "one roll always runs out just when something neat happens." Very soon, in order to assist in the making of wide-angle photos, I added a 24mm lens to my kit. In time I also added a third camera body, a 200mm telephoto lens, and a special "micro" lens, mostly to copy old photographs that I encountered in my fieldwork.

Among the Ohio University journalist-documentary students opinions were divided on the matter of flashguns. A few in the group were dedicated to existing-light photography, believing that added illumination destroyed the naturalness of the scene. On my side of the fence were

those who were willing to add light. We often used small folding flash units that fired small, number 110 bulbs. My flash unit—in a "bare bulb" mode—illuminated the interior view of the Blue Grass Palace reproduced on page 44. Before long I joined others in embracing the Vivitar 283 electronic flash, still a workhorse in the field today. My experience in motion picture and television production from 1967 through 1976 also gave me access to and experience with quartz lights (a.k.a. halogen lamps), and I have used them for still photography as well—for example, the photographs of the Country Gentlemen and Red Allen at Spring Lakes Park on pages 32 and 133.

All of the photographs included here were exposed on Eastman Kodak Tri-X film. Through 1976 I developed my negatives in D-76, diluted 1:1. After I moved to Washington, D.C., in 1976 I began sending my film to Asman Custom Photo, a commercial lab on Capitol Hill where the negatives were developed in replenished and undiluted D-76. As the literature suggests, this increased their graininess but, alas, I was too busy with other things to continue souping my own film. Asman produced the prints from which the halftones in this book have been made.

The 1970s were my most active years, following completion of my photo schooling in 1969 and preceding my employment at the Library of Congress's American Folklife Center; from 1976 forward, every year found me more distracted from my bluegrass project. Although I can't say I photographed *every* person, place, and event in bluegrass from 1966 to the 1990s, I'm pleased to see how much I did manage to cover. Some sense of my activities is suggested by a listing of the states in which I documented aspects of bluegrass during my active years.

Year	Number of Events	States
1966	2	Ohio
1967	4	Ohio
1968	6	Washington, D.C., Ohio, North Carolina
1969	5	Ohio
1970	11	Indiana, Ohio, North Carolina, Pennsylvania, West Virginia
1971	7	Kentucky, Massachusetts, Ohio, North Carolina, West Virginia
1972	13	Washington, D.C., Indiana, Kentucky, Ohio, West Virginia, Virginia
1973	11	Washington, D.C., Kentucky, Maryland, Ohio, Tennessee, West Virginia, Virginia
1974	18	California, Washington, D.C., Maryland, Ohio, Pennsylvania, West Virginia, Virginia
1975	17	Maryland, Mississippi, Ohio, Tennessee, West Virginia, Virginia
1976	11	Maryland, Ohio, Pennsylvania, West Virginia, Virginia
1977	14	Washington, D.C., Maryland, Ohio, West Virginia, Virginia

1978	7	Washington, D.C., Maryland, Ohio, Virginia
1979	8	California, Washington, D.C., Maryland, Ohio, Virginia
1980	7	California, Washington, D.C., Virginia
1981	9	California, Washington, D.C., Virginia
1982	1	Virginia
1983	1	Tennessee
1985	1	Virginia
1986	3	Washington, D.C., Ohio, Pennsylvania
1992	1	Kentucky

Notes

1. Two books by Edward Hall are standard works on nonverbal communication: *The Silent Language* (New York: Doubleday, 1959) and *The Hidden Dimension* (New York: Doubleday, 1966). The role of body movement in communication receives in-depth treatment in Ray L. Birdwhistell's *Kinesics and Context* (1970; reprint, New York: Ballatine Books, 1972). The revised edition of still-photographer John Collier Jr.'s *Visual Anthropology,* with Malcolm Collier (1967; reprint, Albuquerque: University of New Mexico Press, 1986), makes this argument: "Refinements of interpersonal behavior are suggested in still photographs, but conclusions must still rest on often projective impressions that 'fill in' what the photograph does not contain. With moving records, however, the nature and significance of social behavior becomes easier to define with responsible detail, for it is the language of motion that defines love and hate, anger and delight, and other qualities of behavior" (140).

2. For contrasting approaches I commend to readers my two favorite bluegrass photography books (other than *Bluegrass Odyssey!*): Nobuharu Komoriya's *Blue Ridge Mountains: Friendly Shadows* (Tokyo: Kodan-sha Press Service Center, 1974) and Kohsei Yoshida's *Bill Monroe: The Father of Bluegrass, Bill Monroe, and the Bluegrass Boys* (Hyogo, Japan: B.O.M. Service, Ltd., 1985). Both of these books document a slice of bluegrass. The first provides a terrific cross section of 1973's crop of bluegrass festivals, while the second offers a handsome set of photographs taken during the 1984 Blue Grass Boys tour of Japan.

Index

Carl Fleischhauer holds degrees from Kenyon College and Ohio University. His work experience includes film and video production at West Virginia University and media documentation activities at the American Folklife Center at the Library of Congress. His publications include the videodisc *The Ninety-six: A Cattle Ranch in Northern Nevada* (Library of Congress, 1985) and the photographic book *Documenting America, 1935–1943* (University of California Press, 1988). From 1990 to 1994 he coordinated the American Memory Program at the Library of Congress, a pilot project that modeled the dissemination of historical collections in electronic form. In 1995 he joined the Library of Congress's National Digital Library Program, where his current assignment is to develop new approaches for the preservation of sound and video recordings.

Neil V. Rosenberg did his undergraduate work in history at Oberlin College and his graduate work in folklore at Indiana University. He is a professor of folklore at Memorial University of Newfoundland, where he has taught since 1968, and a fellow of the American Folklore Society. His books include *Bill Monroe and His Blue Grass Boys: An Illustrated Discography* (Country Music Foundation, 1974), *Bluegrass: A History* (University of Illinois Press, 1985), and the edited collection *Transforming Tradition* (University of Illinois Press, 1993). In addition to his work on bluegrass music, he has written extensively about aspects of folk and country music in Atlantic Canada. He has also edited and written notes for many recordings. His contribution to Smithsonian/Folkways' *Anthology of American Folk Music* won a 1997 Grammy for best album notes. He is active as a musician with three bands in St. John's, Newfoundland, including the bluegrass outfit Crooked Stovepipe.

Music in American Life

Composed in 10.5/16 Stone Serif
with Lubalin Graph display
by Jim Proefrock at the
University of Illinois Press
Designed by Copenhaver Cumpston
Manufactured by Friesens Corporation

University of Illinois Press
1325 South Oak Street
Champaign, IL 61820-6903
www.press.uillinois.edu